A
is forArctic

A
is forArctic

Natural Wonders of a Polar World

Text and Photographs by
Wayne Lynch

FIREFLY BOOKS

BOOKMAKERS PRESS

A FIREFLY BOOK

Cataloguing-in-Publication Data

Lynch, Wayne
 A is for Arctic

Includes index.
ISBN 1-55209-048-5

1. Animals – Pictorial works.
2. Zoology – Arctic regions – Pictorial works.
3. Zoology – Arctic regions.
I. Title.

QL105.L95 1996 591.998'022'2 C96-930944-9

Published by
Firefly Books Ltd.
3680 Victoria Park Avenue
Willowdale, Ontario
Canada M2H 3K1

Published in the U.S. by
Firefly Books (U.S.) Inc.
P.O. Box 1338, Ellicott Station
Buffalo, New York 14205

Produced by
Bookmakers Press Inc.
12 Pine Street
Kingston, Ontario K7K 1W1

Design by
Linda J. Menyes
Q Kumquat Designs

Maps by
Roberta Voteary

Color separations by
Friesens
Altona, Manitoba

Printed and bound in Canada by
Friesens
Altona, Manitoba

Printed on acid-free paper

To Aubrey, who makes the best conversation,
and bannock, I've ever had.

CONTENTS

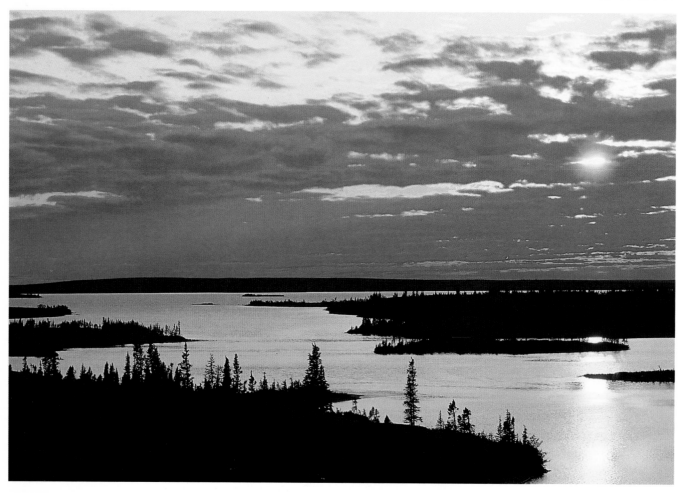

Damant Lake, in the Northwest Territories, is on the migration route of the huge Beverly caribou herd. Migrating caribou swim across such lakes with ease.

In 1978, I was a practicing physician in a hospital emergency department in Regina, Saskatchewan. In January of that year, I received a glossy color travel brochure detailing the cruises made by the *M.S. Lindblad Explorer,* a small 90-passenger adventure ship which sailed to many of the wild coastlines of the world that I longed to visit: New Guinea, Indonesia, the Galápagos Islands, Antarctica and Alaska. After a quick glance at the prices, however, I knew I wouldn't be packing my bags right away.

Over the following days, I thumbed through the brochure so often that I finally wound up reading the fine print on the last page. Tucked at the bottom was this sentence: "There is a qualified physician on board every cruise." When my wife Aubrey suggested I apply for the position of ship's doctor, I was sure that there would be hundreds of American doctors applying for the job and that as a Canadian, I would have little chance. But in less than a month, I was offered the job of ship's physician on three cruises to coastal Alaska and the Aleutian Islands.

For eight weeks that summer, I bobbed and rolled around the Bering Sea and the Gulf of Alaska, attending to seasick passengers and trying to make them feel better than I did. This was my introduction to the Arctic, and it changed my life forever. I was enthralled by thousands of belching walruses crammed onto a rocky shoreline like bloated sunbathers at the beach. I was captivated by the sight and sound of seabird cliffs

overpopulated with screaming kittiwakes and auks. I saw whales and seals, foxes and bears and glaciers that calved great blocks of deep blue ice. I reveled in the raw power and simple beauty of the ocean, and I was often energized by my own vulnerability. The experiences that summer made me feel as if I had seen nothing in the previous 30 years of my life.

A year later, I took what was intended to be a two-year sabbatical from medicine. I have never returned. The beauty and science of the natural world had captured my heart and my mind, and the Arctic was the temptress that lured me away. Seventeen years later, my romance with the Arctic still burns. Every year, I spend a month or more tramping the tundra, and each visit is one of wonderful discovery.

Over the course of many years and many trips to the Arctic since that first life-altering experience, I have worked as a guest lecturer on expedition ships like the *Explorer* and as a naturalist leader of small tour groups. In these capacities, I quickly discovered what kind of information people like to hear: Bore them at your own risk, for after a few moments of tedium, they will simply nod off or walk away, leaving you talking to yourself. It is a lesson I've learned well. In *A is for Arctic*, I discuss many different arctic animals, plants and phenomena, and in these alphabetized entries, I have tried to emphasize just one or two aspects about each that I find particularly fascinating. My hope is to excite readers about the wonders of this world and to whet their appetite to know more.

Before we set out on our journey north, let me briefly review what is meant here by the term Arctic. In many ways, the definition of Arctic is arbitrary and depends largely upon the scientific bent of the author. Geographers frequently use the Arctic Circle—66 degrees 32 minutes north latitude—as the southern boundary of the Arctic. It circles the globe roughly 1,620 miles (2,700 km) from the North Pole and encloses 8 percent of the Earth's surface.

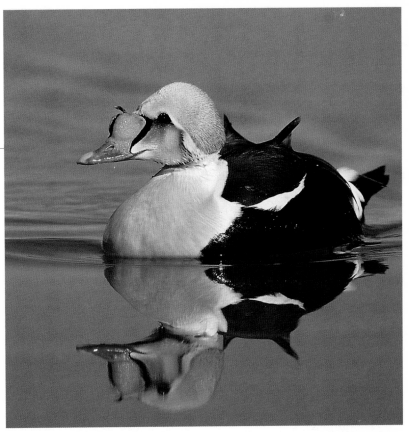

Climatologists, on the other hand, define the Arctic using summer temperatures as a guide. They join together all the points in the northern hemisphere where the average temperature of the warmest month of the year is 50 degrees F (10°C). Everything north of that line, which is called the 50-degree-F isotherm, is considered part of the Arctic. Since plants and animals have a greater reaction to climate than they do to degrees of latitude, the 50-degree-F isotherm is, from an ecological standpoint, more meaningful.

The boundary used by most ecologists, however, is the northern tree line, and this is the one I have used in *A is for Arctic*. The tree line is a physical boundary that a person can see and easily understand. Throughout much of its course, the tree line actually parallels the 50-degree-F isotherm, so the two boundaries encompass roughly the same geographical area.

Those of us who have been lucky enough to travel to the Arctic understand it as a place in which our humanity is put into perspective. Visitors are necessarily humbled and awed, both by the land itself and by its creatures. But even if you never have a chance to experience firsthand this hinterland carved from the cold, it is my hope that *A is for Arctic* will help you to appreciate the logic and purpose in the lives of its inhabitants.

In spring, king eiders often migrate in loose flocks that may number in the tens of thousands. A great many drakes win their mates while they are still on their southern wintering grounds, and the pairs then fly north together.

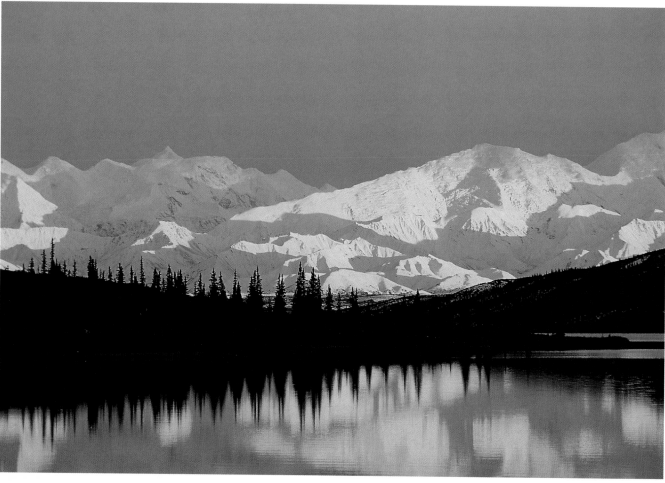

The snowcapped flanks of Mount McKinley were just as impressive to indigenous peoples as they are to visitors today. The Athapascans called the mountain Denali, "the high one."

Alaska

Condemned by many politicians of the day as little more than a worthless "icebox," Alaska was purchased by the United States from Russia in 1867 for a mere $7.2 million. America was just recovering from the social and economic wounds of the four-year Civil War, and many lobbied against the purchase. Today, posh homes in exclusive North American neighborhoods command greater prices, but at the time, the U.S. government was paying for what seemed simply a land rich with magnificent mountain ranges, vast tracts of forest and tundra and an extensive coastline. No one knew then about the region's rich offshore fisheries, and in a horse-and-buggy society, what use were petroleum

and natural-gas reserves anyway? In the end, the purchase of Alaska, at 2¢ an acre (5¢/ha), proved to be one of the great land bargains of all time.

The bulk of Alaska lies beyond 60 degrees latitude, yet despite its northern location, much of the state is covered with forests and so is not considered part of the Arctic. In fact, treeless tundra—one of the main characteristics of the Arctic—is found only along the northern and western coastlines of Alaska. The coastal strip of tundra is widest in the north, where it reaches a maximum width of about 200 miles (320 km).

Islands of treeless tundra also exist on the upper slopes of the Alaska Range—in Denali National Park, for example—and on other smaller mountain ranges within the interior of the state.

The tundra cloaking these different mountains, however, is classified as alpine tundra, rather than arctic tundra. Although the two kinds of tundra have many plants and animals in common and may look similar, most ecologists consider them to be separate and distinct ecosystems. As a result, these alpine regions are not considered part of the Arctic.

If a treeless landscape is one of the distinctive features of the Arctic, what are we to make of the Aleutians, a chain of 70 islands that arcs across the North Pacific for 1,100 miles (1,760 km)? Drenched by year-round fog and rain, the Aleutians also enjoy the warming effect of the ocean, which results in a luxuriant ground cover of grasses, sedges and wildflowers rather than tundra. Because of the characteristic vegetation, the Aleutians are classified as a temperate oceanic landscape rather than part of the Arctic.

Amphipods: Piranhas of the North

Shaped like humpback shrimp that have been flattened on the sides, most amphipods, or "sea lice," are quite small, ranging in length from ⅕ to ⅗ inch (0.5-1.5 cm). There are more than 6,000 different kinds of amphipods, and they hunt in every ocean of the world, but the greatest variety and number occur in cold polar waters. As many as 8,000 per square yard (10,000/m²) can be found along some rocky shorelines.

Amphipods eat a balanced diet from most of the major food groups. In winter, they graze on the microscopic plants growing on the underside of the sea ice. They also hunt and prey on their own kind and, at a moment's notice, will follow a scent trail of blood from a dead or dying animal, swarm over it and reduce it to bones. Writer Jon Percy called amphipods the "piranhas of the frozen seas." I have seen vivid photographs of how well these little crustaceans can scavenge.

Several years ago, a young Inuk drowned when he broke through the ice while hunting seals in the Canadian High Arctic. Rescuers re-

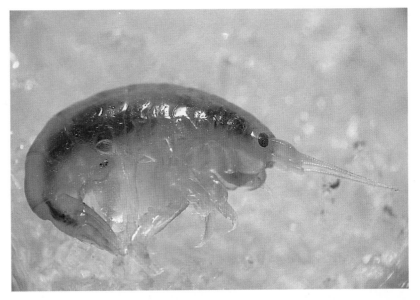

covered his body just 24 hours after the accident, but the amphipods had already been busy. When the dead man was pulled from the water, he looked like a character from a horror movie. Although his body was still covered in overalls, boots and gloves, there was not a single bit of flesh remaining on his skull and neck. The amphipods had picked his bones clean.

Sea lice are not always the ones doing the eating. For at least one arctic expedition of the last century, amphipods meant the difference between life and death. In the winter of 1883, Lt. Adolphus Greely and two dozen of his men were stranded and starving in the Canadian Arctic. Using pieces of sealskin clothing as bait, they fished for amphipods, sometimes managing to catch 20 to 30 pounds (10-15 kg) in a day. When the expedition was rescued the following summer, seven of the men were still alive, thanks to their diet of crunchy raw amphipods.

Arctic Circle

The Arctic Circle is an imaginary line ringing the Earth's North Pole at a latitude of approximately 66½ degrees north. At this latitude, the sun does not set on the longest day of the year (summer solstice), which usually falls around June 21.

An amphipod, such as this one from Ellesmere Island, Northwest Territories, may consume 60 to 100 percent of its body weight in food in a day.

Alaska Trivia

With an elevation of 20,320 feet (6,194 m), Alaska's Mount McKinley is the tallest peak in North America.

A late-September moon rises over the pack ice of the Beaufort Sea, part of the Arctic Ocean. In the coming winter, the unmelted ice will become part of the multiyear ice that covers three-quarters of the ocean's surface.

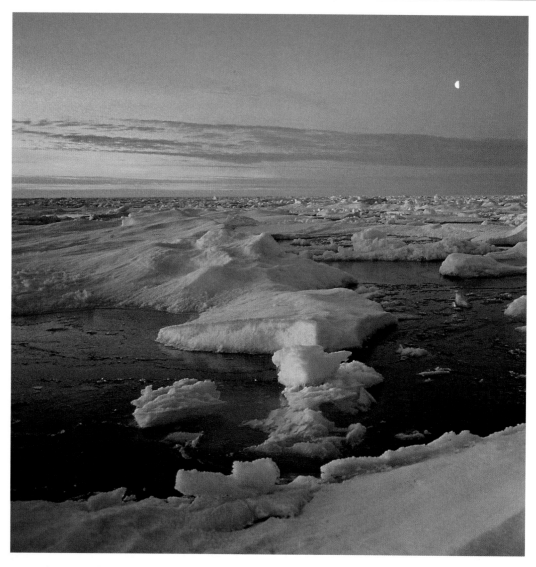

Arctic Circle Trivia

The Arctic Circle is roughly 1,680 miles (2,700 km) from the North Pole.

For every degree of latitude traveled north of the Arctic Circle in summer, there are eight days when the sun does not set.

The Antarctic Circle is the southern hemisphere's equivalent of the Arctic Circle, and on any given day, the conditions of darkness and daylight are exactly opposite.

From the same location six months later, on the shortest day of the year (winter solstice), December 21, the sun does not rise.

In the summer, the farther north you walk from the Arctic Circle, the greater the number of hours of continuous daylight you can enjoy. For example, each summer in the community of Grise Fiord on southern Ellesmere Island 650 miles (1,050 km) north of the Arctic Circle, the sun does not set for 77 consecutive days. In winter, of course, the sun does not rise for an equal number of days.

The Arctic Circle is not a boundary where the climate or the vegetation suddenly changes, nor does it mark the southern border of the Arctic, as many people believe. For example, in northern Quebec, there are 600 miles (1,000 km) of treeless tundra *south* of the Arctic Circle, and in Greenland, a large portion of the massive icefield covering the interior of the island is also south of

the Circle. Clearly, the Arctic region is not confined to the area delineated by the Arctic Circle.

Arctic Ocean: Where Small Is Beautiful

Of the world's five oceans, the Arctic Ocean is the smallest. In fact, it is barely 6 percent the size of the Pacific Ocean, which is the largest. Imagine the floor of the Arctic Ocean as a relatively shallow bowl, almost completely surrounded by landmasses and divided across its center by an undersea range of mountains that stretches from the tip of Greenland through the North Pole to the New Siberian Islands, along the central coast of northern Russia. Although these arctic mountains, called the Lomonosov Ridge, are roughly 9,800 feet (3,000 m) high, they don't quite make it above water. The closest they come is about 500 feet (150 m) below the icy surface of the ocean.

The Arctic Ocean, for the most part, is frozen, which distinguishes it from all other oceans. In winter, it is almost completely covered by ice, something that occurs in none of the other oceans, even the Southern Ocean, which surrounds Antarctica. Although some of the ice melts arounds its edges in summer, three-quarters or more of the sea remains frozen. The year-round presence of ice therefore has a dramatic effect on life in this northern polar sea.

Without sunlight, there is no photosynthesis, and without photosynthesis, virtually no food chain on Earth can gain a foothold. This is one of the problems in the Arctic Ocean. The winters consist of months of darkness, with no sunlight at all, and the sunless winters are followed by summers of continuous daylight, during which most of the sunlight is either absorbed or reflected by the ice covering. As a result, the sunlight does not reach the water underneath, where photosynthesis occurs. The perpetual ice cover also prevents winds from stirring up the ocean surface and mixing the water so that nutrients can be replenished from the depths of the ocean. Because of the scarcity of nutrients and the reduced levels of sunlight, the Arctic Ocean is relatively unproductive. In fact, based on the amount of plant life the Arctic Ocean produces, it is the poorest of the world's oceans.

Poor or not, the ice-covered Arctic Ocean somehow manages to support ample life. Remarkably, algae grow on the underside of the sea ice (see "Under the Ice"). The algae are grazed by a variety of invertebrates, which are then fed on by arctic cod, which in turn are hunted by ringed seals. Because of the community of plants and animals found on the underside of the ice, it is possible for ringed seals to live almost anywhere in the Arctic Ocean.

Other animals, even more unexpected than seals, occasionally make an appearance in the middle of the frozen Arctic Ocean. Arctic foxes or their tracks have been seen a number of times by observers on icebreakers, and there is one report of a fox sighting just 85 miles (140 km) from the North Pole. Polar bears also sometimes roam far out over the center of the frozen ocean. In one instance, an adult female bear and her cub showed up at a research camp located on the sea ice at a latitude of 84 degrees north. The surprise visit would have been just that, except the curious bears became tangled in the wire hook-

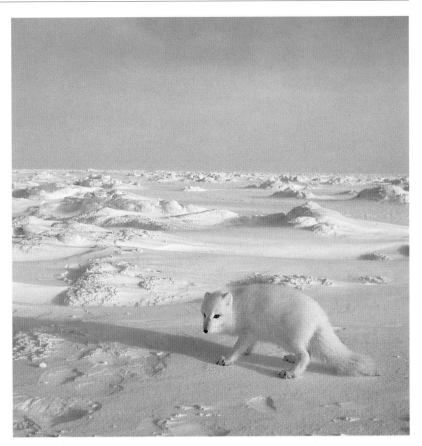

ing up the runway lights and disconnected them just as a supply aircraft was about to land.

Auks: Penguins of the Arctic

Auks are a small group of seabirds with such colorful names as rhinoceros auklet (*Cerorhinca monocerata*), razorbill (*Alca torda*), spectacled guillemot (*Cepphus carbo*), horned puffin (*Fratercula corniculata*) and thick-billed murre (*Uria lomvia*). The auks of the Arctic are the northern look-alikes of the penguins of the southern hemisphere, and the two groups of birds are similar in many ways.

Both the auk and penguin families have relatively few species. There are just 22 kinds of auks and 17 kinds of penguins. Both groups live in cold polar waters and can occur in huge numbers. For example, the world population of the dovekie (*Alle alle*), one of the smaller auks, may be as high as 80 million, making it one of the most abundant birds in the entire northern hemisphere.

Auks and penguins are similar in other ways too. They eat the same kinds of foods—squid, shrimplike krill and small schooling fish. Both chase their meals by "flying" underwater: penguins use their stiff front flippers, while auks use

An arctic fox roams the sea ice in Canada's western Arctic in search of prey. Nearly half of all newborn ringed seals are dug out of their birth lairs under the snow and killed by this hunter.

Auk Trivia

The greatest variety of auks—14 species—occurs on the southern edge of the Arctic, in Alaska's Aleutian Islands.

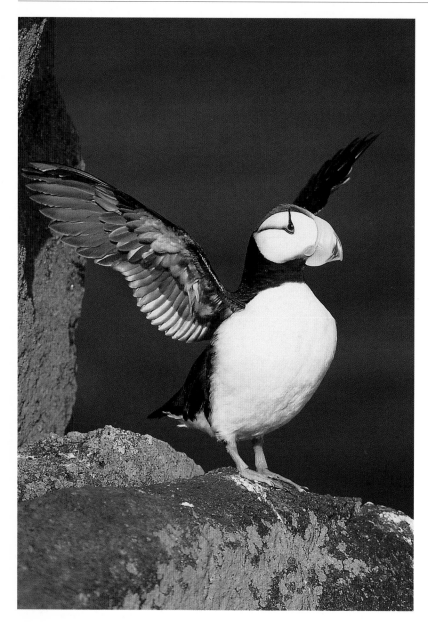

The horned puffin is one of the large auks of the northern Pacific Ocean and the Bering and Chukchi seas. The stiff horn above its eyes is a breeding decoration that is shed at the end of the summer.

their narrow sickle-shaped wings as though they were flippers. As well, the legs of auks and penguins are positioned near the rear of their bodies, so when on land, the birds stand in an upright position and waddle when they walk.

Many auks and penguins have crests and colorful markings on their faces and beaks. In most auk species, however, the attractive head markings are present only during the breeding season. A good example of this is the large, triangular, bright orange-and-yellow beak of the puffin. At the end of the summer mating season, the colorful outside covering of the beak falls off, and the bird is left with a much smaller plain gray beak.

Despite their many similarities, there is one major difference between these birds: auks can fly and penguins can't. Although auks can fly,

their wings are relatively small. Consequently, when they take off from the water, most auks usually must taxi across the surface of the ocean, bouncing off the tops of waves before they finally become airborne. Then they must flap like crazy to remain in the air. They're not really skilled at maneuvering in flight either, especially some of the larger species. On a stormy day on Walrus Island in the Bering Sea, I watched as common murres (*Uria aalge*) tried to land on their nesting cliffs in the high winds. The birds often had to make three or four passes before they settled safely on a ledge. Sometimes, they simply crashed into the cliff with a thud.

Auks are not great flyers for one simple reason: They don't have to be. Auks need to fly just well enough to carry them aloft to steep rocky cliffs and secluded offshore islands, where they breed in immense colonies containing tens of thousands of residents. The birds choose such inaccessible nesting sites to lessen the threat from predatory land mammals. That's a concern penguins don't have, since there are no predatory land mammals in Antarctica or on most of the subantarctic islands where penguins nest.

In the Russian Arctic, biologists have seen polar bears dig dozens of dovekies out of their nesting crevices at the base of rocky cliffs, and in Alaska, brown bears regularly swim up to 10 miles (16 km) offshore to raid colonies of auks and other seabirds. The biggest natural threat to auks, however, is one of the smaller northern carnivores: the arctic fox. The agile fox can climb steep cliffs, squeeze into rocky crevices and dig out burrows, and it doesn't quit when it has eaten its fill—it will continue to hunt and hoard the surplus prey. The stockpile of one fox in Greenland held 36 dovekies neatly arranged in a long row, two young murres, four snow buntings and a large pile of dovekie eggs.

More than any other animal, the arctic fox has influenced the evolutionary history of auks and reinforced their need to keep flying. Indeed, without the fox, we might have had penguins in the Arctic as well as in Antarctica.

Aurora Borealis

Ancient Inuit believed that the northern lights, or aurora borealis, were the torches of spirits guiding souls to a land of happiness and plenty. Indigenous peoples along the Pacific Coast thought that auroras were the cooking fires of Es-

kimos boiling whale blubber. My grandfather said that they were the reflection of the sun off the polar icecap. Auroras have inspired countless wonderful stories and legends; their shifting curtains of green, blue and red light, pulsating and swirling across the blackness of a star-filled sky, are fuel for any imagination. Understanding the science of auroras does not rob the display of any of its beauty but makes the spectacle even more exciting to witness.

The birth of an aurora begins 93 million miles (150 million km) away, on the torrid surface of the sun. There, continuous gigantic explosions (a result of sunspot activity) send showers of charged particles—electrons and protons—hurtling into space and racing toward Earth at two million miles per hour (3 million km/h). It takes two days for the particles to reach Earth, but Earth is not an easy target to penetrate.

Surrounding Earth is a giant invisible magnetic field generated by the molten metals in the planet's interior. Most of the charged particles speeding toward us from the sun are deflected away into space by the force of the Earth's magnetic field. Some, however, do penetrate the field, and once they reach the upper layers of the Earth's atmosphere, they collide with the gases there, producing visible light. (The same thing happens in an ordinary neon sign: electrons collide with the neon gas trapped inside the light tube, and the gas emits a reddish orange light.)

Auroral displays occur far above the Earth's surface, generally at elevations between 75 and 250 miles (120-400 km), even though they may appear to be much closer and seem to touch the ground in the distance. At altitudes higher than that, the nitrogen and oxygen gases of the atmosphere are too thin to produce enough light to be visible from Earth, and below those altitudes, the atmosphere is too thick for charged particles to penetrate any farther.

An aurora can take many different forms. It may be simply a diffuse glow covering the whole sky; at such times, it can be confused with thin, wispy clouds. A common auroral display is an arc that may stretch across the sky for 1,000 miles (1,600 km). The most beautiful auroras are those in which curtains of shimmering light fold and spiral unpredictably across the sky, constantly changing in color, brightness and speed.

Northern lights usually occur between 60 and 70 degrees north latitude. When viewed from

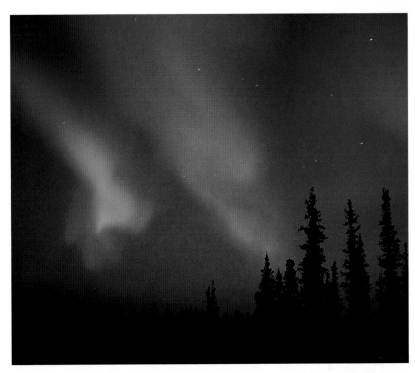

space, an aurora forms a bright crown of light encircling the northern polar region. Because the geomagnetic pole (in northwest Greenland) is different from the geographical North Pole, the circle of the aurora appears to be off center and dips farther south in the North American Arctic than it does in the Russian Arctic. As previously mentioned, auroras form as the result of sunspot activity, which fluctuates and follows an approximate 11-year cycle. During periods of high sunspot activity, the northern lights are bigger and brighter and may occur farther south than usual—in 1989, a peak sunspot year, auroras were seen as far south as Mexico.

The existence of sounds associated with the northern lights has been debated for years. Many observers claim to have heard faint crackling or swishing sounds. To some Inuit, it resembles the soft clicking sound of caribou ankle joints. Even so, despite repeated attempts, scientists have been unable to record any sounds connected with auroral displays.

Here's one final note on the universal appeal of the aurora borealis. Some Japanese newlyweds believe it is good luck to conceive their first child while an aurora dances overhead. With that in mind, a number of enterprising communities in the Canadian Arctic now offer aurora tours for Asian honeymooners in midwinter, when there is no shortage of darkness and the northern lights are most easily seen.

The green of this auroral display over Canada's Barren Lands is the most typical color of the northern lights.

Aurora Trivia

Every aurora borealis display is matched by a mirror-image display in the southern hemisphere, where it is called the aurora australis.

The best months to view an aurora are September and March; the best times are midnight to 2 a.m.; and the next peak of auroral activity should occur around the year 2000.

B

On a sandy ridge over-looking the waters of Rennie Lake, Northwest Territories, archaeologists have found chipped stone spearheads and other artifacts, evidence of the caribou-hunting and fishing peoples who began to inhabit the remote Barren Lands more than 6,000 years ago.

Barren Lands Trivia

The first European to explore the Barren Lands was Samuel Hearne, an Englishman who crossed the region during his 1770-72 expedition.

Barren Lands

Look at any map of North America, and locate the great wedge of the continent west of Hudson Bay and north of the wandering arctic tree line that ends at the mouth of the Mackenzie River. This is the Barren Lands, one of the most remote uninhabited regions in North America and possibly the world. Sometimes called the Barren Grounds, or simply the Barrens, this vast area of tundra is probably best known for the spectacular wild rivers that cross it: the Back, the Dubawnt, the Coppermine, the Kazan and the Thelon. These are the rivers that make canoeists think they've died and gone to heaven.

During the last Ice Age, the Barren Lands were scoured by glaciers several miles thick. The land still bears the scars of those events. In 1984, I paddled a part of the Thelon, and as I flew over the Barren Lands on my way to the river, I recorded my first impressions in my journal:

"The flat, rolling terrain is a giant patchwork of olive-green land and blue-black water. Oddly, it's July 24, the height of summer, yet there is still ice in the center of the large lakes, and from 9,500 feet, the land looks as though the gla-ciers just left yesterday.... I've never seen so many lakes. I may run out of food on the canoe trip, but I won't run out of water."

From a plane, it is easy to see how the Barren Lands might have gotten their name, but it's an ill-deserved name. The Barren Lands are any-thing *but* barren. Home to enormous herds of migrating caribou—the largest herds of animals found anywhere other than the plains of East Africa—the Barren Lands also provide habitat to packs of hunting wolves, sun-bleached grizzly bears, great flocks of cackling geese and count-less other arctic birds.

On the flight to the Thelon River, I realized for the first time what a truly vast country Canada is. That morning, we flew for three hours or more at a speed of 170 miles per hour (270 km/h), and all I saw was an endless vista of wonderful, glorious wilderness.

Bearded Seal:
The Why of the Whiskers

An adult bearded seal (*Erignathus barbatus*) weighs twice as much as any other seal in the Arctic—up to 750 pounds (340 kg)—and often

The maze of lakes so characteristic of the Barren Lands caused many early travelers to become hopelessly lost. Those who were able to keep to their route still ran the risk of being driven mad by the swarms of bloodsucking mosquitoes.

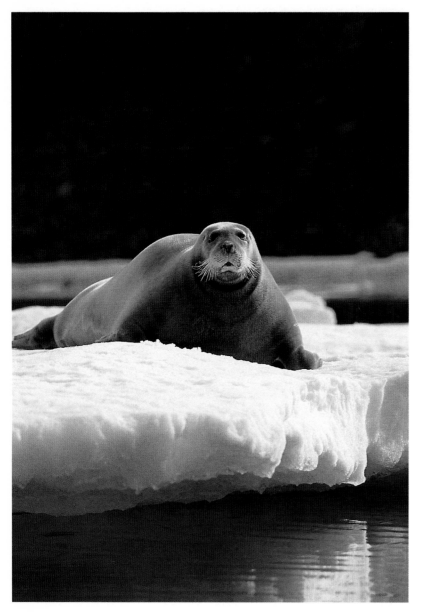

The Russian common name for the bearded seal means sea hare, a reference to the way an alarmed seal sometimes leaps off the ice into a crack of open water to escape attack.

The bearded seal, a bottom feeder as well, may use its long whiskers in a similar fashion.

A seal's whiskers may also help it to navigate under the ice. In one study, a seal was blindfolded and repeatedly released beneath the ice. Each time, the seal managed to surface in the center of its breathing hole. When its whiskers were taped, however, the animal bumped into the ice near the hole several times before successfully emerging.

Finally, a seal may use its whiskers to communicate with other seals. For example, when one harp seal threatens another, it raises its whiskers so that they point almost forward.

There are good theories to explain why animals evolved to look the way they do. Having said that, however, we still do not know why the bearded seal's whiskers are so much longer than those of any other arctic seal. For the time being, the why of the whiskers will remain yet another arctic mystery.

Bears, Both Brown & White

Of the eight bear species in the world today, the two largest ones—the polar bear (*Ursus maritimus*) and the brown bear (*Ursus arctos*), also called a grizzly—are found in many regions of the Arctic. These bears are truly large carnivores, and adult males often weigh over 1,000 pounds (450 kg) and stand 4½ feet (1.4 m) tall at the shoulder. The heaviest wild polar bear on record was from Southampton Island in northern Hudson Bay. It tipped the scales at 1,770 pounds (803 kg). The heftiest wild brown bear, weighing 1,655 pounds (750 kg), was from English Bay on Kodiak Island, Alaska.

Mainly a meat-eating predator, the polar bear specializes in seals but may occasionally hunt walruses and beluga whales. The brown bear, on the other hand, is mostly a vegetarian, clipping off green plants, digging up roots and devouring nuts and berries. When an opportunity arises, however, the brown bear will fish for salmon, hunt the calves of caribou, moose and elk and even attack and kill muskox bulls.

Generally, the polar bear and the brown bear look and behave quite differently, and no one would ever confuse the two. Yet the polar bear is just a modified brown bear that evolved quite recently during the last Ice Age, making it one of the youngest mammals on Earth.

Scientists believe the makeover began around

measures more than six feet (2 m) in length. Its size alone should distinguish it. If it doesn't, the bearded seal's whiskery face is unmistakable.

The whiskers on all seals are richly supplied with nerve fibers, 10 times as many as those of a typical land mammal. It would seem that such sensitive whiskers must relay important information to their owner. While no one is certain how whiskers benefit a seal, researchers have offered a few possibilities. First, a seal may use its whiskers to gauge its swimming speed—the faster it swims, the more its whiskers are distorted. Whiskers may also help a seal detect the vibrations of prey, especially in dark or murky water, where vision is impaired. A walrus, for example, uses its whiskers like fingertips to feel its way along the seafloor as it searches for food.

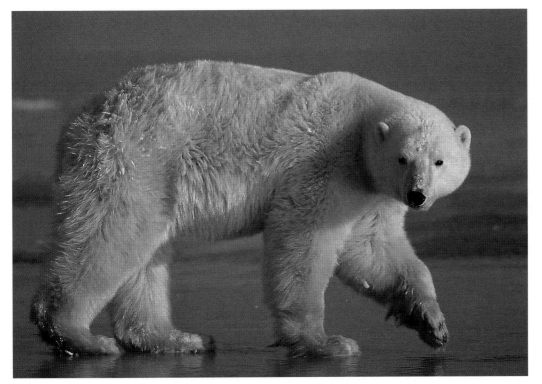

700,000 years ago somewhere in northern Asia, possibly Siberia. At the time, it's likely that a group of brown bears became cut off from other brown bears by an advancing glacial ice sheet. The isolated brown bears found themselves in an arctic world filled with seals and no predators to compete with them. It wasn't long before the adaptive bears began to stalk and kill the seals. In the thousands of years that followed, the brown bears gradually evolved to become the species we know today as the polar bear. They changed color. Their necks got longer, making it easier for them to keep their heads above water when they are swimming. Their canine teeth also grew longer, became sharper and were spaced farther apart, making it easier for them to kill.

In captivity, the two species of northern bears will still interbreed and produce viable cubs that are bluish brown or yellowish white in color, demonstrating how closely related the two bears are. In the wild, however, it's highly unlikely that polar bears and brown bears would ever mate with each other.

Belugas & Bowheads: Natural Icebreakers

Of the world's 76 species of cetaceans, only the beluga (*Delphinapterus leucas*), the bowhead (*Balaena mysticetus*) and the narwhal (*Monodon monoceros*) are truly adapted to life in the ice.

All three of these whales occur in the Arctic. (No ice-adapted whale species live in the waters of Antarctica, although more than a dozen different cetaceans have been sighted around that continent during the ice-free months of the austral summer.) For the moment, we will concentrate on the beluga and the bowhead; the narwhal is discussed under "Narwhal: Arctic Unicorn."

After wintering along the southern edge of the pack ice, belugas and bowheads migrate back to the Arctic each spring, often starting their return in April, months before there is much open water to be found. Both whales are skilled at penetrating the pack ice by following narrow cracks and leads. The pack ice shifts constantly, so new channels regularly open. Taking advantage of such openings, the whales move slowly northward. However, cracks in the ice can close as rapidly as they open; in addition, the water may simply freeze over in the cold temperatures. If this happens, a beluga can remain submerged for up to 20 minutes, during which it is able to travel almost two miles (3 km) in search of a patch of open water. If it cannot find any open water, a beluga will break through ice up to four inches (10 cm) thick or simply lift the ice with its back, take a breath in the air space created, then let the ice down without breaking it and continue on its way.

Bear Trivia

A brown bear's front claws may be almost five inches (12 cm) long.

Newborn bear cubs are exceptionally small, weighing less than 1½ pounds (680 g).

In autumn, the deeply veined leaves of the bearberry provide a crimson background for the smaller leaves and berries of the mountain cranberry.

Bowheads, being much larger and more powerful than belugas, are even better at breaking ice. There are many accounts from Inupiaq whale hunters of bowheads in the Bering Sea breaking through ice up to eight inches (20 cm) thick. Near Barrow, Alaska, one group of hunters even saw a bowhead crash through ice that was nearly 25 inches (60 cm) thick.

When a bowhead becomes trapped beneath the ice, it uses the top of its head to exert pressure on the underside of the ice. The area around the whale's blowhole is padded with thick connective tissue, which helps absorb the impact and prevent injury. Even so, most bowheads have scars on their backs and around their blowholes from colliding with the rough ice. It's significant that neither the bowhead nor the beluga has a dorsal fin. If a fin were present on the back, it could easily be injured when the whales bang and shove against the ice. This is a further example of how the beluga and bowhead are well adapted to life in the Arctic.

Another challenge belugas and bowheads face is navigating the ice-filled water. To anticipate ice, the beluga relies on a highly sensitive echolocation system, one superior even to that of the much-studied bottlenose dolphin. The bowhead may also use reflected sound waves. Whereas the echolocation system of a beluga is made up of rapidly fired high-frequency clicks, the sound system of the bowhead consists of slowly delivered low-frequency "songs." Using its own style of echoes, each whale is able to locate safe corridors of thinner new ice through dangerous fields of thick multiyear ice.

Despite similarities, the beluga and the bowhead actually occupy places at opposite ends of the evolutionary scale and represent the two different types of whales alive today: the beluga is a toothed whale, and the bowhead is a filter-feeding baleen whale. The fact that both thrive in the ice-filled world of the Arctic is just one more example of how natural selection rarely misses a good opportunity.

Berries

Berries grow in many areas of the Arctic, and just about every furred and feathered critter, from ground squirrels to gulls and caribou to cranes, will eat them at some time during the year. One type of arctic berry is so typically a part of a grizzly bear's diet that it is known as bearberry (*Arctostaphylos* spp). Soapberries (*Shepherdia canadensis*) are also frequently eaten by grizzly bears in Alaska and Yukon. In August, the bears gorge themselves on the tiny red berries, eating up to 200,000 a day.

From late summer to autumn, polar bears along the western coast of Hudson Bay are forced ashore when the sea ice melts. For three or four months, they are unable to hunt seals. Some of the fasting bears turn to shiny black crowberries (*Empetrum nigrum*) to take the edge off their appetites. The bruins sometimes consume so many berries that the white fur around their muzzles is stained with their juice.

Crowberries are one of the most common berries found in the Arctic. Pulpy and bland-tasting early on, crowberries improve somewhat after the first frosts of autumn. Apparently, the sugar content of the berries goes up after they freeze. Crowberries, unlike most berries, remain on the plant throughout the winter. Traditionally, Inuit gathered the frozen berries from under the snow, storing the fruit in sealskin bags and eating it mixed with blubber. Frozen crowberries are also important to early migrating birds, such as geese, which often return to their nesting grounds in spring, when snow still covers the ground and there is little else for them to eat.

My favorite arctic berry is the baked-apple, or cloudberry (*Rubus chamaemorus*). The juicy, amber-colored berries have a taste and texture that reminds me of custard. These berries happen to be a favorite of indigenous peoples as well. In Alaska, the fresh fruit is added to a mixture of seal oil and chewed caribou fat, then

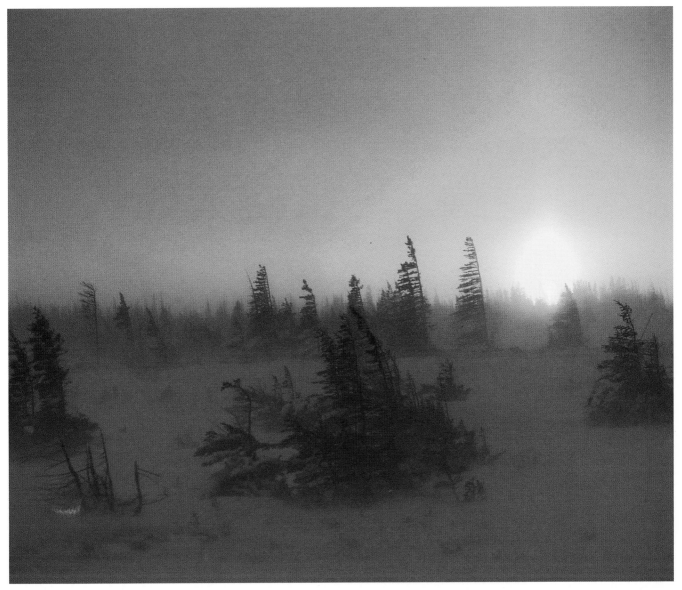

beaten to the consistency of whipped cream. It's called Eskimo ice cream.

Blizzards

The blizzard is the Arctic's most violent winter storm. There is no shortage of stories of both early arctic explorers and contemporary travelers foolishly straying from their campsites during an arctic blizzard, becoming lost within minutes and freezing to death just a few short steps from safety.

To qualify as a blizzard, a storm must have certain characteristics. The temperature must be 10 degrees F (–12°C) or colder, with winds blowing at speeds of 25 miles per hour (40 km/h) or more. Add to that enough snow or blowing snow to reduce visibility to 1,000 yards (1 km) or less. A whiteout occurs when the visibility is

drastically reduced to less than 30 feet (10 m). Finally, these conditions must last for at least three to six hours before a storm is classified as a blizzard.

In Canada, blizzards occur most commonly in the Arctic Islands and on the central mainland of the Northwest Territories, where there may be several dozen in a single winter. One outstanding arctic blizzard occurred in Iqaluit, on Baffin Island, in February 1979. During that snowstorm, the temperature sank to around minus 40 degrees F (–40°C), and the howling wind raged at 60 miles per hour (100 km/h). The storm confined residents to their homes for 10 days.

Blubber

In preparation for the energy demands of migrating thousands of miles, a shorebird leaving

Along the Hudson Bay coastline, spruce trees are naturally pruned along one side of their trunks by blizzard-driven ice crystals. The residents of Churchill, Manitoba, joke that it takes two such trees to make a proper Christmas tree.

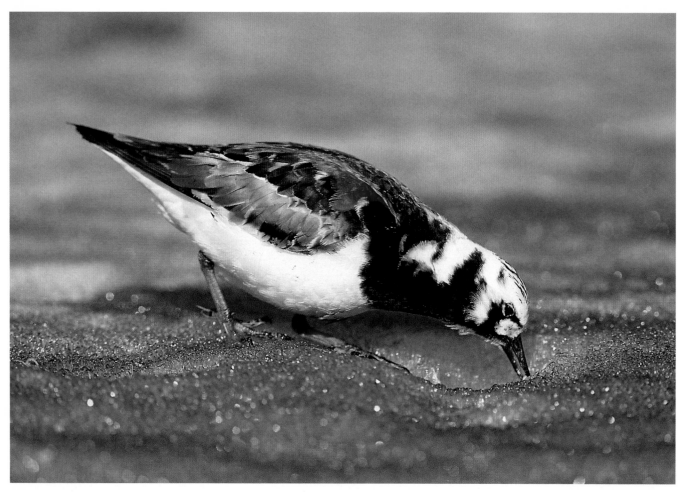

Moments before this photograph was taken, this male ruddy turnstone (Arenaria interpres) had been scavenging scraps of fat and flesh from the carcass of a caribou that had been felled three days earlier by a pack of wolves.

the Arctic in autumn may double its body weight with fat. A grizzly bear likewise packs on the pounds when it prepares for winter hibernation. Such a bear may put on nearly 4½ pounds (2 kg) of padding a day. One adult male grizzly in the Barn Mountains of northern Yukon gained a total of 183 pounds (83 kg) in late summer and early autumn. But the record weight gain by a bruin is held by a pregnant female polar bear along the western coast of Hudson Bay. Between November and August, the female plumped up from a lean 218 pounds (99 kg) to a hefty 903 pounds (410 kg), gaining 685 pounds (311 kg) in nine months.

Body fat is an efficient way to store energy, because every pound of fat can be burned to yield 3,500 calories of energy (1 kg yields 7,700 calories). Not only is body fat a convenient energy reserve, but it is also a good insulator, protecting the animal from the cold. When body fat is used as insulation, it is called blubber. Thus even though all blubber is fat, not all fat is blubber. One of the ways to tell the difference is to look at how the fat is distributed over the animal's body.

When fat is stored principally as an energy reserve, it accumulates in distinct locations, or fat depots. A good example of this is seen in humans. Men store fat around their stomachs, and women add inches to their hips and thighs. Blubber, on the other hand, covers the body in a continuous blanket, insulating the animal so that it loses the least amount of body heat.

Birds do not have blubber, and among mammals, it is the marine mammals, such as seals, walruses and whales, that are blubbery. Water conducts heat 25 times better than air, so it follows that most marine mammals rely on the insulation of blubber to keep warm, since they spend virtually their entire lives in cold, often frigid water.

Among seals and whales, the blubber layer is thickest in those animals which live in the Arctic, and the fattest of them all is the bowhead whale (*Balaena mysticetus*). The bowhead is one of the right whales, named so by early whalers because it was one of the "right" whales to harpoon. It was timid and slow-swimming, so it was a safe, easy target for wooden ships powered by

sail, and because it was padded with fat, it did not sink when it was killed.

The bowhead is a large whale, up to 60 feet (18 m) in length. With a blubber layer 20 inches (50 cm) thick, a bowhead might weigh almost 100 tons (90 t). Once slaughtered, such a behemoth could yield 3,355 gallons (12,700 L) of oil after its carcass had been butchered and boiled. In the 1800s, the oil from just one such whale could generate enough money for a whaler to finance the entire cost of outfitting a yearlong voyage to the Arctic.

Whalers searching for bowheads in the 17th and 18th centuries were among the first Europeans to explore and map large portions of the Arctic. In a sense, these areas were discovered because of blubber.

Bumblebees: Hot-Blooded Queens

Although it was July 18 and the height of summer on Devon Island in Canada's High Arctic, it was snowing. I was lying on the ground photographing the colorful blossoms of a purple saxifrage when a large bumblebee (*Bombus polaris*) buzzed over my head. At the time, I wondered what the bee was doing and how it was able to fly in such cold weather when every other arctic insect around, including the hungry hordes of mosquitoes, was chilled and sluggish, waiting for the temperature to rise.

The bumblebee I had seen that day was a queen. I knew this because only queens survive the winter to emerge in the summer. This queen was probably looking for flowers, with their offerings of sweet nectar and protein-rich pollen; she may also have been searching for a place to nest and lay her eggs.

House-hunting bumblebees in the Arctic often choose an abandoned rodent burrow as the site for a nest. Once a queen makes her selection, she gathers some leaves and grasses to insulate her new home. A homeless queen bumblebee may also move into the old feathered nest of a small bird, such as a snow bunting or longspur. Sometimes, the assertive queen will move in before the birds have vacated, forcing the rightful owners to surrender their nest. Late-emerging queens are the most desperate. In their urgent search for a nest, they may try to steal one from another queen bee, either driving her out or, in some cases, killing her.

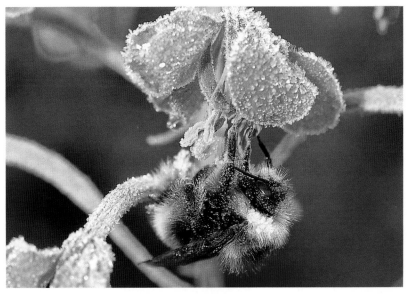

The first batch of eggs a queen lays usually develops into a small force of 16 or so devoted worker bees. The workers are sterile female bees that tirelessly gather more pollen to nourish the next batch of offspring, which will be a mixture of fertile male bees, called drones, and fertile queens. By this time, summer is almost over, and the drones and young queens abandon the nest, fly off and mate. Only the newly mated queens will survive the coming winter; all other members of the small bumblebee colony, including the drones, the worker bees and the old queen, will die in the autumn.

Summer in the High Arctic can be extremely brief—sometimes lasting just a matter of weeks —and the arctic bumblebee is able to complete its life cycle in so short a time because of one important characteristic: it is hot-blooded. By shivering its large flight muscles, a bumblebee can raise its body temperature up to 60 Fahrenheit degrees (33C°) above the air temperature. So when a queen bumblebee first emerges in early summer and is gathering nectar and pollen, her hot-blooded body is "incubating" the eggs inside her even before she lays them.

After egg laying, the queen continues to warm her eggs and larvae by brooding them in the same way that a bird does. In fact, she keeps the temperature inside her nest at around 90 degrees F (32°C), the kind of temperature you would expect to find in the Tropics, not the High Arctic. The body heat generated by the queen bumblebee is crucial in speeding up the development of her eggs and larvae and completing the life cycle before the killing frosts of autumn.

Overnight, frost formed on the chilled body of this arctic bumblebee hanging beneath a fireweed blossom. By about 10 o'clock in the morning, the frost had melted, and after several minutes of shivering its large flight muscles, the bee raised its body temperature enough to fly away.

C

When a bull caribou first rubs the velvet from its antlers, the underlying bone is stained red with dried blood. As the animal repeatedly thrashes the tundra shrubbery with its rack, the antlers take on a varnished brown color.

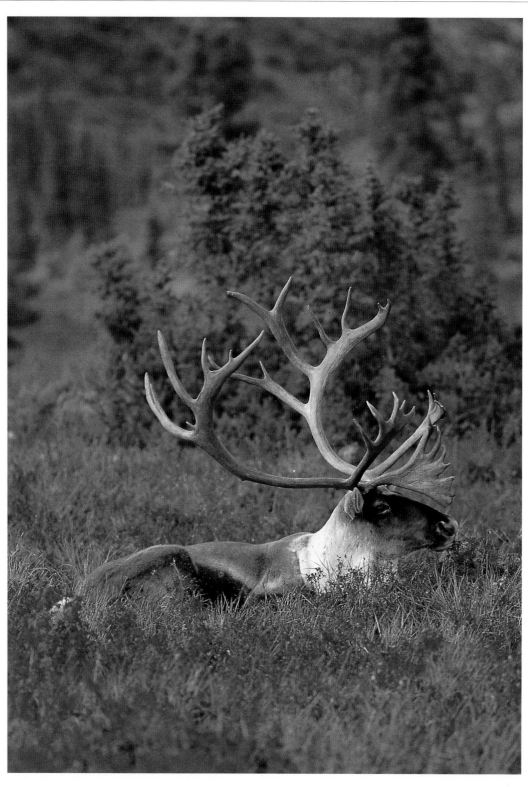

Caribou

Antlers are the badge of the deer family (Cervidae), and this bony headgear is largest in those family members living in cold northern climates. The heavy-bodied moose has the biggest antlers of any deer. Record-setting bull-moose racks weigh more than 65 pounds (30 kg) and measure 4½ feet (1.4 m) in length on each side. Trophy caribou antlers reach similar lengths, but because they are shaped differently, they are not nearly as heavy as those of the moose. Nevertheless, when you compare the weight of a caribou's antlers with its body weight—which may be one-third less than that of the moose—pound for pound, a majestic bull caribou packs more antler for its size than any moose around.

One of the unique features of a caribou's antlers is the so-called shovel, a single palm-shaped branch that sweeps forward above the ridge of the animal's muzzle like a bony miniature sail. It is known as the shovel because it was once thought that the caribou used it to dig craters in the snow when it foraged for food in winter. Actually, caribou scrape out feeding craters with their front hooves. The shovel probably acts as a shield to protect the caribou's eyes when bulls thrust and parry antlers in combat. (In one study conducted in the Canadian Arctic, it was found that the shovel grew from the base of the left antler 69 percent of the time and from the base of the right antler 23 percent of the time. Eight percent of the time, a shovel grew from both antlers, a growth pattern that produces the trophy rack most coveted by hunters.)

The elaborate antlers of a caribou bull take just five months to grow. By mid-September, the velvety covering has been rubbed off, the underlying bone is polished and hardened and the owner is looking for a rival to challenge. For caribou bulls, antlers are a form of male advertising, and their size correlates well with the animal's age and health. At the end of each rutting season, the antlers are shed. As a bull ages, each new set of antlers is larger than the previous

year's; the maximum size is reached when the bull is 5 or 6 years old.

The autumn life of an antlered bull is one sparring match after another. The matches are relaxed affairs. They start slowly, with opponents carefully locking antlers, so there is little risk of injury. Then the caribou push and twist for a few moments until one animal, usually the bull with the smaller rack, turns away. The whole bout lasts only about 30 seconds. By sparring with many different bulls, an individual male learns to recognize the different sizes of antlers and to determine how each relates to the owner's body size, strength and fighting ability. The male also acquires valuable information about his own size and strength relative to the other bulls.

The autumn sparring is simply preparation for the serious business of breeding. During the October breeding season, large, powerful bulls monopolize harems of cows and breed with each member of the group. Only a caribou of equal status will challenge such a bull, and the fights between rivals are nothing like the gentle sparring matches of hopeful bachelors.

Actual fights are rare events, and for the contestants, they are all-out combat. The battles are extremely violent, and because there are no rules, the risk of injuries to the caribou, such as broken antlers, puncture wounds and lacerations, is high. Such fights end quickly, usually in less than a minute. After the loser attempts to flee, little mercy is shown; the victor may even try to gore his opponent. On rare occasions, a bull caribou is killed when a vital organ is stabbed or ruptured.

Female caribou also grow antlers—the only female deer to do so—but not to spar with. The most northerly ranging deer, caribou must endure long, cold winters on a meager diet of lichens, willow twigs and dried grasses. Antlers give cows an advantage in the competition for winter food. Bulls shed their antlers in November, at the end of the rut, but cows keep their antlers throughout the winter and spring, until

Caribou Trivia

The name caribou is derived from a Micmac word meaning "pawer" or "shoveler."

The Inuit name for the caribou is tuktu.

25

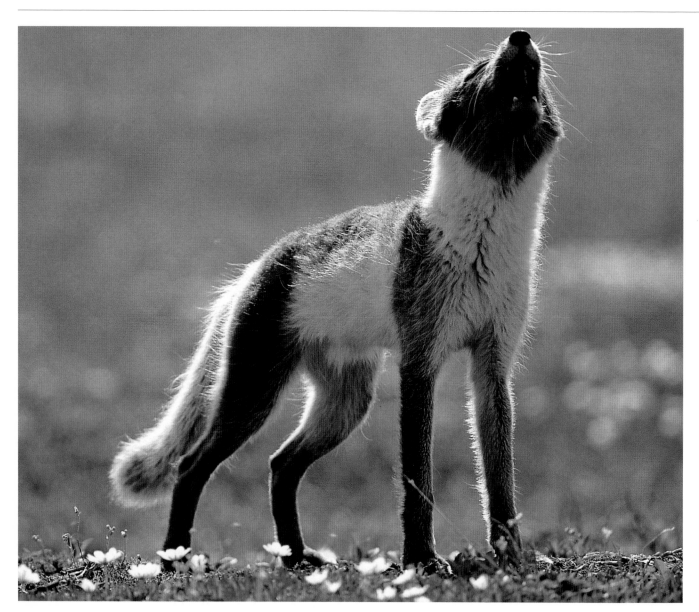

When a predator such as a wolf, a grizzly bear or a wolverine wanders near an arctic fox den, the parent fox gives a bark of alarm that sends the pups scurrying underground to safety.

early June, usually until after the birth of their calves. An antlered female is dominant over an antlerless bull, despite her smaller body size, and can displace him from a choice feeding site whenever she chooses. In this way, the cows gain a nutritional advantage in winter, and since most of the females are pregnant during that time, having antlers may improve the survival rate of their calves.

Every year in Canada, another two million sets of caribou antlers tumble to the tundra. Why isn't the Arctic littered with these bony racks? Rich in calcium and other essential minerals, the cast-off antlers are chiseled up by lemmings, voles and ground squirrels. But the animals with the biggest appetite for antlers are the caribou themselves, which chew on them regularly, thereby recycling the minerals and keeping the

tundra tidy. Because of this, most cast-off antlers disappear in just a couple of years.

Carrion: Life After Death

Finding the remains of a dead animal in the Arctic is a relatively rare event, and there's a good reason for that: scavengers. Scavenging is a part-time job for many arctic creatures, from hawks to ground squirrels, and they do it with remarkable efficiency. The best of the arctic scavengers by far is the raven (*Corvus corax*). In one study on Alaska's North Slope, researchers stationed themselves near carcasses to see which scavengers would show up. Ravens appeared every time, and three out of four times, these keen-sighted birds were the first scavengers to arrive.

Many other arctic birds scavenge as well, including gulls, jaegers, rough-legged hawks and

even golden eagles. Biologist Peter Clarkson told me about an incident in which two grizzly bears traveling together killed five young muskox calves, one after the other, in a single day. When Clarkson checked the following day, the two grizzlies were feeding on one of the dead calves, a wolverine was tearing at another one and a golden eagle was feeding on a third. Within days, everything was eaten.

Whereas most birds use sight to locate carrion, scavenging mammals such as bears, wolves, foxes and ermine rely more on their sensitive noses. In one instance, a red fox was able to detect the scent of a frozen duck wing under 18 inches (43 cm) of snow. It took the fox nearly five minutes to dig up its dinner. Even more impressive was the arctic fox that sniffed out a dried-up lemming carcass buried beneath 28 inches (72 cm) of snow. Bears are often said to have such sensitive noses that they can detect ripe carrion 20 miles (32 km) away. I doubt this. More probably, they can smell a dead animal no farther away than several miles.

Large carcasses often attract more than one scavenger, so the rules of etiquette in the Arctic are simple: Eat as much as you can, as fast as you can, then hide the rest. For this reason, foxes, ravens and wolves often stash mouthfuls of meat under willow bushes, in rock piles and in small holes they dig in the tundra, making dozens of trips to hiding places up to half a mile away.

Even grizzly bears try to conceal leftovers from other scavengers, but they don't do it a mouthful at a time. In northern Alaska, a biologist watched a female grizzly that had discovered a dead caribou. After the bear had eaten her fill, she spent 2½ hours covering the remains with grass that she raked from the surrounding tundra.

Besides trying to camouflage a carcass, a grizzly will also actively defend it. A bear may spend a week or more feeding on a large carcass. While it guards its prize, the bear will rest nearby. Sometimes, it will even sleep on top of the carcass. Another bear or any other scavenger that approaches is aggressively chased away.

If the carcass is too big to hide, another option is to move in, which is exactly what some arctic foxes did one winter on St. Lawrence Island, in the Bering Sea. The foxes located a dead walrus that had washed up on the beach. After chewing holes through the animal's tough, frozen hide, some of the foxes actually lived in-

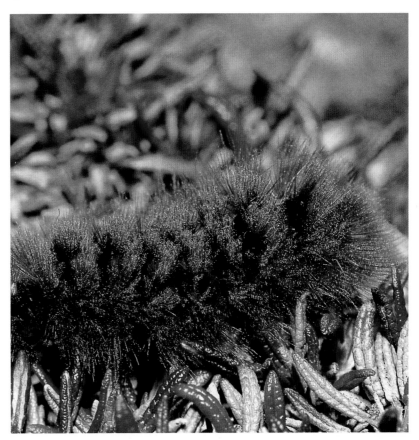

side the carcass, slowly eating it from the inside out. As many as 40 arctic foxes were seen feeding on the carcass at one time.

Caterpillars: Woolly Bears

Every living thing needs some heat to survive, and the creatures of the Arctic have developed some ingenious ways to make the most of a scarce necessity. None does it better than the thumb-sized woolly bear caterpillar (*Gynaephora groenlandica*), which ranges the farthest north of any species of moth or butterfly.

In the High Arctic, woolly bears appear at the beginning of summer, in early June. For three weeks or so, the fuzzy caterpillars while away their days chewing tender willow-leaf buds and their evenings luxuriating in the midnight sun, soaking up its meager rays. Woolly bears spend more than 60 percent of their time basking, slowly tracking the movement of the sun and always positioning themselves so that they are perpendicular to the sun. The insect's dense coat of hairs traps the sun's warmth and can raise its body temperature as high as 86 degrees F (30°C).

At the end of June, several weeks before the peak of the summer season and the time of year when other arctic insects are most active, woolly

The arctic woolly bear caterpillar lives life in the slow lane. Active for just one month of the year, the woolly bear lives for 13 years, longer than any other caterpillar known.

bear caterpillars suddenly stop feeding and disappear for the next 11 months. In a climate where the summer season of activity is already extremely short, why do the caterpillars shorten their summers even more? It's not cold temperatures that send them into hiding…it's life-threatening parasites.

Woolly bears are slow-moving—they've been clocked at a tundra-tearing pace of two inches (5 cm) per minute—so they are easy targets for two arctic parasites: the wasp and the bristle fly. Both insects lay their eggs on the slowpoke caterpillars. When the eggs hatch, the larvae slowly eat the caterpillars alive.

What do the woolly bears do when they disappear halfway through the summer? Predictably, they prepare for winter. Woolly bears are among the most cold-tolerant of any insect, surviving temperatures as low as minus 94 degrees F (–70°C). And they don't do it for just one winter. Woolly bears freeze and thaw year after year after year.

Most moth caterpillars remain in the caterpillar stage for just two to four weeks before changing into adults. The arctic woolly bear, however, lives for 13 years, the longest-lived caterpillar known. In its fourteenth summer, it spins a silk cocoon. Like the woolly bear itself, the cocoon is designed to trap as much of the arctic sun's meager warmth as possible. The cocoon is surrounded by a loose mesh of silk thread that lets in sunlight and traps a layer of warm air inside, in much the same way that the fuzz around the caterpillar's own body does.

Within a week or so, the cocoon splits and the small adult moth slips free. After a few frantic days of mating and egg laying, the adult moths die, and the woolly bear's remarkable 14-year cycle of hide-and-heat begins anew.

Cold Solutions

Without question, the Arctic is a frigid place to live. It can snow on any day of the summer, and the winters are long and bone-numbingly cold. Any creature with a heartbeat that lives in the Arctic needs as much protection from the cold as it can get. What, then, are some of the ways these animals protect themselves from the cold?

Let me introduce you to Bergmann and Allen. They may sound like a stand-up comedy team, but Carl Bergmann and Joel Allen were actually biologists in the 1800s. Although they worked

Cotton Grass Trivia

Wild fires influenced the vegetation in many ecosystems, including the cotton grass tussock tundra of the Arctic. Fire kills competing willow and birch shrubs while sparing the resistant cotton grass tussocks.

separately, both men were interested in how an animal varied depending upon whether it lived in a cold climate or a warm one.

Allen noticed that among mammals and birds, body extremities were shorter when the animals lived in cool climates than when they lived in warmer ones. Thus an arctic hare living in northern Greenland, for instance, had shorter ears, a shorter snout and shorter legs than one living in Labrador, 3,725 miles (6,000 km) farther south. Birds living in a cool climate had shorter wings and legs and smaller beaks than those living in warmer climes. This pattern in animals is known as Allen's rule, and its namesake believed it was nature's way of conserving body heat.

Bergmann, on the other hand, noticed a different trend in northern animals—their bodies were bigger. Thus a moose from Yukon was taller and heavier than a moose from Wyoming.

As a frequent visitor to the Arctic, I have a somewhat modified perspective. In my view, Bergmann's rule probably applies to birds that live in the North year-round, rather than those which migrate south in the winter. For the rule to apply to large mammals, they must live *south* of 60 degrees north latitude. As it turns out, most large Arctic mammals, including muskoxen, caribou, Dall's sheep, wolves and arctic foxes, get smaller the farther north you move from the 60-degree-latitude mark. In any case, chances are that when Bergmann published his report in 1847, he would not have guessed that 150 years later, biologists would still be arguing over whether Bergmann's rule is true or not.

Cotton Grass

Cotton grass (*Eriophorum* spp), which despite its common name is actually a sedge and not a grass at all, is probably one of the first plants that every summer traveler to the Arctic learns to identify—just watch for any plant that has one or more long, thin stems with a wad of white fluff at the end of each. An Inuit friend from Banks Island showed me how her people had used the "cotton" as a wick for the seal-oil lamps they once kept inside their igloos during the months of winter darkness. I've also seen small birds, such as redpolls, Lapland longspurs and white-crowned sparrows, lining the insides of their nests with the white fluffy fibers. Of course, the cotton in cotton grass didn't evolve for either of these purposes. Attached to seeds in the head

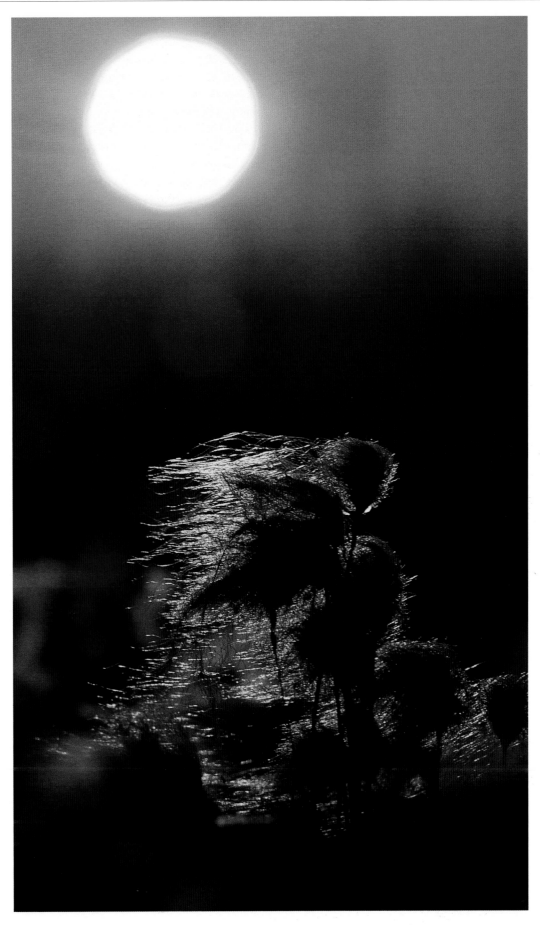

Plumed seeds are one of the most common methods arctic plants such as the cotton grass employ to promote long-distance dispersal. The strategy is also used by fireweeds, willows, mountain avens, flea-banes and, of course, the ubiquitous dandelion.

29

The number of crane fly species decreases the farther north you travel. On Ellesmere Island, where this photograph was taken, there are only six different kinds of crane flies, and some of the hardiest live just 560 miles (900 km) from the North Pole.

Although a crane fly may look like a mosquito, it isn't one: it doesn't bite, nor does it suck blood. Some adult crane flies may sip a little nectar from flowers, but since they live for only a few days, most don't ever eat. With such a short life span, there's no time to waste.

One summer on Banks Island, I observed two adult crane flies mating. As I watched, a sudden gust of wind scooped them up, still joined together, and bounced the pair repeatedly across the tundra for 20 feet (6 m). When the jostled couple finally landed, one of them had lost a hind leg. The insects separated moments later, and each crept into the shelter of some grass, beyond the grip of the wind. It's all part of the tough, short life of this mosquito look-alike.

Cranes: Buglers & Painters
It was one of those glorious autumn days in Alaska when the sky is clear, the temperature cool and the air full of the earthy odor of the tundra. The first cranes flew over at 10:30 a.m. I heard their wonderful bugling calls minutes before I finally spotted the birds themselves, a cluster of tiny specks circling above some distant hills. For the next two days, flock after flock of these long-necked buglers filled the skies with their music, as tens of thousands of them funneled east from the vast Alaskan tundra of the Yukon and Kuskokwim River deltas, heading for their distant wintering grounds in the wetlands of Texas and New Mexico.

Like 95 percent of all arctic birds, the sandhill crane (*Grus canadensis*) flies north for a few months each summer to breed. Crane nests are usually difficult to find, because the birds are very secretive, and the three or four times I've stumbled upon a crane's nest, it was quite by accident. I remember one nest in particular.

I was searching for king eiders at the time, wandering slowly through an area of wet tundra dotted with dozens of tiny ponds. The nesting crane had stretched out its neck and flattened its body against the ground. Even though the bird stands over three feet (1 m) tall and has a body the size of a small goose, I did not see it until it suddenly jumped up just a couple of yards in front of me and flapped away. In the nest was a single olive-colored egg marked with dark blotches, and leaning against the egg was a downy chick covered with reddish fluff.

One of the reasons I hadn't seen the nesting

of the plant, the fluffy fibers act as sails to help the wind disperse the seeds.

Crane Flies:
A Case of Mistaken Identity
Usually, the insects you notice most in the Arctic are those trying to siphon off some of your blood, and it's the bloodthirsty ones that give the rest of the insect clan a bad name. In the Arctic, it's easy to believe that all critters with three sets of legs and a pair of antennae are up to no good and, to be on the safe side, that you had better smack all of them. Before you whack another one, though, let me make a case for the harmless crane fly.

There are at least 16 different kinds of crane flies (Tipulidae family) in the Arctic, but they all look much the same. Unfortunately for them, a crane fly resembles a large mosquito with a six-pack of unusually long, dangling legs. Their oversized legs have earned them the nickname "daddy-longlegs."

All the crane fly larvae in any given area tend to hatch at the same time, so usually one day in midsummer, the adults suddenly appear and can be seen walking everywhere across the tundra. When they do, the needle-beaked shorebirds are waiting for them.

The nesting cycles of many arctic shorebirds (plovers, sandpipers and phalaropes) are closely timed with the crane fly cycle, and chicks hatch just when there are the greatest number of newly emerging crane flies for them to eat. The survival of the young birds depends on an abundant supply of these insects.

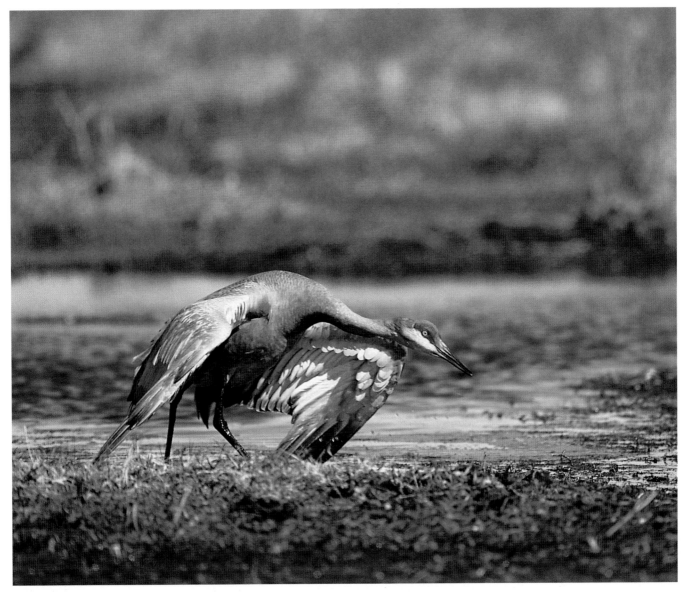

crane was that its rusty-tinted feathers blended so well with the color of the tundra, and this camouflage doesn't happen naturally. Sandhill cranes are one of the few birds in the world that actually "paint" their feathers. I once hid under some camouflaged cloth in northern Yukon and spied on some cranes as they preened. Several of the birds picked up wads of wet mud and rotting vegetation and dabbed it on the feathers on their backs and sides. Later, I examined the mud and found that it contained red iron pigments, which accounted for the rusty staining on the cranes' normally gray feathers.

Do cranes intentionally paint their feathers to make themselves less conspicuous when they are sitting on their nests? I strongly suspect so. Consider the crane that researchers marked with a bright green leg band. Afterward, the crane was observed "painting" the colorful band with rusty mud over and over again.

The sandhill crane typically lays two eggs, two to three days apart, and the parents begin to incubate their clutch after the first egg is laid. This gives the first chick a head start—it usually hatches a day or two before its nestmate. Soon after hatching, the chick leaves the nest, following its father over the tundra, while the mother continues to incubate the second egg. The family reunites once chick number two hatches. By this time, the first chick is noticeably larger than its sibling, and a contest for survival often ensues. Frequently, the two chicks fight and peck each other viciously, until one of them—usually the older—drives away its sibling, which wanders off and eventually starves. Through all of this, the crane parents never intervene.

The drooping-wing act of the sandhill crane is a common distraction display used by many birds to lure predators away from their nests.

D

This month-old lamb, a lone offspring, was probably born at the end of April. Twins are extremely rare in Dall's sheep. Lambs begin to nibble grass when just 2 weeks old and are finally weaned at 4 to 5 months.

Dall's Sheep Trivia

The scientific word for eating soil is geophagy.

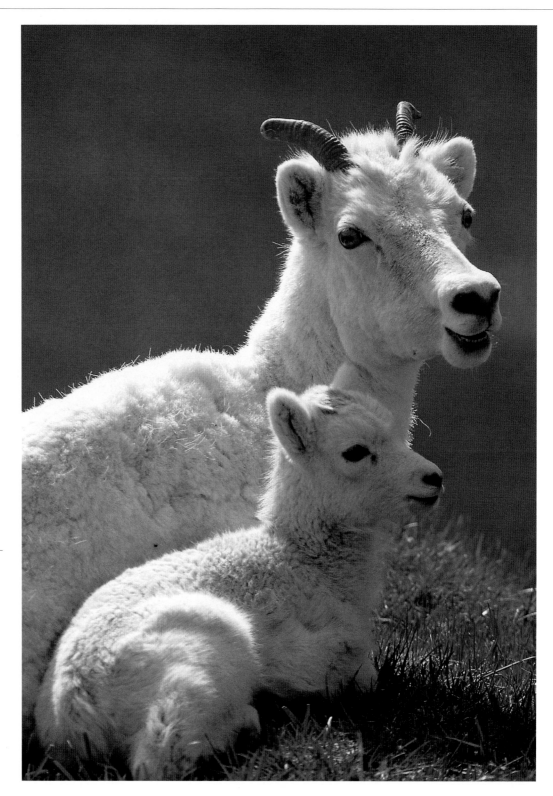

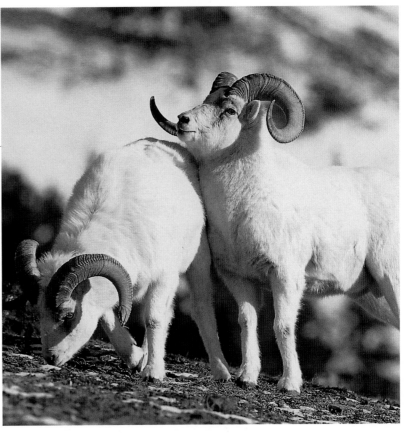

Dall's Sheep: A Taste for Salt

The handsome white Dall's, or thinhorn, sheep (*Ovis dalli*) ranges throughout the rugged northern mountains of western North America. In the Arctic, it takes the place of the more familiar bighorn sheep (*Ovis canadensis*), which lives farther south, in the mountains of southern Alberta, British Columbia and the western United States. The Dall's sheep is a little smaller than the bighorn but is no less impressive.

One week in June, I watched a band of Dall's sheep in northern Yukon make a daily visit to a mineral lick near my camp beside the Firth River. The lick was a dry, barren patch of dirt on a small hillside. With binoculars, I could follow the sheep as they left the steep slopes and ledges of the nearby mountains and marched to the lick, single file. As many as 30 sheep at a time gathered to lick the dirt, kick it loose with their hooves and chew on mouthfuls of gritty soil. They came at different times of the day and usually left after less than an hour, the dominant ewe leading the group back to the safety of the mountains.

Dall's sheep, like humans, need a variety of minerals in their diet, but the one they crave most is sodium—the main ingredient in common table salt. In fact, every large grazing animal in North America seems to hunger for salt in late spring and early summer, which is when they search out mineral licks. But why only in spring?

The answer has to do with the animals' winter diet, which consists mostly of dry plants and twigs that contain very little sodium. Thus by the time the sheep, as well as muskoxen and caribou, have chewed their way through a long arctic winter, they have depleted their body reserve of sodium and need to replenish it. They do so quickly and easily by eating salty soil.

The appetite for salt is a strong one, and some animals will go after it in the most unexpected places. I once watched a salt-crazed bighorn attack a parked car in a parking lot in Alberta's Waterton Lakes National Park. When I first spotted the ewe, she'd been working the car over for some time—the car's rear fender was covered with dents and scratches. The sheep had a routine: She would give the fender half a dozen quick kicks with her front hoof, then stop to lick up the flakes of dirt and rusted metal that had fallen to the ground. The rusted car looked as though it had traveled many miles on salted winter roads, and the underside must have been caked with dried salt. Before you park in a wilderness area, you might want to check the insurance policy on your vehicle to see whether it covers four-legged vandals with a taste for salt.

Dorset Culture: The Arctic Pioneers

Four thousand years ago, native peoples had spread throughout the Americas, from the dark spruce and fir forests of Alaska all the way to the windswept plains of Patagonia, at the southern tip of South America. One final frontier remained to be inhabited—the barren shores of the Canadian Arctic and Greenland, virtually the last places on Earth, besides Antarctica, to be tracked by humans.

The people who finally moved into the Canadian Arctic didn't come from the forests south of the tree line. Rather, they came from the west, from the distant shores of Siberia. This earliest

A strict hierarchy operates among members of a bachelor herd of Dall's sheep. The ram on the right is showing dominance over its companion by placing its chin across the other ram's back.

The male smew (Mergus albellus) *is one of the most handsome of the northern ducks. This small diving duck nests all across the Eurasian Arctic.*

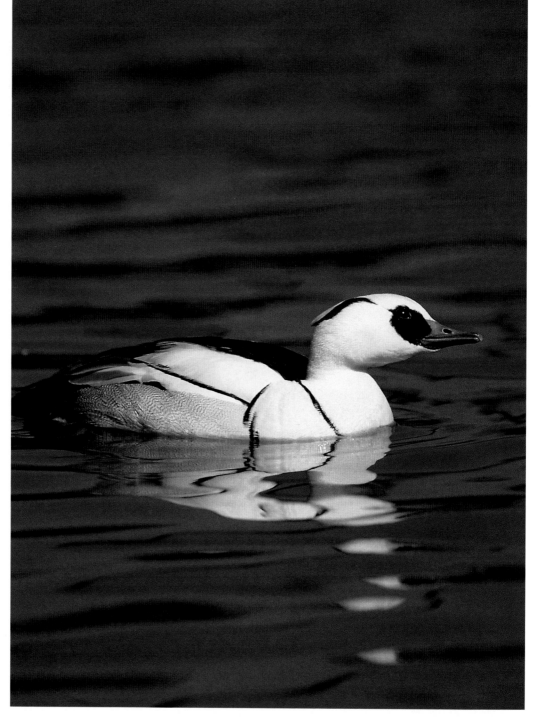

Dorset Trivia

The name Dorset comes from excavations of early campsites made at Cape Dorset, on Baffin Island.

wave of Arctic people probably walked across the ice of the Bering Sea in winter, for they owned neither boats nor dogsleds. Once the immigrants reached Alaska, they trekked along the northern coast and, from there, reached the western edge of the Canadian Arctic. Beyond were hundreds of islands and thousands of miles of coastline, where they pitched their animal-skin tents and hunted with stone-tipped weapons. The descendants of these earliest

Arctic people are known as the Dorset Culture.

The Dorset people hunted seals and muskoxen with harpoons and bows and arrows. In fact, they were probably the first people to introduce the bow to North America. From these tough northern hunters, this versatile and lethal weapon spread south across the entire continent.

These early arctic people never settled in great numbers but, instead, lived in small, widely scattered groups that struggled desperately just to

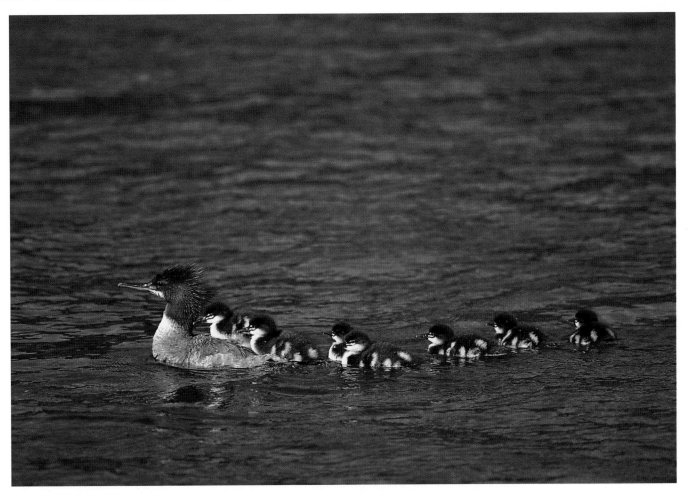

survive. Even so, the Dorset Culture lasted for many generations. About 1,000 years ago, the people suddenly disappeared, killed or absorbed by the second great wave of arctic inhabitants: the Thule Culture.

Ducks: Dabblers & Divers

There are at least 15 different kinds of ducks that commonly occur in the Arctic, and identifying them can be a challenge. Ducks can be divided into two main groups: dabblers and divers. Watching how ducks feed and how they take flight will allow you to distinguish between the two different groups.

Dabblers either paddle along the top of the water, skimming food from the surface, or go bottoms up, stretching their necks underwater to reach food just below the surface. There are four arctic dabbling ducks: the mallard, the brown-and-white northern pintail, the tiny green-winged teal and the American wigeon. When the dabblers take off, they jump straight into the air and are gone. This trait is the surest way to identify the dabbler group of ducks.

The diving ducks, as their name suggests, dive completely underwater when searching for food and may remain submerged for up to one minute. These ducks have bigger feet than the dabblers, and their legs are positioned closer to the rear of their bodies, giving them more power and steering ability. On land, however, the position of their legs produces an awkward gait, and divers have difficulty taking off. When in the water, diving ducks must run across the surface to build up speed before they can become airborne. The arctic diving ducks greatly outnumber the dabblers and include the four types of eiders, the three species of scoters with black feathers and ducks with such interesting names as smew, oldsquaw and red-breasted merganser.

When I was a boy in the late 1950s, duck watching was for nerds, and I was one of them, creeping around marshes trying to get a closer look at whichever duck I happened to spot. Today, I'm still watching ducks, and I find the search more exciting, the ducks more beautiful and the details of their lives more fascinating than ever.

Here, a mother red-breasted merganser and her brood of ducklings swim across a salmon-spawning stream. Whenever the mother dives underwater to chase salmon fry, the ducklings mill around the surface until she returns.

35

E

The golden eagle uses a threat display called mantling to deter other eagles from stealing its catch. Typically, the feathers of the head and neck are erect, the wings are partly opened and the bird sits back on its tail, freeing its powerful feet and talons to strike forward.

The Eagle & Its Aerie

One of the largest birds of prey in the North American Arctic is the golden eagle (*Aquila chrysaetos*). With its butcher beak, 2$\frac{1}{2}$-inch-long (6 cm) curved talons and six-foot (2 m) wingspan, this magnificent raptor ranges well beyond the tree line in Canada but never soars past the edge of the continent.

In the treeless Arctic, cliffs are the most likely place for this bird to settle for the short summer nesting season. The favorable updrafts along the cliff faces allow an eagle carrying heavy prey to land more easily on its nest and nearby ledges, and good nest sites are frequently used year after year. One cliff in the eastern United States was populated by successive generations of golden eagles for almost 250 years, from 1689 to 1938!

Because the birds add new sticks to it each year, an eagle's nest, or aerie, can become quite massive. The largest one I ever saw was over 10 feet (3 m) high, balanced on the ledge of a cliff in Yukon. I set up a blind 230 feet (70 m) from the nest to watch the adult birds feed their two gray downy chicks. While the parents were away hunting one day, a female Dall's sheep and her new lamb climbed up the cliff and happened upon the nest. The curious mother sheep walked to the nest's edge, peered at the two eaglets huddled in the center, then suddenly jumped back as if she had been startled by what she saw or smelled. Given that eagles sometimes prey on young lambs, I suspected the sheep had good reason to be frightened.

Golden eagles in the Arctic also hunt marmots, hares, ground squirrels and ptarmigan. Despite their reputation as tireless hunters, however, these "noble" birds will scavenge at every opportunity. In Alaska, I noticed a golden eagle circling above a foraging grizzly bear. At the time, I thought that the eagle was trying to determine whether the grizzly had found anything the bird might share, such as a carcass. The late biologist Adolph Murie believed that resource-

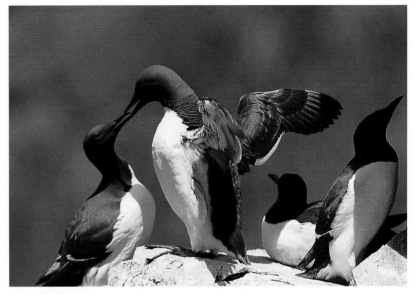

ful eagles soared over bears on a regular basis for just this reason.

Once, Murie watched a golden eagle follow a grizzly along a ridge for an hour and a half as the bear dug for ground squirrels. Each time the bear moved on, the eagle followed and perched on the ground nearby. Occasionally, such patient vigilance pays off, and the eagle is able to grab a squirrel escaping from a back tunnel while the grizzly is busy digging up the rodent's front door.

Arctic Eggs

Some arctic birds lay beautifully colored eggs, and my favorites are the blotched rusty eggs of the willow ptarmigan and the brown-spotted turquoise eggs of the raven. As a rule, the color, pattern and, of course, size of these eggs are consistent among birds of the same species. However, the common murre (*Uria aalge*), an arctic seabird, is the exception to this rule.

The murre's eggs display a greater variety of colors and markings than do the eggs of any other arctic bird species. The basic egg colors range from stark white to pale blue, rusty red or deep aquamarine, and the markings may be spots, blotches or scribbles in red, yellow, brown or black. Although the appearance of murre eggs

Bill fencing is a typical courtship display exhibited by the common murre. Prospective mates also engage in lengthy mutual preening sessions in which the birds groom the feathers on each other's head and neck.

Egg Trivia

The complete set of eggs of some arctic shorebirds weighs more than the parent bird itself.

In 1993, the spectacled eider (Somateria fischeri) was added to the U.S. Endangered Species List. Since the early 1970s, eider numbers in western Alaska had mysteriously plunged from over 100,000 nesting birds to fewer than 5,000. Although the cause of the U.S. decline is unclear, Russian spectacled eiders appear to be holding their own and number over 130,000.

Eider Trivia

The bones of common eiders in the Pacific are tinted pink, the result of a diet that includes large numbers of sea urchins.

The common eider is the largest duck in the northern hemisphere.

varies greatly among individuals, each murre learns to recognize its own egg, something most birds cannot do.

Why are murre eggs so different from each other? Murres nest in dense colonies on cliffs, where the birds are strung out side by side like bowling pins along the rocky ledges. Each bird lays its single egg on the bare rock. Birds continually fly off and return, so there's lots of commotion and jostling on a ledge. It's not hard to imagine that an egg could get moved around or lost in the confusion. Because murre eggs are so distinctively colored, however, it's easier for a bird to locate its own in the jumble of nesting birds. In the end, every egg ends up parked under its rightful owner.

One of the mysteries about eggs that has always intrigued me has to do with the source of the calcium used by female birds to reinforce their eggshells. I discovered that most birds do

not store calcium in anticipation of the demands of egg laying. I knew that some calcium was leached from their own bones and replaced after the nesting season. Nevertheless, the calcium required by many arctic shorebirds to produce a clutch of eggs is often twice as much as the total amount of calcium in the bird's entire skeleton.

As it turns out, some of these birds eat bones. Biologists have found that the stomachs of many arctic-nesting sandpipers, such as the dunlin, Baird's sandpiper, semipalmated sandpiper and pectoral sandpiper, contain the teeth and vertebrae of lemmings and voles. Apparently, the birds scavenge from decomposed carcasses or from the undigested pellets regurgitated by owls, hawks and jaegers. These pellets are commonly found on mounds and other prominences on the tundra and may be a ready source of rodent skeletal remains.

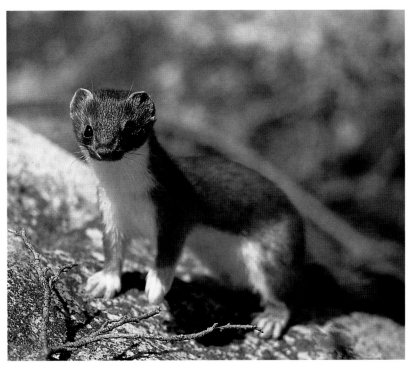

Eider Ducks

Four kinds of eiders live in the Arctic. Large diving ducks, eiders stay fit and beefy by eating a rich diet of seafood, including amphipods, barnacles, marine worms, crabs and clams, all of which they crush with their heavy, broad bills.

The common eider (*Somateria mollissima*), weighing up to six pounds (2.6 kg), is the largest duck in the quartet and is the source of eiderdown, the warm filling used in sleeping bags, quilts and winter jackets. The female eider plucks the soft, fluffy feathers from her belly to line her nest. Once the ducklings hatch and leave the nest, the down can be collected, and this is done by people in many parts of the Arctic. It takes about 60 nests to produce two pounds (1 kg) of eiderdown, which sells for $600 to $700 (U.S.).

Ermine

The ermine (*Mustela erminea*), or short-tailed weasel, is the tiny terror of the tundra. This 2½-ounce (70 g) lightweight hunts lemmings, mice and ground squirrels with the ferocity of a grizzly bear, dispatching its victims with a single bite to the back of the neck. The kill is made when the ermine's needle-sharp upper canines penetrate the rodent's spine or skull. Death for the hapless victim is instantaneous.

A thick blanket of snow protects rodents from most arctic predators, but not from the ermine. The weasel's long, slender body allows it to tun-

nel beneath the snow and pursue prey along their own runways. An ermine always moves at full speed, and it doesn't run so much as flow from spot to spot, checking every hole and crack as it goes. Then, suddenly, it's gone, squeezing into a crevice that seems too narrow even for the wind to slip through.

Songbirds and small rodents are the ermine's bread-and-butter prey, but the animal's fierce determination and remarkable strength sometimes drive it to tackle prey much larger than itself, such as oldsquaw ducks, rock ptarmigan and even burly young arctic hares and marmots.

Like so many arctic animals, the ermine changes color with the seasons. In summer, it is an earthy brown on top and creamy white underneath, and its tail is tipped with black. In winter, the weasel turns snowy white, except for the end of its tail, which remains black. Often, it is the bouncing black tip of the ermine's tail that catches my attention. You'd think that such a conspicuous marking would make the weasel more noticeable to an owl or a hawk, thus lessening its chances of survival, but as we'll see, nature is remarkable in its wisdom.

To find out how important the black tail tip was to the survival of the ermine, an ingenious researcher trained a hungry hawk to attack various models of weasels. All the models were covered with white fur, but some had a single black spot painted on the body and others had a

The ermine belongs to a large family of carnivores called Mustelidae, which includes not only the weasel but also the otter, mink, badger, skunk, marten, fisher and wolverine. Among them, this impressive cast of carnivores employs a wide range of hunting methods, from aquatic, arboreal, terrestrial and fossorial (digging) to cursorial (running) and scavenging.

black spot on the tip of the tail. During the tests, the hunting hawk was most successful capturing the models with the black spot on the body, while it often missed those with the spot on the tip of the tail. The researcher concluded that in real life, the waving black tip on a weasel's tail might often confuse a fast-flying predator so that it either misses the target completely or grabs the animal by the tail, in which case the squirming weasel stands a good chance of escaping.

Reading about the ermine's tail made me wonder whether the same trick is also used by the ptarmigan. In winter, both the rock and willow ptarmigan are completely white except for the outer tips of their tail feathers, which are black. Across most of the Arctic, another fast-flying predator, the gyrfalcon, hunts both kinds of ptarmigan. I would bet that the black tip on the ptarmigan's tail might confuse a diving gyrfalcon and cause it to botch its attack.

Eskers: Tundra Highways

Snaking across the arctic tundra are land formations called eskers—long, winding ridges of sand and gravel that can reach heights of 100 feet (30 m). From an airplane high over the Barren Lands of the Northwest Territories, dozens of eskers are visible. Sometimes, they occur in clusters that run parallel to each other; some may be several miles long. Where did they come from?

As the massive arctic glaciers began to melt, the meltwater carved tunnels inside the ice. The water carried great loads of sand and gravel that eventually settled at the bottom of these tunnels. When the last of the ice disappeared, the sand and gravel were left behind as ridges. Eskers, then, are leftovers from the Ice Age.

Eskers are of interest to me because of their importance to arctic wildlife. Many different animals, from wolverines to caribou, use the dry, elevated ridges as travel routes to cross stretches of soggy, mosquito-infested tundra. These elevated ridges are also an ideal spot for animals to rest, since they can keep an eye out for predators, and the slopes of sand and gravel are likewise an easy place for wolves, ground squirrels, foxes and grizzlies to dig their dens.

Eskimo Curlew: The Hunt Is On

During the 1800s, the flocks of Eskimo curlews (*Numenius borealis*) were so large that in flight, they reportedly darkened the sky. Curlews by the millions would set out from their arctic nesting grounds in the Barren Lands of the Northwest Territories and funnel eastward toward the coast of Labrador, where they often stopped to eat. From there, they flew south to the New England States before heading out over the Atlantic Ocean on a 60-hour nonstop flight to South America. In spring, the great flocks returned to North America by a different route, traveling instead up through the prairies, in the center of the continent, on a direct line to the tundra of the Barren Lands.

As the last century ended, however, the unwary flocks became too great a temptation for gunners. All along their migration routes, the birds were slaughtered by the wagonload, salted, barreled and shipped to restaurants in big cities. Sometimes, hunters didn't even need to use guns. In Labrador, great flocks of curlews roosted together at night along the shoreline. An observer of the day wrote that "a man armed with a lantern to dazzle their eyes and a stick to strike them down could kill enormous numbers."

Then, suddenly, the Eskimo curlews were gone. Within 20 years, from 1880 to 1900, the curlew was beaten and blasted to the edge of extinction. Today, the Eskimo curlew is the rarest bird in the Arctic. There are probably fewer than 20 of them left in the world.

Now, the hunt is on to discover where the last of the Eskimo curlews breed in the Arctic and where they overwinter in South America. Many believe that the most likely nesting grounds are along the Anderson River in the western Northwest Territories. Billy Jacobson, an Inuit birdwatching friend of mine, saw a curlew there in the mid-1980s, but no nest has been found for more than a century. In South America, the search also continues, centered in the province of Córdoba in Argentina, where four Eskimo curlews were spotted in 1989, two in 1993.

For several years, I have spent a few weeks each December photographing wildlife in the grasslands of Argentina. I always keep an eye out for the Eskimo curlew, a plain brownish bird about 10 inches (25 cm) in length, with stiltlike legs and a long down-curved bill. The sighting of this elusive bird would be the best Christmas present I could imagine. Unfortunately, the holiday has always come and gone without a single curlew. How many Decembers does the curlew have left—or is it already extinct?

Curlew Trivia

No Eskimo curlew nest has been found in more than 125 years, making this bird the Arctic's rarest of the rare.

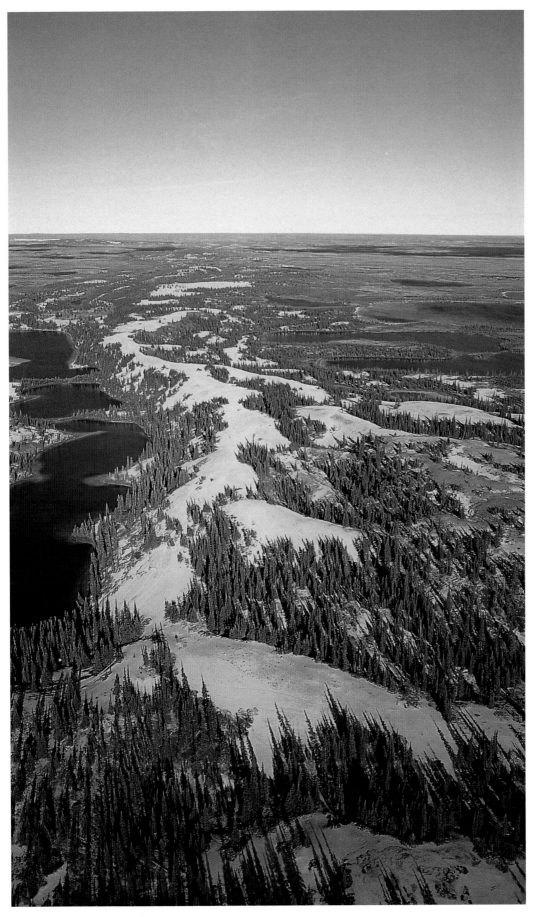

The word esker comes from the Old Irish word eiscir, meaning ridge. Eskers occur in many northern regions, even Ireland—wherever glaciers scoured the landscape during the last glaciation. Pictured is the Howard Esker in Canada's Barren Lands.

F

The warmth-seeking blossoms of the arctic poppy, shaped like miniature dish antennas, track the sun throughout the long arctic day.

Fish Schools

Topping out at a mere six ounces (180 g), fins and all, the arctic cod (*Boreogadus saida*) is abundant throughout the seas of the circumpolar Arctic, even living beneath the ice of the North Pole itself. In fact, the undersurface of the sea ice is a common place for the tiny cod to live as it hunts for planktonic shrimp, copepods and amphipods. Perhaps more than any other fish, this small fry plays a key role in the lives of northern marine animals. It is a major food for harp seals, ringed seals, belugas, narwhals and all of the dominant arctic seabirds, including thick-billed murres, fulmars and kittiwakes.

One June, I spent five glorious days camping with Inuit guides along the edge of the sea ice offshore from Pond Inlet, on northeastern Baffin Island. The steady chatter of hundreds of seabirds was audible every hour of our stay, as the birds patrolled the edge of the ice and beneath its surface searching for arctic cod. The quantity of cod that such seabirds can consume is impressive: Along one ice edge which stretched for 75 miles (120 km), researchers estimated that nearly 10 million arctic cod were eaten in a 35-day period by hungry seabirds stationed there.

At the height of summer, during the open-water season, arctic cod are commonly seen in schools so dense that they remind me of the swarms of krill I've seen in the Southern Ocean surrounding Antarctica. The schools vary greatly

in size. The smallest contain a few hundred fish, but the largest ever measured was an impressive 1,400 feet (425 m) long, 1,300 feet (400 m) wide and 30 to 65 feet (10-20 m) thick. Biologists estimated that the school contained approximately 400 million fish—that's 14,330 tons (13,000 t) of food for predators.

In Lancaster Sound, one school of arctic cod attracted 500 belugas, hundreds of harp seals and thousands of kittiwakes and fulmars. Another cod cluster in the same area brought thousands of harp seals, hundreds of belugas and 15 narwhals. The second of these schools was over 1,600 feet (490 m) long but just 16 feet (5 m) wide—a conga line of cod weighing 50 tons (45 t).

When feeding is good, fulmars may simply eviscerate the tiny fish and eat only its oil-rich liver, discarding the rest of the carcass, which sinks to the bottom. The dead fish eventually wash up on shore and are eaten later by the same birds when the pickings aren't so good or are scavenged by gulls and arctic foxes. Sometimes thousands of dead fish end up on the beach for another reason: Inuit hunters from Ellesmere Island tell of large schools of arctic cod being "driven ashore" by belugas every summer.

It is not yet clear why arctic cod form such compact schools. Using sonar, scientists have even detected schools of cod under the ice, so the clumping behavior in these fish is not simply a response to the open-water conditions of summer. The fish are not feeding, since the majority of them are found to have empty stomachs, and spawning occurs under the ice in late winter, so that eliminates two other possible explanations. In other fish, schooling behavior seems to lessen the risk of predation, since an individual can hide more easily in a crowd. This may also be the case with arctic cod, though schooling fish actually attract attention and appear to concentrate predators in such numbers that 500,000 cod may be caught in a single day.

Despite the arctic cod's importance in the marine food web, there is still relatively little

known about its natural history. Future research promises exciting discoveries.

Flower Tricks

In northern Greenland, roughly 600 miles (970 km) from the North Pole, botanists have found 76 different kinds of flowering plants. To survive so far north, arctic flowers have developed a number of interesting ways to bloom in the cold.

Most arctic flowers grow just a few inches tall, and it is common for many flowering plants to form dense, compact little cushions that hug the ground. In this way, the plants escape the cooling effects of cold arctic winds, and temperatures at ground level are frequently many degrees warmer than the air above. In the Canadian Arctic Islands, for example, a curious botanist discovered that when the air temperature was a freezing 10 degrees F (–12°C), the temperature in a clump of dried willow leaves on the ground was 38 degrees (3°C). Inside a compact cushion of mosses, his thermometer read a remarkable 50 degrees (10°C)—40 Fahrenheit degrees (22C°) warmer than the air!

Another way for arctic flowering plants to keep warm is to wrap themselves in a fur coat, which is one reason the stems and leaves of many of them are covered with fine whitish

The showy flowers of the mountain avens have very little fragrance. They are eaten by arctic hares and ground squirrels; caribou and muskoxen occasionally nip off a few blossoms.

Flower Trivia

The floral emblem of the Northwest Territories is the cream-colored mountain avens. Yukon chose the pink-flowered fireweed (Epilobium latifolium), while the blue forget-me-not (Myosotis alpestris) is Alaska's state flower.

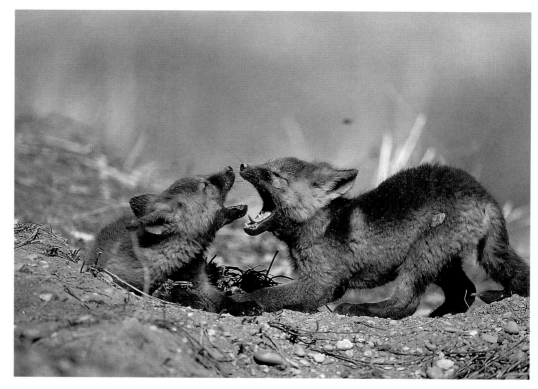

Play between a pair of red fox pups ("cross" color variety) is very serious business. It helps the young canids to develop coordination, strengthen muscles and bones and refine the skills of social interaction.

hairs. These hairs trap a layer of air next to the plant that is then warmed by the sun. This in turn raises the temperature of the plant, making it possible for it to grow. The woolly lousewort (*Pedicularis lanata*), one of the earliest plants to bloom in the High Arctic, is true to its name—it has one of the thickest fur coats of all.

There's a third way in which some arctic flowers cope with the cold: they follow the sun. Two examples of sun-tracking flowers are the yellow arctic poppy (*Papaver radicatum*) and the mountain avens (*Dryas integrifolia*). The petals of these flowers, which are shaped like saucers, reflect the sun's rays into the center of the blossoms. Facing directly into the sun as it travels across the sky throughout the long arctic day, the miniature solar collectors thereby raise the temperature of the flower's center by as much as 18 Fahrenheit degrees (10C°), which speeds up the growth and development of the plant's seeds. The warmer temperatures also attract tiny beetles and other insects, which huddle in the center of the flowers to take advantage of the heat. In the process, the insects benefit the flowers by inadvertently pollinating them.

Outfoxing the Cold

Two species of foxes live in the Arctic: the cosmopolitan red fox (*Vulpes vulpes*), which has the widest distribution of any wild mammal on Earth, and the circumpolar arctic fox (*Alopex lagopus*). Generally, the red fox lives in forests, while the arctic fox lives on the tundra. During the past century, however, red foxes in North America and Russia have slowly moved beyond the tree line, penetrating farther and farther into the tundra of the Arctic. The red fox is now a year-round resident on the Barren Lands. It lives on Baffin Island, and it has even been sighted along the southern end of Ellesmere Island, 650 miles (1,050 km) north of the Arctic Circle and 930 miles (1,500 km) from the nearest forest.

Wherever the territories of the two foxes overlap, the red fox is always dominant over the compact arctic fox. The reds, which may be up to 60 percent heavier, commonly chase the white foxes whenever the two meet, ousting them from dens when homesites are in short supply and killing their pups. When competition is intense, they may even kill the adults.

At first glance, the red fox seems capable not only of surviving in the Arctic but of thriving in it. Like the arctic fox, the russet canid is a skilled hunter of lemmings, hares and nesting birds. It can scale precipitous seabird-nesting cliffs with the kind of agility an arctic fox would envy. In the Bering Sea, I saw a daredevil female red fox raid a cliff-nesting colony of murres and kittiwakes. Jumping effortlessly from ledge to ledge, she cleaned out one nest after another.

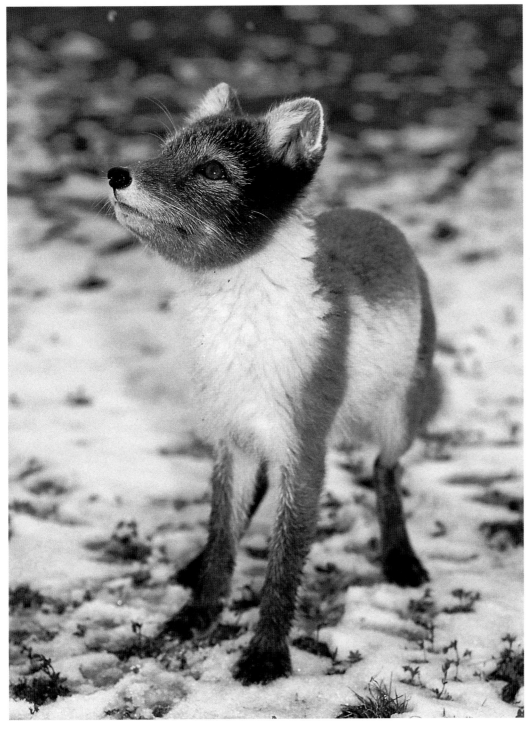

The short muzzle and relatively small ears of the arctic fox (shown here in its summer pelt) reduce the animal's surface area, which lessens the loss of body heat in winter.

No challenge, it seems, is too great for the adaptable red fox. The red fox commonly scavenges wherever it lives, but in the late 1970s, researchers spotted red foxes scavenging on the sea ice off northern Labrador. Twenty-four foxes were seen, five of them feeding on carcasses of ringed seals that had been killed by polar bears. Before then, only arctic foxes were known for this scavenging behavior.

If the dominant red fox can do everything that the arctic fox can, why hasn't the red fox simply taken over? Throughout the Arctic, white foxes still greatly outnumber reds. The probable explanation has to do with energy. As capable as the red fox is, it may simply not be able to adapt to the cold, and in the end, the animal's anatomy may prevent it from deposing the better-adapted arctic fox.

When biologist Joel Allen developed his famous theory to explain how animals conserve

Wood frogs lay their eggs as soon as the ice melts in spring, often when the water temperature is still very close to the freezing point. Males select female mates that are larger in body size, presumably because they can lay more eggs.

heat (see "Cold Solutions"), he must have had the arctic fox in mind. According to Allen's rule, animals from cold climates have smaller ears, muzzles, legs and tails than their relatives from warmer climates. The arctic fox, compared with the red fox, fits that pattern perfectly. In fact, everything about an arctic fox is designed to cope with the cold. To begin with, the undersides of its feet are covered with fur, and its coat provides the best insulation of any land mammal studied. The arctic fox can weather temperatures as low as minus 49 degrees F (–45°C) before it must increase its metabolism to keep warm. In one study, an arctic fox was subjected to an astonishing minus 112 degrees (–80°C) for an hour, and its body temperature never dropped a single degree.

The red fox, on the other hand, must raise its metabolism as soon as the temperature drops below a relatively balmy 8 degrees F (–13°C). With its thermostat set so high, a red fox living in the Arctic must frequently tap into its energy reserves. Its anatomical energy costs keep the red fox living on the edge, hanging on but unable to conquer—a fact of life that may well be the reason it will never evict its arctic cousin.

Fresh-Frozen Frogs

Without *some* body heat, a frog could not hop around, escape from predators, catch its food, digest its meals or wrestle with its mating partners every spring. But a frog is an amphibian and, like all of its kind, is unable to generate its own body heat. Instead, it must soak up warmth from the sun. With eight or more months of win-

ter, the Arctic is, needless to say, a challenging place for a frog to live. Yet the hardy wood frog (*Rana sylvatica*) has managed to inhabit Alaska, Yukon and the western Northwest Territories— the only North American amphibian to cross the Arctic Circle. To do so, the wood frog has evolved a rather startling method to survive the long, brutal winters: Each year, it freezes alive.

Wood frogs spend the winter under a rock, beneath a thin covering of leaf litter or buried several inches deep in the soil. If you uncovered a wood frog in the middle of winter, as did 18th-century arctic explorer Samuel Hearne, the frog would appear to be dead. Hearne wrote in his journal in 1770: "I have frequently seen them dug up with the moss (when pitching tents in Winter), frozen as hard as ice; in which state the legs are as easily broken off as a pipe-stem." If you examined the frog closely, you would notice that its eyes were cloudy, it wasn't breathing, it had no heartbeat and it would not bleed if any of its major blood vessels were cut. Also, you could readily feel ice under the frog's skin. On the inside, all of the animal's organs would be surrounded by a mass of ice. But, like Hearne, you would discover that "by wrapping them in warm skins and exposing them to a slow fire, they soon recover life."

Anyone who has ever experienced a painful frostbitten fingertip or toe has to wonder how the wood frog survives when as much as two-thirds of the water in its entire body is frozen solid for most of the year. The damage in frostbite is caused by tiny crystals of ice, but what is important is where the ice crystals form. Ice crystals cause damage when they form *inside* a cell, where they can puncture membranes and generally upset the microscopic machinery of the cell, causing its death. It's a different story, however, when the ice crystals form *outside* the cell, in the spaces between the cells, which is where ice forms in the wood frog. And this is how the small amphibian is able to survive such freezing.

Medical researchers are understandably fascinated by the details of the wood frog's life history. Solving the mystery of how this species and other cold-blooded northern animals, such as the gray tree frog and hatchling painted turtles, tolerate the cold may yield benefits that are now impossible to predict. One day, the secrets of the tiny frog's metabolism may enable us to extend significantly the viability of the human organs,

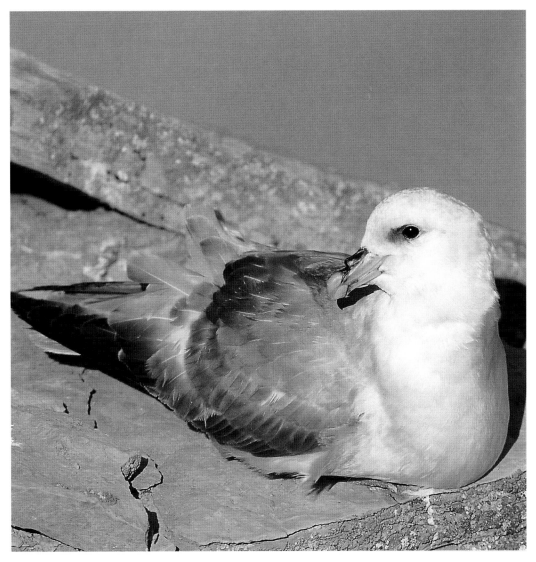

The northern fulmar occurs in white (as pictured here), dark, in which the entire plumage is a smoky gray, and a variety of intermediate colors ranging between these two extremes.

such as hearts, kidneys and livers, that are now routinely used in transplant operations.

Fulmars

Although the northern fulmar (*Fulmarus glacialis*) of the Arctic could easily be mistaken for a gull, it belongs to a group of seabirds called "tubenoses," which includes those celebrities of the bird world, the albatrosses. Tubenoses get their name from the fact that their nostrils are located at the end of rigid tubes on the sides or top of their beaks. Normally, a bird's nostrils are hidden in the feathers of its face.

No one is quite sure of the purpose of these nose tubes, but there is no scarcity of theories. One is that the nose tubes serve as miniature wind tunnels to help the bird gauge the strength of air currents. Another is that the tubes allow these birds, which eat nothing but salty seafood, to snort away the excess salt without crusting up their face feathers. The most likely explanation, however, is that nose tubes help the birds sniff their way around.

Tubenoses are among the few birds, along with the turkey vulture, that have a good sense of smell. Early bowhead whalers noted in their diaries that hundreds of fulmars often flocked to a ship when the men were butchering a whale. The birds were attracted by the smell of the warm blood and oil that spread over the water.

During the nesting season, the fulmar feeds its young by regurgitating a strong-smelling oily mixture from its stomach. When an adult fulmar or its chick is disturbed, the adult can forcefully vomit a stream of this stomach sludge at another bird trying to steal its nesting ledge, paste a persistent fox nosing around for lunch or spray a wildlife photographer who ventures too near. I washed that shirt several times, but it still smelled so foul that I finally had to throw it away.

Fulmar Trivia

The fulmar's average life span is over 25 years, longer than any other bird in the Arctic.

It takes 55 days for a fulmar egg to hatch, the longest incubation period of any arctic bird.

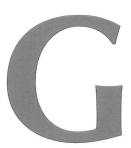

G

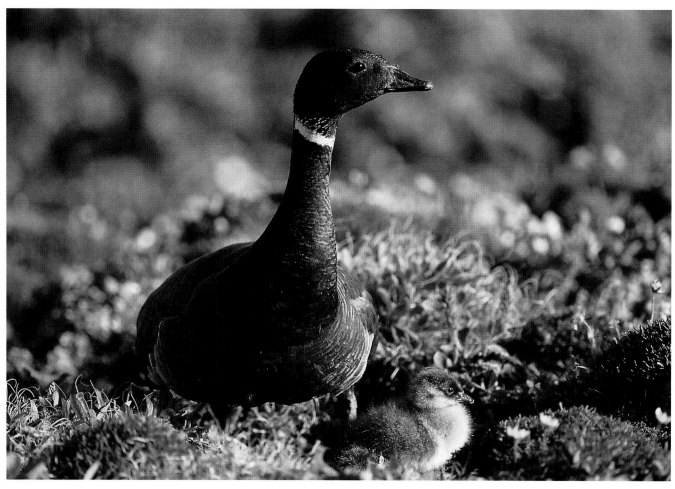

This female brant (Branta bernicla) nested within 150 feet (45 m) of a nesting snowy owl, a common strategy in this species of goose. The owl's aggressive defense of its nest probably protects the goose from egg-stealing arctic foxes.

Gaggles of Geese

The small lakes and ponds of the prairies have been called the "duck factories" of the continent, because more than half of all the ducks in North America are reared there. If that is so, then the Arctic could be dubbed North America's goose factory. Five of North America's six species of geese have their main nesting grounds north of 60 degrees. The exception is the ubiquitous Canada goose, which nests from the Arctic to the central United States.

Geese differ from ducks in a number of ways. Not only are they larger than ducks, but male and female geese resemble each other in the pattern of their plumage. While the diet of ducks includes fish, crustaceans,

aquatic insects and plant life, geese are primarily vegetarians. Even though geese are accomplished swimmers, they do not always feed in the water. Many spend considerable time waddling over the tundra grazing on flowers, seeds and greenery.

Another essential difference between geese and ducks is the strength of the pair bond. With the possible exception of eider ducks, most ducks mate with a different partner each year, and the pair bond typically breaks down soon after the eggs are laid. From that point on, the female duck is a single mother.

In geese, however, the pair bond is very strong, often lasting a lifetime. During the arctic nesting season, the male goose assumes a

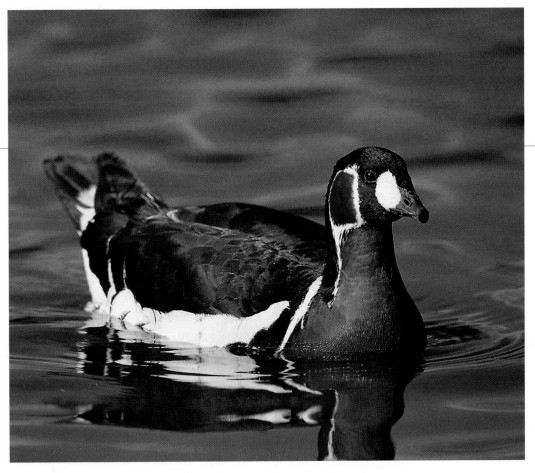

The Russian red-breasted goose takes out one of nature's insurance policies by nesting almost exclusively in association with birds of prey, especially rough-legged hawks and peregrine falcons. The goose may even delay laying its eggs in order to synchronize with the nesting time of its talon-armed neighbor, thereby taking advantage of the predator bird's home-defense system.

large role in family duties. He defends the territory from trespassers, he may help to incubate the eggs, he guards the female while she incubates, and he accompanies the goslings on outings and protects them from predators. In autumn, the goose family then migrates together. The faithful pair remain together on the wintering grounds and return to the Arctic the following spring.

One marked difference between arctic geese and ducks is how they choose to nest. Ducks nest alone (again, with the exception of some eiders), whereas most geese nest in colonies, some of which may contain more than 100,000 birds. Many arctic goose colonies are also quite restricted in distribution. As a result, each area of the circumpolar Arctic is often dominated by one or two goose species that may nest almost nowhere else. For example, most of the 45,000 emperor geese (*Chen canagica*) nest in Alaska's Yukon-Kuskokwim Delta; all 75,000 red-breasted geese (*Branta ruficollis*) nest in the Taymyr Peninsula of Russia; the 200,000 or so Ross' geese (*Chen rossii*) nest entirely within the Queen Maud Gulf region of the central Northwest Territories; and all of the world's barnacle geese (*Branta leucopsis*) nest in Svalbard, eastern Greenland or the Russian island of Novaya Zemlya.

The most abundant goose in the Arctic, and possibly the world, is the handsome snow goose (*Chen caerulescens*), which numbers in the millions. Even this arctic goose nests in only a handful of large colonies scattered throughout the North American Arctic as well as a colony on Wrangel Island off northeastern Siberia. At 460,000 birds, the largest of these colonies is the one on the Great Plain of the Koukdjuak (pronounced KOO-jew-ack), on southwestern Baffin Island, a remarkable concentration of life and living proof of the Arctic's productivity.

Glaciers: Rivers of Ice

Whenever more snow falls in winter than melts in summer, the surplus builds up. As the snow increases in depth, the deepest layers, which are under the greatest pressure, are compressed to form ice. If snow continues to accumulate year after year, the weight of the resulting ice can become great enough that the ice begins to flow like thick, cold toothpaste—and a glacier is born.

Glaciers come in all sizes, from a patch of ice several hundred feet across to a massive ice

An ancient glacier winds through the rugged St. Elias Mountains in southwestern Yukon. The mountains are home to Canada's tallest peak, Mount Logan.

Glacier Trivia

The fastest-flowing glacier in the Arctic, and possibly the world, is Jakobshavn Isbrae, in northwestern Greenland, which surges forward 5,140 yards (4,700 m) a year, an average of 43 feet (13 m) per day.

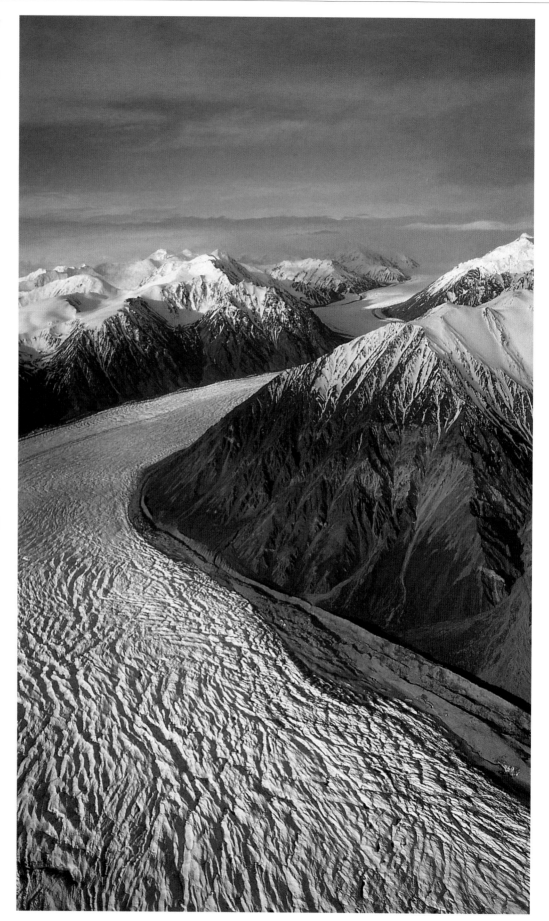

sheet that can bury an entire continent, as has happened in Antarctica. It's no surprise that the Arctic has its share of glaciers, but they are found in fewer locations than you might imagine. The reason for this has to do with aridity.

Cold weather is not the only factor that determines where glaciers are found; precipitation also plays a central role. Much of the Arctic is a relatively dry place, receiving less moisture than many desert regions, and vast sections of the Arctic are glacier-free as a result. In fact, in the North American Arctic, glaciers occur in just two main belts, one in the extreme east and the other in the extreme west.

The eastern chain of glaciers runs along the entire edge of Canada's Arctic Islands, from the top of Ellesmere to the bottom of Baffin. Baffin Island alone has 10,526 glaciers, covering 13,850 square miles (35,890 km²). Ellesmere has more than twice that area of ice, enough to cover all of the province of New Brunswick.

If you boarded a plane on Baffin Island and flew west, you would not see another glacier until you reached southern Yukon and southern Alaska. Here, there is a great arc of glaciers rimming the Gulf of Alaska. It is also home to the two longest glaciers on the continent: the 125-mile-long (200 km) Bering Glacier and the 95-mile-long (150 km) Hubbard Glacier.

Outside of North America, there are glaciers in other arctic regions as well. Some occur in Norway's Svalbard Archipelago, others in the island clusters of Franz Josef Land, Severnaya Zemlya and Novaya Zemlya off Russia's northern coast. And, of course, there's Greenland, where there are more glaciers than barren land.

The Great Auk: Flightless & Gone Forever

If any northern bird could have been mistaken for a penguin, it was the now extinct great auk. At just under three feet (1 m) tall, the great auk (*Pinguinus impennis*) was easily the largest member of the modern-day auk family. These bulky, flightless seabirds lived in the cold waters of the North Atlantic, nesting in large colonies on secluded offshore islands. One of the more massive nesting colonies was on Funk Island, off the northern coast of Newfoundland, where as many as 200,000 great auks may have nested.

For thousands of years, the great auk was hunted by indigenous peoples, but the real

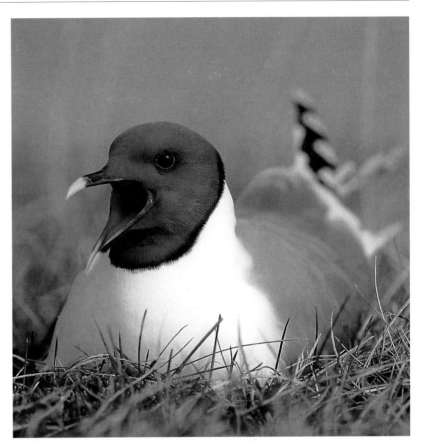

slaughter of this defenseless bird didn't begin until the 1500s, when the first Europeans began to sail regularly to the New World. Ships routinely stopped at Funk Island, where crew members collected fresh eggs and killed and salted barrels of birds. The pickings were easy for the sailors; sometimes, they simply herded the doomed birds up a gangplank onto the ships. Seabird researcher Dr. Bill Montevecchi has observed that "Funk Island may be regarded as the New World's first fast-food takeout."

The killing could not go on forever, and the great auk soon began its slide into eventual extinction. As the end drew near, it seemed even nature plotted against the bird. In 1830, one of the last island breeding sites disappeared in a volcanic eruption off Iceland. On June 3, 1844, it is believed that the last two great auks in the world were clubbed to death by collectors on Eldey Island, along the southern coast of Iceland.

Greenland

My first sight of Greenland was from 35,000 feet (10,670 m), on a flight from Calgary, Alberta, to London, England. It was a beautiful, clear day, and all I could see from both sides of the plane was a vast white landscape of ice and snow

The nest of the Sabine's gull is a shallow cup with little or no lining. The handsome bird nests in small colonies, often in association with arctic terns.

Great Auk Trivia

In 1971, the Iceland Natural History Museum paid $18,000 (Cdn) for a stuffed flightless auk, the highest price ever paid for a dead bird.

51

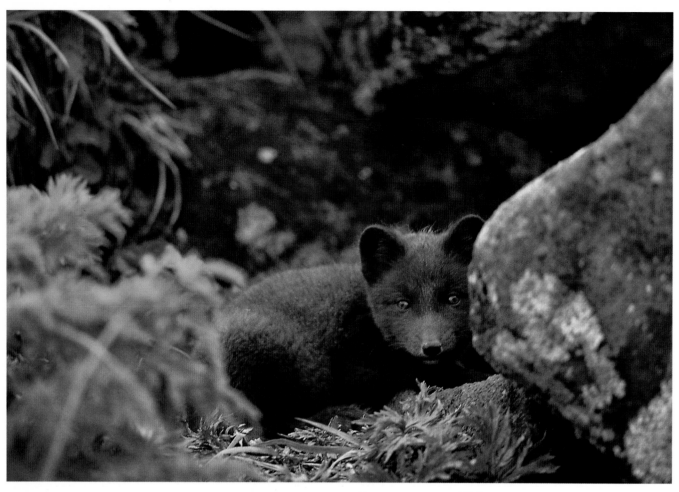

The fur of most arctic foxes changes from pure white in winter to dark brown with a tan belly in summer. In some coastal areas, especially Greenland and Iceland, 50 percent or more of the arctic foxes have blue-black fur year-round. These canids are called blue foxes.

Greenland Trivia

Greenland is the largest island in the world, 2½ times larger than second-ranked New Guinea.

stretching to the horizon in every direction. As hard as I looked, I could not find a single patch of green. In fact, there's very little green in Greenland, which was deliberately misnamed in the 10th century by the Norwegian outlaw Eric the Red in an attempt to lure settlers from Iceland.

Even without the green, however, Greenland is still a spectacular and beautiful arctic land. Towering coastal cliffs teem with seabirds, and huge expanses of tundra are inhabited by muskoxen, caribou, arctic foxes, ptarmigan, gyrfalcons and numerous other arctic birds. There are also magnificent rugged mountains and an intricate coastline carved by picturesque fjords. And, if that's not enough, the entire center of the island is buried under the largest icefield in the northern hemisphere, 1,550 miles (2,500 km) long and 620 miles (1,000 km) wide.

Ice, in fact, covers 84 percent of Greenland to an average depth of 5,000 feet (1,525 m). All but the southern quarter of Greenland lies north of the Arctic Circle, making it the most northern country in the world. With a total population of only 55,000 inhabitants, Greenland is also the

least populated country in the world. For me, this ungreen land of dramatic scenery and northern wildlife remains one of the great arctic wilderness areas on Earth.

Gull Madness

Most people think of gulls as "trash birds" that spend their days skulking around the dumpsters beside fast-food restaurants. I have a photographer friend whose opinion of these birds is exactly the opposite. Get Rod Planck started on the topic of gulls, and he becomes almost teary-eyed talking about the color of their eye rings and the subtle feather pattern on the back of juvenile birds. In short, he's a gull nut. One hundred and fifty years ago, Rod's addiction to gulls would not have been unusual at all.

In the 1800s, certain birds and their eggs were prized as trophies. The richest feathered treasures were those species which were both rare and found only in the most remote areas of the distant Arctic. Three species of gulls qualified as targets: Ross' gull (*Rhodostethia rosea*), Sabine's gull (*Xema sabini*) and the ivory gull (*Pagophila*

eburnea). All three are elegantly handsome gulls, and each has its own points of beauty. The feathers of an adult ivory gull are ghostly white, and in flight, the bird floats like a butterfly. The Ross' gull, on the other hand, has a soft pinkish blush on its breast and belly, and its neck is encircled with a thin black necklace. My favorite is the Sabine's gull, which, in its breeding finery, has a dark gray hood and a beautiful forked tail.

In addition to their great looks, these three gulls are the hardiest, the rarest and the farthest-flying of their kind. The hardiest of the lot is surely the ivory gull, the only gull that winters in the Arctic. Ross' gull, which breeds mainly in Siberia, is easily the rarest nesting gull in North America. And Sabine's gull, which winters off the central coast of South America, migrates at least 8,000 miles (13,000 km) twice a year, the farthest of any gull.

Though illegal, trophy hunting for these arctic gulls and their eggs still takes place today. In June 1980, the first Ross' gull nest in North America was found near Churchill, Manitoba. The news of this rare discovery spread fast and far. The following summer, a shovel-toting "eggnapper" dug up the nest and made off with everything—the nest, the eggs and the mound of tundra on which it had been perched. There were three eggs in the nest; on the black market, each egg was probably worth at least $10,000 (Cdn).

Before 1980, Ross' gull was thought to nest only in northern Siberia. It is believed that the birds in Churchill were blown off course in a storm and then settled on the nearby tundra. Wildlife biologist Dr. Andy Derocher described his feelings about the theft of the rare eggs by writing: "This story always seemed to me to be a tragedy of evolutionary proportion. A species breaks a tradition of thousands of years only to be hacked off by human mindlessness."

Gyrfalcon

The gyrfalcon (*Falco rusticolus*), or simply gyr (pronounced jeer), is the largest and most northern falcon in the world, nesting to the very edge of all the lands rimming the Arctic. It varies in color from all white, with some scattered darkish markings on its back, to an overall dark gray. The white ones, naturally, are the birds that everyone wants to see. Many years ago, when I was at university in Ottawa, Ontario, a white gyr showed up one winter and hung around for

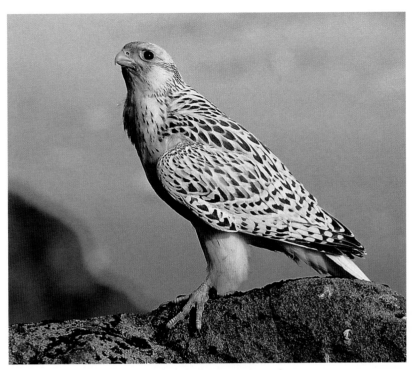

several weeks hunting a flock of pigeons that roosted on the ledges of an eastern Ontario rock quarry. Bird watchers came from as far away as California, a 4,800-mile (7,800 km) round trip, to catch a glimpse of this splendid arctic raptor. The gyr, in fact, is on the top-10 list of birds most bird watchers hope to see in their lifetime.

Among birds of prey, the females are bigger and quite a bit heavier than the males, and they also have larger, more powerful feet and talons. For instance, the female gyrfalcon weighs, on average, 40 percent more than her mate, and her wingspan is three to four inches (7-10 cm) longer. Biologists continue to argue about why this is so.

One possible reason for the marked difference in size between the sexes is that it allows a male and female falcon to hunt different-sized prey and, as a result, possibly compete less with each other. A second explanation is that since a smaller bird can accelerate, climb and roll faster than a larger one can, the male falcon is better adapted for aerial displays, as well as territorial defense. A third possibility, the one that I favor, has to do with reducing the risk of injury to the female during the breeding season. Male falcons are aggressive in mating, and like all of their kind, they have a fierce disposition and are armed with a dangerous beak and lethal talons. Since the female is bigger, the male is less likely to overpower her and accidentally cause injury.

For many falconers, the white gyrfalcon of the Arctic is the most prized raptor of them all. A few years ago, in a diplomatic gesture, the Canadian government presented one of these valued birds to the leaders of Saudi Arabia.

Gyrfalcon Trivia

Falconers call a female falcon a hen and a male a tiercel.

H

During the spring mating season, the docile-looking arctic hare turns into a feisty fighter. The hares stand on their hind legs and cuff each other in the face and ears. The real surprise is, it's the females that do most of the clouting.

Hare Trivia

A male hare is called a buck, a female is a doe, and a newborn is a leveret.

Arctic hares have added a new twist to the art of recycling. They eat their own droppings, a behavior called coprophagy.

Herding Hares

The arctic hare (*Lepus arcticus*), the most northern member of its family, is the heavyweight of hares. This burly bunny has an average weight of around 10 pounds (4.5 kg), almost three times that of its nearest southern relative, the snowshoe hare (*Lepus americanus*). The arctic hare is different in other ways as well—strange ways indeed for a hare to behave.

When alarmed, the arctic hare does not bound away with the usual four-legged bunny hop. Instead, it jumps up on its hind legs, sometimes bouncing on its tiptoes. If it decides to run off, it hops away on two legs as a kangaroo does, with its front legs tucked tightly against its chest. Now imagine the sight of a whole herd of hares hopping off into the distance!

Most hares are quite solitary. Not so with the arctic version, which in winter may crowd together in herds of more than a hundred. An Inuit hunter told me that when a group of hares that size hops across the snow, it looks as though the whole hillside is moving. The largest groups of hares have been seen on Ellesmere and Axel Heiberg islands, Canada's most northern lands. While I was researching this book, I counted the hares in a photograph that had been taken from a plane flying over Axel Heiberg Island. There were 390 hares in the shot. I soon learned that that number was nothing compared with the count made by a biologist who happened to be flying near Eureka, on Ellesmere Island, in 1971. That lucky fellow found arctic hares in groups of thousands! He estimated that there were 25,000 hares in an area of tundra just five square miles (13 km²) in size.

Why do arctic hares travel in herds, and why do they run standing upright? The answer, in a word, is predators. To begin with, a large group of hares will have hundreds of eyes and noses scanning and sniffing the surroundings for the first hint of a stalking wolf or a swooping snowy owl or gyrfalcon. Once the chase is on, an individual hare fleeing as a member of a crowd is less likely to be singled out by a predator. (Besides, an individual can always use its traveling companions as a shield.)

Standing and running upright may be another way the hare can protect itself from predators. The arctic hare's trademark two-legged hopping escape is speedy and maneuverable and may be as fast as the familiar four-legged sprint used by all other hares. But why do the hares stand bolt upright at the first glimpse of a predator? It's often said that such a stance helps them to see better. That might be so in tall vegetation, but on the flat, open tundra, it is unlikely the case. Recent research on the European brown hare (*Lepus europaeus*), a closely related species, offers a more likely explanation.

The brown hare also stands on its hind legs when it spots a nearby red fox. British researcher Tony Holley believes the hare is telling the fox that it has been spotted and that a sneak attack is a waste of time. Thomson's gazelles of Africa likewise adopt a peculiar stiff-legged bouncing gait, called stotting, when they spot a hunting cheetah. As well, purple gallinules and common moorhens signal hunting marsh harriers that they have been seen and that the game is over. The scientific term for this kind of animal behavior is "pursuit deterrence signal." The behavior benefits both species because it saves the exertion of a chase that is unlikely to end in success for the predator. When the arctic hare springs to attention, it's just another example of the prey talking to the predator.

Hibernation: Down & Out for the Winter

Animals hibernate in winter for one simple reason: to conserve energy at a time of year when weather conditions are severe and food is scarce. It's the same idea as turning down the thermostat on your furnace when you want to burn less fuel and save money. Although hibernation works well, surprisingly few arctic animals do it to survive the winters. No birds hi-

Hibernation Trivia

Scientists who study hibernation call themselves "hiberniks."

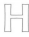

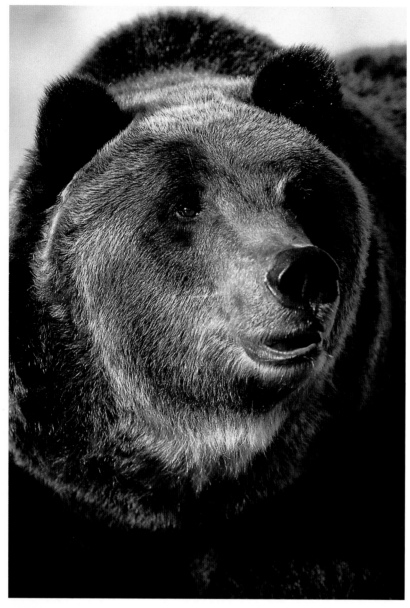

When researchers injected serum from a denning bear into an active ground squirrel, the ground squirrel immediately went into hibernation. It now appears that hibernation is induced by the same hormone in all hibernating mammals.

tucked between its legs and its long, bushy tail wrapped around its body for insulation. The squirrel will remain in this deep sleep for up to three weeks at a time, but then it wakes up, revving its heart rate and body temperature back to normal. After staying active for only a day or two, it slides back into hibernation for another couple of weeks.

This routine forces the squirrel to burn a lot of energy every few weeks. In fact, it seems like a terrible waste of the body fat the animal uses as its winter fuel, so why does it bother? Unfortunately, the squirrel has no choice. It *must* wake up to urinate and defecate. If it doesn't, it will die of internal poisoning.

Bears, because they are so much larger than ground squirrels and marmots, hibernate in a slightly different way. A bear's heart rate drops from its normal 40 to 70 beats per minute to about 8 to 12 beats per minute, and its temperature drops only slightly, by 5 to 9 Fahrenheit degrees (3-5C°). The biggest difference between the hibernation of a bear and that of all other hibernating animals is that once a bear is down, it does not wake up again until the end of winter, which may be up to eight months long. Think about it. This means that the bear may not eat, drink, urinate or defecate for well over half a year. If you attempted such a feat, you would die in less than a week.

Hooded & Harp Seal Pups

Six different kinds of seals live in the Arctic—bearded, ringed, spotted, ribbon, harp and hooded—and all of them give birth to a single pup on the sea ice in early spring. In most cases, the seal nurseries are on unstable pack ice that is prone to shift and break up during stormy spring weather. If that happens, the newborn pups may be prematurely separated from their mothers or dumped into the ice-cold water before they have developed a thick insulating layer of blubber to keep them from freezing to death. Nature's solution is fast-growing pups, and two of the fastest-growing in the Arctic are those of the harp seal (*Phoca groenlandica*) and the hooded seal (*Cystophora cristata*).

At birth, a white-coated harp seal pup weighs 22 pounds (10 kg). For the first 12 days of the young seal's life, the mother is never far away and the youngster just dozes and dines, suckling six or seven times a day. On such a feeding

bernate, and in Canada, for instance, only seven of the roughly two dozen arctic land mammals hibernate, the familiar ones being bears, marmots and ground squirrels.

Let's use the arctic ground squirrel (*Spermophilus parryii*) as an example of how hibernation works. In autumn, over the course of a day or two, most of the squirrel's bodily functions slow down drastically. Its heart rate plunges from a blurring 500 beats per minute (a human's heart rate is typically 60 to 80 beats per minute) to just 25 beats or less, and its body temperature chills to the freezing point, sometimes dipping as low as 27 degrees F (–3°C).

In deep hibernation, a ground squirrel feels cold to the touch and appears to be dead. The animal curls into a tight little ball, with its head

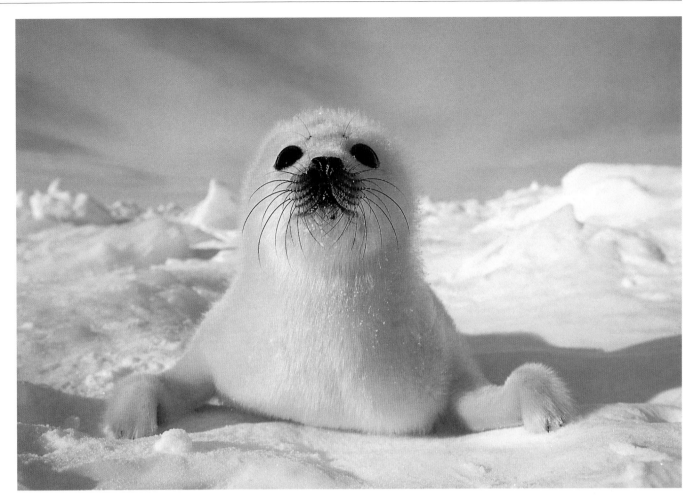

schedule, the newborn seal pup seems to inflate like a balloon, and by the end of the 12 days, it weighs about 75 pounds (34 kg) and looks like an overstuffed sausage. Then, without warning, the attentive mother seal is gone. The young whitecoat cries out repeatedly for several days, but eventually, it accepts the situation and begins life on its own.

Fast-growing harp seal pups have a shorter nursing period than any other seal except one, the hooded seal, whose growth is so fast that researchers were astonished when they first observed it. Hooded seal pups, called "bluebacks" because of their beautiful bluish silver pelts, suckle for just four days, the shortest nursing period known for *any* mammal on Earth. In those few days, the pups swell from 48 pounds (22 kg) to 92 pounds (42 kg), gaining a remarkable 11 pounds (5 kg) a day. If you were to gain the same amount of weight, you would have to gobble down an additional 38,500 calories—the equivalent of 17 Big Macs, 42 cheeseburgers, 25 regular orders of French fries, 12 thick, creamy chocolate milk shakes and 15 hot-fudge sun-

daes—every day for four days. And you would have to eat this mountain of food on top of the meals and snacks you normally eat in a day.

How do hooded and harp seal pups gain so much weight so quickly? The answer is in the mother's fat-rich milk, which is more than twice as thick as whipping cream. Consider that regular cow's milk contains roughly 4 percent fat, and whipping cream usually has about 30 percent fat. Compare that with harp and hooded seal milk, which averages about 50 percent fat and can rise as high as 70 percent.

Understandably, a rapidly growing seal pup is a great drain on its mother. Since the mother seal doesn't eat while she is nursing, she must draw on the fat in her blubber layer to provide her with enough energy to support herself as well as to produce the milk her pup requires. As a result, a mother seal will ordinarily lose over one-quarter of her body weight while she is nursing her pup. It's little wonder, then, that arctic seals normally raise only one pup. The energy cost of raising twins would be more than a mother seal could possibly manage.

A newborn harp seal pup is called a yellowcoat. The straw coloration of its fur, which is staining from the birth fluids, gradually fades in the sunshine over three or four days.

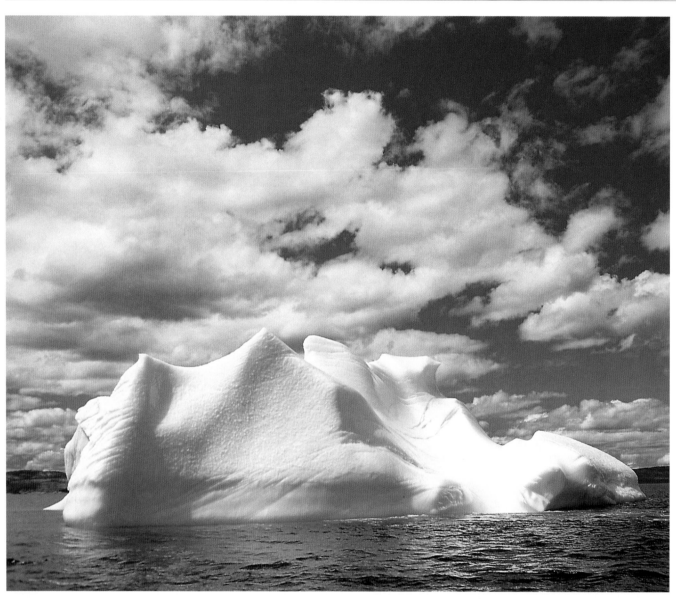

Finally grounded off the eastern coast of Newfoundland, this wave-sculpted iceberg floated at least 850 miles (1,370 km) and possibly as far as 2,000 miles (3,220 km) from its birthplace in the Arctic.

Ice Age Forecast

At present, glaciers cover 10 percent of the Earth's land surface, but at the height of the last glaciation, 15,000 to 18,000 years ago, nearly 30 percent of our planet was laden with ice. In North America, the massive Laurentide Ice Sheet engulfed most of Canada east of the Rockies, extending into the northern-tier states of the United States. Another ice sheet, the Cordilleran, buried the western mountains of Canada. During this

frozen time, much of Alaska and western Yukon remained ice-free, offering a refuge for arctic wildlife. Afterward, when the ice melted, the animals and birds from this glacier-free sanctuary simply recolonized the newly exposed land.

The most recent Ice Age, which began two to three million years ago, has not been a continuous stretch of frigid temperatures and glacial occupation of the land. Rather, the Earth's climate has alternated between glacial periods,

millennia of cold when ice sheets grow, and interglacial periods, millennia of warmer temperatures when the ice melts. This is somewhat oversimplified, since during every glacial period, there are brief periods of warming, and similarly, during every interglacial period, there are brief periods of cooling. A recent example of one of these brief periods of cooling was the Little Ice Age that occurred between 1450 and 1850, when there was a drop in global temperature of 1.8 Fahrenheit degrees (1C°).

It's a commonly held belief that the Ice Age is somehow over. Actually, we are only in the midst of the most recent interglacial period. The last two interglacials lingered for roughly 75,000 to 100,000 years each, so we may still have some time to go. Nor is the Ice Age of today the first to befall Earth. A major Ice Age occurred 450 million years ago; another occurred 300 million years ago and continued for at least 50 million years. Looking at the bigger picture, this Ice Age isn't about to come to an end. In fact, it may have just begun.

Big, Bad Icebergs

To make an iceberg, you need only two things: a large advancing glacier and a nearby ocean. As the snout of the glacier slowly inches forward, pieces of ice continually break off and drop into the water, a process called calving. The pieces are then carried away by the ocean currents. These floating pieces of glacial ice are icebergs.

Over 90 percent of all icebergs are born in Antarctica. They calve off the continent's massive ice shelves by the tens of thousands, some of them the size of small countries. The largest one ever recorded was more than 200 miles (330 km) long and 60 miles (100 km) wide. Having said that, the Arctic still holds its own when it comes to iceberg production.

There are three main iceberg factories in the Arctic: Ellesmere Island, in the Canadian High Arctic; the Svalbard Islands, north of Norway; and Greenland. Of the three areas, Greenland produces the most icebergs, about 15,000 per year, one-third of which come from just six glaciers along the country's southwestern coast. These are the fastest-moving glaciers on Earth, and they calve icebergs almost like an assembly line.

Most arctic icebergs are relatively small compared with those in Antarctica. Nevertheless, some of them may be the size of a small island and long enough to be used as a landing strip for a large cargo plane. The expression "just the tip of the iceberg" is an apt one, because icebergs are always much larger underwater than they appear at the surface. In general, an iceberg is four to five times bulkier below the water than above.

Icebergs usually melt or become grounded on shore before they have a chance to drift beyond the Arctic. Fewer than 1 in 20 icebergs, in fact, ever makes it as far south as Newfoundland, and only 1 in 140 ever makes it past that point. It was just such a rare iceberg that collided with the *Titanic* on April 14, 1912, on its maiden voyage, sinking the ship in less than three hours and causing the drowning deaths of 1,513 people.

Iceland

According to an old Icelandic saga, the country acquired its name in a rather unusual way. An early Viking settler, Floki Vigerdarson, became so obsessive about trout fishing one summer that he forgot to gather hay for his livestock, and the following winter, most of his animals starved. The embittered angler returned home to Norway and spread false stories about how this "ice land" was to blame for the death of his animals. In fact, despite its name, Iceland is ice-free except for a few glaciers in the center of the country.

Eighty percent of Iceland is uninhabited and consists of rocky, windswept moorlands, lava fields and glaciers. The native wildlife includes many species we associate with the Arctic, including northern fulmars, six kinds of auks, eider ducks, rock ptarmigan and arctic foxes. Polar bears occasionally drift ashore on ice floes, but the bears have a very short life expectancy once

Iceberg Trivia

Icebergs the size of small houses are called growlers; smaller chunks are bergy bits.

Taking advantage of the continuous daylight in summer, Inuit children, such as these boys from Sachs Harbour, on Banks Island, play outside until 2 or 3 o'clock in the morning.

they begin to explore the countryside. The islanders' reaction to the bears is not new. During the 13th and 14th centuries, almost every church in Iceland had a polar bear rug or two covering the cold stone floor at the base of the altar at the front of the church.

Igloo

Historically, igloos were used mainly by Inuit in the Canadian Arctic. They were usually temporary winter shelters built when an Inuit hunter and his family went on a hunting trip. A skilled hunter using a special snow knife, which resembled a short sword with a blade of bone or metal, could fashion an igloo in less than an hour. Blocks of compact snow, not ice, were used to build the igloo, because snow is easier to cut and insulates better. Once the walls were finished, a door and a short entrance tunnel were added and the cracks were stuffed with loose snow. Sometimes, the hunter even made a window using a piece of clear ice or seal intestine.

An igloo could be any size, but it was typically built just large enough for a single family to

squeeze inside. That way, the interior would warm up faster. Four or five bare-chested bodies could raise the inside temperature of an igloo to as much as 50 degrees F (10°C).

Inuit

When I was growing up, everyone called the native peoples of the Arctic Eskimos, and we thought nothing more about it. The name, however, is an Indian expression meaning "eaters of raw meat," and it was originally intended to slur the image of the arctic peoples and to suggest that they were savages. Today, indigenous peoples in arctic Alaska still call themselves Eskimos, but elsewhere—in Siberia, Greenland and Canada—the different cultures have adopted proud names taken from their own traditional languages. In arctic Canada, the natives commonly call themselves Inuit (pronounced INN-yoo-it), which simply means "the people." One Inuit person is an Inuk, and the language is known as Inuktitut. Most of Canada's 33,400 Inuit live in the Northwest Territories, northern Quebec and Labrador. Even today, some still follow a

traditional life style, hunting, fishing and trapping on the land they love.

Inuksuit: Inuit Men of Stone

One summer, I was hiking back to the Inuit community of Sachs Harbour, on the southern coast of Banks Island, when a thick fog rolled in from the ocean, reducing visibility to less than 150 feet (45 m). I had been relying on a view of the coastline to find my way, and without it, I was soon lost. I should have stayed where I was and waited for the fog to clear, but instead, I kept walking. Suddenly, a huge stone figure, 10 feet (3 m) tall, materialized out of the mist. It was an *inuksuk*, and I sat happily beside it for several hours, until the wind finally blew away the fog. When the skies cleared, I saw that my *inuksuk* was just one of a series of similar stone figures that marked a safe route from hill to hill all along the coast of the island.

In many places in the Arctic, the indigenous peoples have piled stones on top of each other or made stone figures that, from a distance, look like a man with legs and outstretched arms. All these stone figures, whether simple or elaborate, are called *inuksuit* (singular *inuksuk*), which in Inuktitut means "something resembling a man." Some *inuksuit*, crusted with colorful lichens, are over 1,000 years old.

Inuksuit (pronounced INUK-shoo-it) were built for many different reasons. A line of them might lead hunters over the flat, featureless Barren Lands to an important caribou crossing. Arctic expert Fred Bruemmer wrote about another line of stone figures in northwestern Hudson Bay that led to a large seabird colony, where native peoples had, for centuries, harvested the eggs and young of cliff-nesting seabirds.

On a canoe trip along the Thomsen River, I learned about another use for these Inuit men of stone. I saw *inuksuit*—in this case, just piles of boulders—on many hilltops along the river. A hundred and fifty years earlier, Copper Inuit had camped and stashed surplus caribou and muskox meat on these hills, and the stone signposts would have helped the hunting parties return to the sites later to recover the stored meat.

Inuksuit sometimes had a spiritual purpose as well. An Inuit hunter might build one as a shrine before a long or hazardous journey across the tundra or out to sea. Before he left, he would leave behind an offering beside the stone

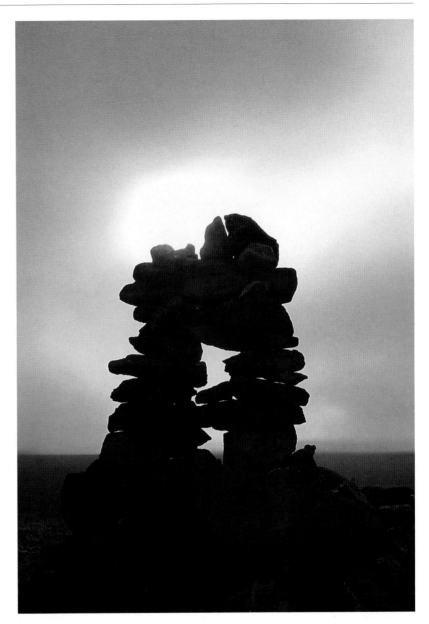

figure and a prayer requesting his safe return.

Before Inuit had guns, one of the most important functions of the stone figures was to funnel caribou toward hidden hunters who, in early times, were armed with simple bows and arrows that could kill only at very close range. At the start of the hunt, a herd of caribou was slowly driven between two lines of *inuksuit*. For some reason, the caribou rarely broke through the lines of stone figures, even though the piles of stones were sometimes 300 to 500 feet (100-150 m) apart. Women or children often hid behind the *inuksuit*, and when the caribou passed, they waved their arms and howled like wolves to frighten the animals and hasten them along. The end of the stone funnel usually led to a narrow ravine, where the hunters were waiting.

Fog rolling in from the Beaufort Sea lends an ethereal quality to this 12-foot-tall (3.6 m) inuksuk on southern Banks Island.

JK

Jaegers: Thugs of the Arctic

In the world of birds, piracy is an uncommon way to make a living, but the three species of arctic jaegers—the parasitic jaeger (*Stercorarius parasiticus*), the pomarine jaeger (*S. pomarinus*) and the long-tailed jaeger (*S. longicaudus*)—are all experts at it. Close relatives of the gulls, jaegers (pronounced YAY-gers) have modified the basic gull pattern so that in many ways, they now resemble birds of prey.

Jaegers have strong hooked bills, sharp curved claws and hard, tough scales on their legs. Female jaegers are also larger than males, another characteristic they share with birds of prey. The aggressive female defends the nest and chicks, while the small male brings food to her, provisioning her completely throughout incubation and for much of the chick rearing.

The most common victims of jaegers are seabirds, especially terns, kittiwakes, puffins and other auks. Typically, a jaeger swoops down from above or makes a head-on attack that forces the bird to slow down. The jaeger may pull food right out of the seabird's mouth. More often, the robber harasses the victim by chasing it and tugging at its wing tip or tail. In those attacks where the jaeger wins, the desperate seabird finally drops its fish, and the pirate catches the stolen food in midair or retrieves it from the surface of the water.

In general, piracy is practiced most often during the nonbreeding season, when the various jaeger species have migrated from the Arctic and are wintering at sea. On the equator off the coast of New Guinea, for instance, I saw several pomarine jaegers steal fish from crested terns that were returning to their nesting island. During the summer breeding season, when the jaegers are in the Arctic, they frequently must hunt for themselves, but it's a short step from pirate to predator and all of them are expert hunters as well as thieves.

Jaegers raid nests for eggs, chase and kill lemmings and snap up young shorebirds from the tundra. They'll even eat insects and berries if they get hungry enough. One spring, I saw a jaeger tackle a meal that was just too much for it. The spring had been very cold, and it had snowed repeatedly, causing many snow geese to abandon their nests. The jaeger found a goose nest with four large eggs in it—a real bonanza. A friend and I watched the frustrated bird peck at the eggs more than a dozen times, trying unsuccessfully to break the thick shells. It finally flew away hungry, having scored, so to speak, a big goose egg.

Kayak

One bright, sunny day in the 1930s, a sealskin kayak skimmed ashore at the port of Churchill, Manitoba, on the western coast of Hudson Bay. The Inuit hunter had paddled from Baker Lake, 560 choppy, rolling miles (900 km) to the north. The journey in itself was a major feat, but that was only half of the story. Moments after the hardy, tanned paddler slipped free of his kayak, his wife's grinning face suddenly appeared in the cockpit. The patient woman had ridden squeezed inside for what must have seemed an endless journey. Once she was out, she then reached down and pulled out their child!

Traditional Inuit kayaks varied in length from 13 to 23 feet (4-7 m) and were built to carry one to three persons. The Greenlanders crafted their kayaks to fit snugly, with a length three times the height of the hunter. A kayak was as personal as a pair of trousers, and Inuit spoke of a hunter "wearing" his kayak.

Most kayaks were made using five or six shaved sealskins stitched together with sinew. The Netsilik tribe of arctic Canada preferred sinew from the back of a caribou, because it swelled and tightened when wet, making the kayak watertight. The sewn sealskins were stretched over a flexible framework of driftwood and antlers, with ribs of willow branches. The one concession to comfort was a mat of polar bear fur on which the paddler sat. Remarkably lightweight, the entire kayak usually weighed

Jaeger Trivia

The technical term for piracy is kleptoparasitism.

The name jaeger comes from the German word for hunter.

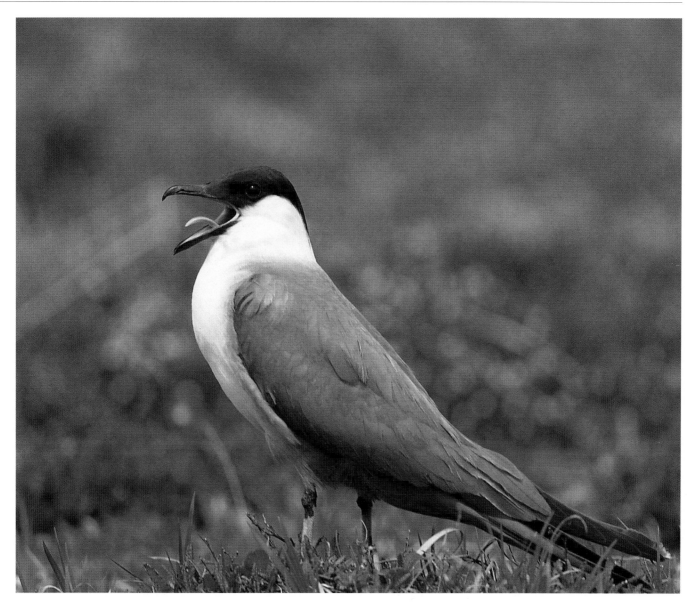

less than 40 pounds (18 kg) and could be balanced on the hunter's head or shoulder and carried easily cross-country for many miles. Since Inuit never learned to swim, it was important always to stay inside the kayak; if the vessel flipped over and the paddler fell out, he would drown, if he didn't die of hypothermia first. As soon as a hunter was seated, therefore, he buttoned the bottom of his skin parka to the outer lip of the cockpit. If his parka was also pulled tight around his face, he could stay warm and dry in the roughest seas.

Unsafe for hunting walruses and whales on the ocean, the kayak was used mainly to hunt the smaller seals. Inland, the kayak was also used to hunt caribou at traditional water crossings in lakes and rivers. Several hunters and their families would herd the frightened animals into the water and then chase them in their kayaks, lancing them with special caribou spears.

The long-tailed jaeger aggressively attacks predators near its nest or chicks. I've seen jaegers swoop down on foxes, wolves, caribou, muskoxen and, of course, Homo photographicus.

When ledges are scarce, the rough-legged hawk nests directly on the ground, typically on the upper third of a steep slope and, as in this case on Victoria Island, at a site with a broad vista.

Hawk Trivia

Plumage coloration varies greatly in rough-legged hawks, from predominantly pale-feathered birds to those which are nearly completely black.

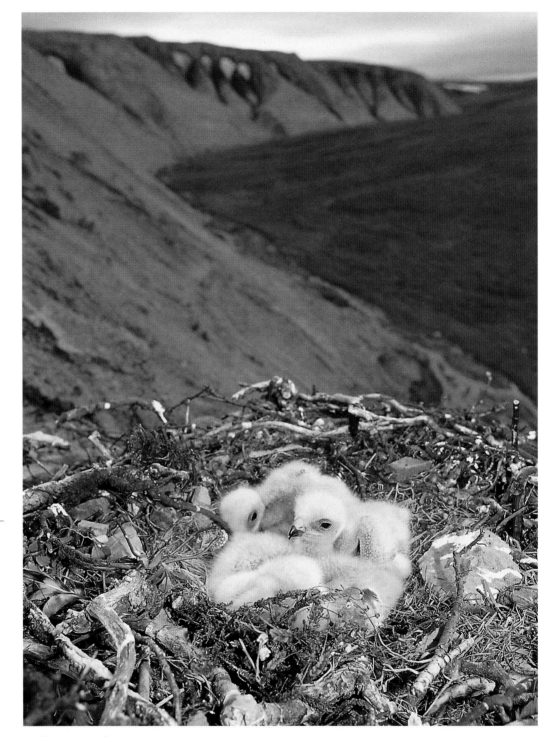

Killer Hawks

The rough-legged hawk (*Buteo lagopus*) is probably the most common bird of prey in the Arctic. And the success of the hawk, like that of so many predators, including owls, weasels, arctic foxes and jaegers, is closely tied to the lemming cycle. In years when lemming numbers are high, the hawks are able to raise a large family. On some trips north, I've counted as many as seven chicks in a nest. In the years when the lem-

ming population plummets, however, the hawks may be unable to raise a single chick.

In an ideal world, the hawks would be equipped to predict in late May what the lemming population might be during the summer ahead. Instead, the birds must simply lay their eggs and take their chances.

The young of rough-legged hawks don't generally hatch at the same time, and as a result, the hawk nestlings in one nest are often different ages

64

and sizes. Naturally, the largest chicks are able to beg the loudest and so are fed first, while the smaller ones get shoved out of the way. When there is a surfeit of lemmings being delivered to the family door, that is not much of a hardship. The smaller chicks simply wait until their larger nest-mates have eaten their fill and then grab a share. When lemmings are scarce, however, it is an entirely different story. The parents are unable to bring much food to the nest, and the largest chicks not only take what little food there is but actually attack their smaller siblings.

In the summer of 1994, when lemming numbers were very low on Banks Island, in the North-west Territories, I found a "roughy" nest containing five downy chicks, the largest of which was clearly the boss. While it regularly pecked all the other chicks, it had also pulled out tufts of fluff from the tiniest chick. At its worst, such rivalry can become deadly. When food is scarce, larger chicks will peck their nestmates to death to eliminate the competition. The parents never interfere in these battles. In the end, the number of hawk chicks that survive depends entirely upon the ups and downs of the lemming world.

Killer Whale Summer

Killer whales (*Orcinus orca*), or orcas, shadow the depths of every ocean on Earth, but they are most common in cold temperate and polar waters. These striking black-and-white predators, with their distinctive knife-edge dorsal fins, move into the Arctic in summer. In the northern Pacific, Eskimo hunters have seen killer whales as far north as the Chukchi and Beaufort seas. In the northern Atlantic, they range into the eastern Arctic Islands of Canada, around Greenland and across to the Barents Sea, off the northwestern coast of Russia.

Like wolves, with which they are so often compared, orcas form strong social bonds and rove in pods—stable groups of anywhere from a few animals up to 35 or 40. Typically, a pod includes one or more 26-foot (8 m) 5½-ton (5,000 kg) bulls, a number of adult cows and their calves, and juveniles. The similarity with pack-hunting wolves is also evident in the way orcas hunt and kill their prey. Several animals or the entire pod may cooperate in a hunt, and the chase and capture of quarry often involves a remarkably coordinated effort.

Orcas are not fussy feeders. In a phrase, if it

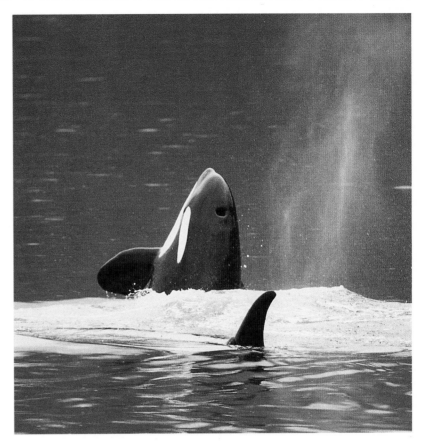

swims, it's food. Off the coast of Norway, killer whales circle schools of salmon to tighten their ranks, then race through the milling fish with their mouths agape. Elsewhere, they eat sea turtles, squid, sharks and seabirds, and in the cold Southern Ocean, they pursue penguins of every size. In the Arctic, as everywhere else, these sociable carnivores hunt marine mammals, their most popular prey, and no species is spared.

The largest prey tackled by orcas are other species of whales. Slow-swimming bowheads are easy targets, and when they're attacked, they are battered and bitten in repeated strikes until they eventually die. Some authorities believe that this predation may be one of the reasons bowhead numbers in Canada's eastern Arctic have not recovered as well as they have in Alaska. Eastern bowheads probably number fewer than 1,000 and are listed as endangered, whereas in Alaska, the population may be 8,000 strong.

Belugas and narwhals are the arctic whales most frequently selected by hunting orcas, but the killers don't always catch their prey. Researchers watched as a pod of 12 orcas swam into Koluktoo Bay in Baffin Island, where 200 narwhals were gathered. As soon as the narwhals heard the first orca calls, the group im-

A killer whale spyhops to see better above the water. Other surface behaviors, such as leaping out of the water (breaching), headstands and tail slaps, make the killer whale one of the most interesting cetaceans to watch.

65

mediately stopped vocalizing, moved close to shore and lay quietly in the water. The narwhals were never discovered by the passing orcas.

Narwhals rarely venture close to shore, but doing so under these circumstances may benefit them for a couple of reasons. The noise of surf breaking on the shoreline and the limited water depth could confuse the echolocation system of hunting orcas and lessen their chances of detecting the hiding narwhals. Ringed seals move into shallow water when they hear orcas approaching as well, probably for the same reasons. It's also a good strategy for narwhals and seals to stop vocalizing at such times, since orcas hunt by listening.

The incident in Koluktoo Bay took place during summer, when there was open water. In ice-filled water, belugas and narwhals adopt a different strategy against orcas. As soon as a roaming pod of killer whales is heard, belugas and narwhals head under the ice edge or flee into the loose pack ice. It has been theorized that either the ice may confuse orcas in the same way the shallow water of the shoreline does or the high-finned killer whales naturally avoid ice-filled water to reduce the risk of injury.

Seals and walruses are another common prey of orcas, and even a walrus's tough, thick hide seems to offer it little protection. Alaskan biologist Francis Fay examined four dead walruses he thought had been mauled by killer whales. The victims were found cast up on the beach, and although all had lacerations on their flippers and puncture wounds on their faces, it was not these injuries that had killed them. The walruses had had most of their ribs broken, some had smashed shoulder blades, and one adult bull had a broken pelvis and three fractures along its spinal column. All of the walruses had died from massive internal bleeding. Fay noted that the injuries were consistent not only with Eskimo lore but with sightings by other scientists as well. He concluded that "the use of the blunt snout as a battering ram for killing or disabling...marine mammals is part of the repertoire of aggressive behaviors of the killer whale."

Kittiwakes: Out on a Ledge

Most of the dozen or so gull species that breed in the Arctic build simple nests on the ground. Only two gulls, the black-legged kittiwake (*Rissa tridactyla*) and the red-legged kittiwake (*R. bre-*

virostris), commonly stray from this ancestral pattern, preferring to nest on the narrow ledges of vertical sea cliffs up to 980 feet (300 m) high. This habit has led to the evolution of a unique set of adaptations among kittiwakes and is a fascinating example of how a bird's environment can shape and modify its behavior. Black-legged kittiwakes are much more abundant and widespread than are their red-legged relatives, and we will focus on them, although much of what is discussed applies to both species.

Black-legged kittiwakes nest in cliff colonies whose size ranges from a few dozen birds to hundreds of thousands. The gulls seem to select the narrowest ledges on a cliff face, sometimes no wider than four inches (10 cm), and to add to the challenge, the ledges are often sloped. On a cliff in the Bering Sea, I measured some nesting ledges that were sloped more than 60 degrees. By choosing such sites, the kittiwakes diminish the competition with other cliff-nesting seabirds, such as murres and fulmars, which prefer wider, flat ledges. The small ledges are also less accessible to red and arctic foxes, so the kittiwake loses fewer eggs and chicks to the nimble-footed predators.

The meager ledges used by kittiwakes demand that they build elaborate nests to hold their eggs safely. The typical ground-nesting gull builds a shallow cup of loose grass and twigs. A kittiwake's nest, on the other hand, is a sturdy, deep cup of plastered mud, seaweed and other vegetation. The nests are quite large, averaging 18 inches (45 cm) in diameter, and they vary considerably in height. Some arctic kittiwake nests are more than three feet (1 m) high. Researcher Dr. Bruce Lyon told me about a kittiwake nest that fell on a friend of his while they were climbing the cliffs of Bylot Island, at the mouth of Lancaster Sound, conducting seabird studies. The nest was teeming with worms, probably nematodes, he said, and was absolutely disgusting.

Kittiwakes are incurable kleptomaniacs that pilfer nesting materials at every opportunity. To protect against this, a kittiwake pair guards its nest continuously until the female begins to lay eggs. Ground-nesting gulls, alternatively, often leave their nests unattended for days until egg laying finally begins.

When they hatch, kittiwake chicks are covered with conspicuous gray-and-white down. Until they are almost big enough to fly, they sit

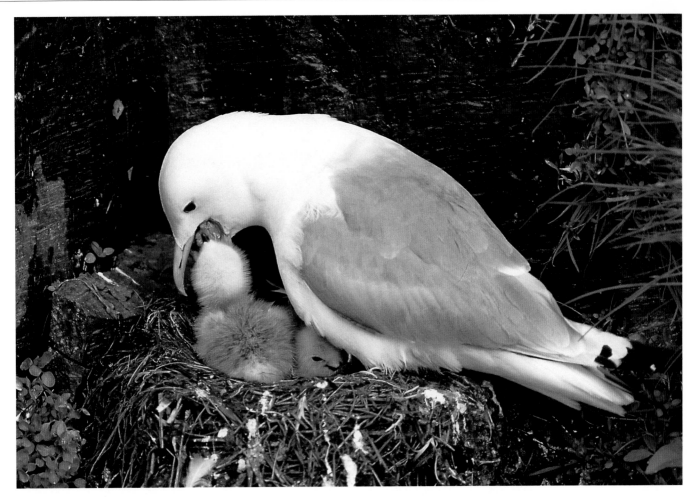

quietly in the nest, facing toward the cliff; any incautious step outside the nest is apt to be a long one. By contrast, ground-nesting gull chicks are cryptically colored and commonly wander away from the nest as soon as they are a few days old. If the adult gives an alarm call, the chicks run off in all directions, crouch and hide.

Ground-nesting gulls worry about their nests being located by predators; kittiwakes do not. For this reason, ground nesters defecate away from the nest, while kittiwakes just back up to the edge and let things fly, painting the nest, adjacent cliff and neighbors with a slurry of whitewash. The same concern over nest detection causes ground nesters to remove eggshells as soon as the chicks hatch, while kittiwakes leave the empty shells lying around, and they are eventually trampled into the nest.

All gulls feed their chicks by regurgitation. Once again, the behavior of kittiwakes is different from that of other gull species. Ground-nesting gulls regurgitate food onto the ground in front of their chicks, and the youngsters then pick it up. Kittiwake chicks take the food directly from

their parents' throats. That way, less of it falls into the sea and is wasted. Also, portions of slimy half-digested fish spilled onto the floor of a kittiwake's nest would quickly become soiled and rotten. Since kittiwakes live in a more restricted space than ground-nesting gulls, they need to keep things cleaner.

Unlike ground-nesting gulls, kittiwake parents cannot recognize their own chicks, and consequently, they will feed any chick in the nest. Inquisitive biologists have substituted older and younger chicks, and all were accepted. One pair of energetic kittiwakes even adopted a gargantuan snake-necked, black-feathered cormorant chick and fed it to fledging.

At first glance, moving from a ground nest to the ledge of a cliff might appear to be a fairly easy transition for a bird, requiring relatively few adjustments in its behavior. The marked differences seen in the behavior of the black-legged kittiwake when compared with that of other gulls demonstrate how seemingly insignificant changes can drastically affect the life of a bird and how it copes with its environment.

A black-legged kittiwake chick feeds directly from its parent's beak, an uncommon behavior in gulls.

L

The four northern bears —American black bear, brown bear, polar bear and Asiatic black bear— are the only mammals that give birth while they are hibernating. For this reason, bear cubs are exceptionally tiny at birth, most weighing less than 1½ pounds (680 g). The American black bear cub pictured here is 6 to 8 weeks old.

Labrador

Labrador is the mainland section of the province of Newfoundland on the eastern edge of Canada. Most of Labrador is cloaked in forests of tamarack, spruce and poplar, etched by rivers and pockmarked with myriad lakes and bogs. Only the northern triangular tip penetrates the tree line and enters the Arctic. This is the territory of the Torngats, the highest, most rugged mountains in eastern North America. Some think this is one of the world's most beautiful wilderness coastlines, defined by countless fjords and graced by flotillas of passing icebergs. Its scenic splendor aside, arctic Labrador has the same cast of northern characters as do many other regions of the Arctic and would seem no different, except for one thing: Here, black bears have taken over the tundra.

Up until the mid-1800s, a small population of grizzly bears ruled the tundra of northern Labrador and the nearby Ungava Peninsula of Quebec. Regrettably, the great bears disappeared soon afterward, probably from overhunting, and the tundra was left without a monarch. Then, in the 1950s, black bears in Ungava began to venture beyond the tree line in increasing numbers. In 1967, for example, a black bear was seen on the tundra near Povungnituk, about 200 miles (320 km) north of the trees. In the past seven or eight years, there have been many sightings of black bears in the Torngat Mountains, hundreds of miles beyond the tree line. Now that the grizzly is gone, the black bear has come north to rule.

The arctic bruin of Labrador is different from most other black bears. First of all, it's smaller. Adult males average around 220 pounds (100 kg), and the lightweight females are only 132 pounds (60 kg). Compare that with black bears in nearby Newfoundland, where the males and females average 300 (136 kg) and 200 pounds (90 kg), respectively, with a number of bears over 500 pounds (227 kg). The arctic blacks are probably smaller because they have less to eat.

What they eat is also different from the diet of most of their kind. The Labrador black bears dig up rodents, grizzly-style, prey on adult caribou and calves and even venture onto the sea ice to feed on ringed seals.

To find enough food, these adaptable carnivores must tread over great tracts of tundra. Adult males commonly cover 200 to 400 square miles (500-1,000 km²). Most male black bears elsewhere are using less than 80 square miles (200 km²), and many less than 40 square miles (100 km²).

Nothing is ordinary about these bears. Once they enter their winter dens in early October, most won't emerge again until the first half of May, and some may delay until early June. That's over seven months of denning—almost a record. It's two to three times longer than many southern black bears and one of the longest denning periods of any of the northern blacks. Only black bears in Alaska are known to den occasionally for a longer time.

Many animals living on the edge of the range of their species continually test new habitats, attempting to colonize where they may never have lived before. It is in these situations where the greatest changes in an animal's behavior can occur. Such situations also offer an opportunity to observe how flexible and adaptable many species of wildlife can be.

Lancaster Sound: A Wealth of Wildlife

Lancaster Sound, located 500 miles (800 km) north of the Arctic Circle, is possibly the richest wildlife area in the entire Canadian High Arctic. Situated between Devon and Baffin islands, Lancaster Sound is home to at least three million seabirds, mostly thick-billed murres, northern fulmars and black-legged kittiwakes, that crowd the ledges of huge nesting cliffs to capacity. The area is also an important habitat for polar bears and their prey, including ringed seals, bearded seals and Atlantic walruses. Add to this tens of thousands of beluga whales, hundreds of giant

Labrador Trivia

The offshore waters of the Labrador Sea flow southward, carrying so many icebergs that the area has been dubbed Iceberg Alley.

During the 1770s, 32 polar bears were seen fishing for Atlantic salmon in a single river in Labrador. This behavior, common in black bears and brown bears, has never been reported for polar bears anywhere else in the world.

Lancaster Sound straddles the 74-degree-north-latitude line, where the sun disappears for 60 days every winter. In the final weeks of autumn, the sun's low position on the horizon often produces vivid sunsets.

bowheads—the most endangered whale in the North—and pods of rare narwhals sporting six-foot-long (2 m) ivory tusks, and you have an arctic marine oasis like no other on Earth.

Lancaster Sound is rich in wildlife for at least two reasons. The strong ocean currents that flow through the area stir up nutrients; these, in turn, enrich the water and promote the growth of phytoplankton, which ultimately sustains the large populations of seabirds and marine mammals. Furthermore, when Lancaster Sound is largely choked with ice during the winter, a narrow lead of open water usually remains along its northern and southern edges. These persistent leads, as well as ice-free areas called polynyas, are vitally important to the survival of arctic wildlife, and it is here that it concentrates (see "Polynyas: Oases in the Arctic Ice").

Land Bridge to America

A land bridge is the general name given to any stretch of land that connects two major landmasses, most often two continents. For the Arctic, the most important land bridge was the

Bering Land Bridge, which connected Siberia to Alaska across the present-day Bering Sea. Today, the bridge is totally underwater, but at many different times during the past 50 million years, it was passable.

At the height of the last glaciation, for instance, so much of the Earth's water was frozen in glaciers that global sea levels dropped more than 325 feet (100 m). The water covering the land bridge disappeared, and in its place, a dry corridor of arctic grassland linked Asia and North America. For thousands of years, animals migrated between the two continents using this bridge of land.

Migrating west to Asia were ancestral horses and camels that later evolved into the zebras, wild asses, dromedaries and Bactrian camels of today. The migration in the opposite direction was far greater. From Asia came caribou, moose, wolves, bears, foxes, lemmings, ground squirrels and hares, to name just a few. Certainly the most important among the new Asian immigrants were the spear-wielding humans who followed the herds of game. The humans were important

not because they were superior to other animal immigrants but because their arrival in North America may have marked the end of so many Ice Age mammals. Mastodons, mammoths, giant ground sloths, horses, camels, saber-toothed cats and many others disappeared, possibly the victims of overhunting, according to one theory.

It is not clear exactly when humans first arrived in North America across the Bering Land Bridge, but they were definitely stalking the prairies of southern Canada by 12,000 years ago. Then, migrating south at an easy nine miles (15 km) per year, they could have reached Panama in just 600 years. In the time scale of the Earth, humankind moved from immigrant hunter to master of a continent practically overnight.

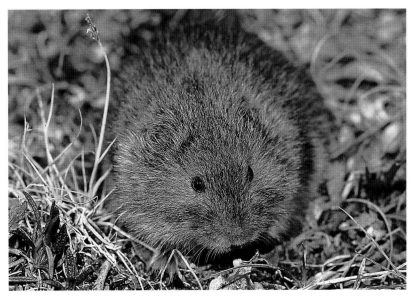

Lemmings

In North America, three species of lemmings are arctic specialists: the collared lemming (*Dicrostonyx groenlandicus*), the Ungava lemming (*D. hudsonius*) and the brown lemming (*Lemmus trimucronatus*). Of the three, the collared lemming occurs the farthest north, ranging to the top of Ellesmere Island, at 82 degrees north latitude, where it endures the longest winters of almost any land mammal on Earth. To survive such difficult arctic conditions, the collared lemming employs a couple of simple tactics.

The body shape most perfectly suited for heat conservation is the sphere, and the collared lemming comes as close to having that shape as any mammal. Nothing sticks out from its fat, rounded body. Its legs are short, its small ears are hidden in long fur, and it has next to nothing for a tail. Even with this ideal shape, the lemming still needs lots of insulation to protect it from the cold. It has long, bristly fur on the soles of its feet, and its winter coat is the densest of any rodent its size.

Lemmings do not hibernate. Active throughout the winter, they move to areas where the snowdrifts are deepest, excavating a network of tunnels to connect their winter nests with different feeding areas beneath the protective snow cover. Although the snow insulates the lemmings from the extremes of the arctic climate, the temperatures can still be very cold. For example, one collared lemming on Devon Island, at 75 degrees north latitude, had to contend with snowbank temperatures that plunged below minus 4 degrees F (–20°C) for 11 weeks. The dense winter coat of this small mammal helped to pro-

vide vital protection against such potentially lethal freezing temperatures.

The warm fur coat of the collared lemming is unique in another way. As the days of autumn shorten, the rotund rodent changes in color from summer brown to cryptic winter white, the only rodent in the world to do so. In former times, the Inuit name for the white lemming was *kilangmiutak*, which translates as "that which drops from the sky." Since the lemming's color change often coincided with the first snowstorms of the season, the indigenous peoples apparently believed the white lemmings fell from the sky with the snowflakes.

The one thing which most people know about lemmings is that their numbers fluctuate wildly between boom and bust. One year, it may be hard to find a single lemming; three to four years later, they are everywhere on the tundra, in densities as high as 160 per acre (400/ha). The following summer, they're gone again, their numbers crashing to less than a single lemming in two or three acres.

Scientists have labored for decades to determine the cause of lemming cycles. Some of the explanations have included overcrowding and social stress, poisoning by plant toxins, overkill by predators, parasites and disease epidemics—even sunspot activity. I can still remember a wildlife film I saw as a boy that showed lemmings swimming out into a lake to drown themselves and leaping to their deaths off the top of a cliff when the animals supposedly could no longer endure the overcrowded conditions of their world. In the 1950s, I guess committing

Brown and collared lemmings reduce competition by eating different foods. The brown lemming, seen here, feeds on grasses, sedges and mosses, while the collared lemming prefers wildflowers and willows.

Lemming Trivia

The habitat beneath the snow is called the subnivean environment.

71

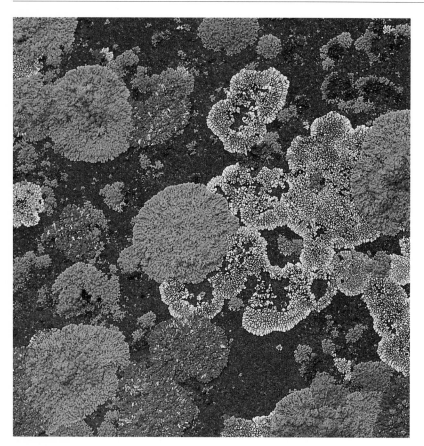

Half a dozen different kinds of lichens may grow on the same rock. Besides clinging to rocks of every shape and chemical composition, these tough, adaptable plants also settle on bark, bones, discarded antlers, old wood and metal artifacts; some even grow on dung.

suicide was an acceptable and understandable solution for the problems of a distressed lemming. Years later, I learned that the filmmaker had deliberately driven the lemmings off the cliff to their deaths to re-create what he believed was natural behavior. Today, even Disney knows lemmings are not suicidal, yet despite much research, the reasons for their dramatically mercurial life cycle remain largely a mystery.

Lichens

In high school biology, I learned that a lichen (pronounced LIKE-en, sometimes LITCH-en) was a partnership between two plants, one an alga and the other a fungus, and that neither plant could survive alone. I was told that the fungus provided a moist refuge where the chlorophyll-rich alga carried on photosynthesis and produced sugars which both plants then shared, and together, the two lived happily ever after.

Old stories die slowly, and this is one of them. It now appears that the algal cells inside a lichen are actually prisoners of the fungus, in a relationship biologists call controlled parasitism. The algae, which can grow perfectly well on their own, receive no benefit from the fungus. One lichenologist has described the plant as "the

union between a captive algal damsel and a tyrant fungal master."

Worldwide, there are roughly 20,000 kinds of lichens, nearly 1,000 of which grow in the North American Arctic, making them the dominant plant of the continent's northland. But even as the number-one player in the plant world, lichens are often overlooked. Carolus Linnaeus, the famous 18th-century Swedish taxonomist, called them "the poor trash of vegetation."

It's time to change the record. In addition to introducing welcome splashes of color throughout the arctic tundra, the hardy lichens are among the toughest and oldest plants on Earth.

Lichens are virtually indestructible. No place is too cold, too dry or too hot to keep them out. A French researcher once subjected a lichen to a temperature of minus 460 degrees F (–273°C)—absolute zero—and the plant survived. No place in the Arctic, or even in the entire universe, gets that cold, except perhaps the heart of a tax collector.

Being so tough, it's not surprising that individual lichens can live a long time. Some arctic lichens are thousands of years old. Individuals of such vintage share with other Methuselahs of the botanical world, such as the creosote bush (*Larrea tridentata*) of the American deserts and the bristlecone pine (*Pinus aristata*) of the southern Rockies, the distinction of having lived since the earliest days of human civilization.

We've conceded that lichens are seasoned and hardy, but what are their other contributions? First of all, lichens are colonizers. When an arctic glacier recedes, lichens are the first plants to return to the denuded terrain. By knowing how fast the plants grow, scientists can measure the size of the colonizing lichens and then estimate when a glacier disappeared. This is called the science of lichenometry, and it was used as early as 1960 in the Canadian Arctic Islands to date the disappearance of glaciers as far back as 5,000 years ago.

More relevant to us all, lichens are sensitive indicators of air quality. Being rootless, these plants take all of their moisture and nutrients from the air, and they are therefore sensitive to air pollution. For decades, scientists have monitored the health of lichens in order to track the effects of acid rain. But not until 1986 did lichens really move into the spotlight. That year, a nuclear reactor in Chernobyl, Ukraine, spewed a cloud

of radioactivity into the atmosphere. The cloud drifted over Scandinavia, where rain flushed its cargo of deadly cesium 137 out of the sky onto the lowly lichens of Lapland. Reindeer ate the contaminated lichens, as they have eaten lichens for millennia, and afterward, 70,000 animals had to be slaughtered because their meat had become tainted with high levels of radiation.

Eating lichens, however, is only rarely hazardous. None of the species in the Arctic are poisonous, although most of them contain acids that must be leached out by boiling. Throughout the history of Canada's Arctic, one group of edible lichens is mentioned time and again in the journals of explorers. They called it rock tripe (*Umbilicaria* spp), and it was eaten mostly as a last resort to stave off starvation. The desperate explorers rarely boiled the black, leathery lichens they tore from the rocks, and the acids in the plants gave the unfortunate men nausea and diarrhea.

Arctic Loon-acy

If you like loons, then the Arctic is the place for you. All five species of these handsome birds share the limelight in the warm glow of the midnight sun: the familiar necklaced common loon (*Gavia immer*), the look-alike Pacific and arctic loons (*G. pacifica* and *G. arctica*, respectively), the yellow-billed loon (*G. adamsii*), the largest one of the lot, and the red-throated loon (*G. stellata*), the runt of the bunch.

In Europe, bird watchers refer to loons by another common name, diver, and with good reason, for this is one of the things these northern birds do best. Using their large webbed feet, loons propel themselves underwater, while auks and penguins use their wings for this purpose. Because loons are foot-propelled divers, their legs are located as far to the rear of their bodies as possible. In this position, the feet and legs give the bird more power and maneuverability so that it can turn quickly when chasing fish and dive faster and deeper for its finned food. Befitting an accomplished diver, the wings of a loon are quite small; in fact, relative to their body weight, loons have the smallest wings of any group of flying birds.

While great for diving, such rear-positioned legs are extremely limiting on land. Only the small red-throated loon can actually stand upright; all the others must slide on their chests, shoving themselves along with their feet like a

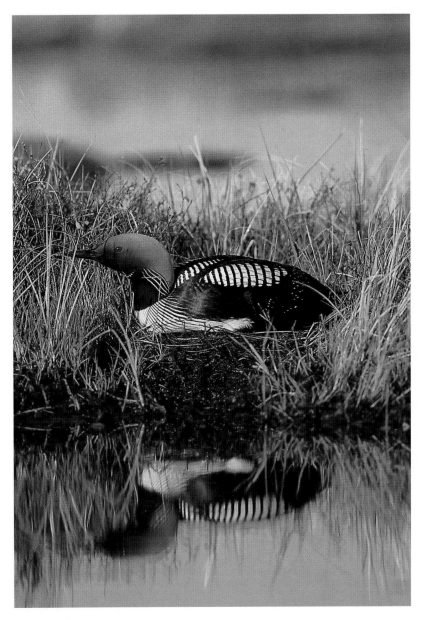

kid on a toboggan. The name loon was originally derived from an Old English word meaning lame, because of the awkward way these birds walk on land. This "lameness" explains why all loons build their nests as close to the water's edge as possible, keeping their strolls on land to a minimum.

The mournful wail of the common loon is familiar to almost everyone, and I suppose it should be, since Hollywood filmmakers seem to use it whenever they want to portray a sense of wilderness. For moviegoers who are also sticklers for accuracy, a problem emerges when the loon's beautiful call is heard in Southeast Asia, in the rainforests of the Amazon and in the nighttime deserts of Arizona—places where no self-respecting loon would ever be found.

One Pacific loon made 201 dives in 3 hours 25 minutes with only three pauses longer than a minute in length. The majority of the dives lasted 45 to 50 seconds. The deepest recorded dive by a common loon is 265 feet (80 m).

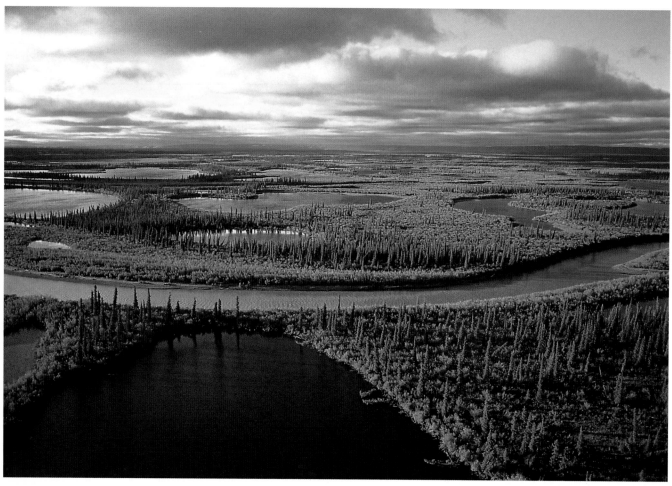

The long, meandering tree line comes closest to the Arctic Ocean as it cuts across the mighty delta of the Mackenzie River.

Mackenzie: The Mighty Waterway

In 1789, Alexander Mackenzie, then only 25 years old, led an expedition of a dozen men in three bark canoes down the vast northern waterway that now bears his name. The mighty Mackenzie River begins in Great Slave Lake and flows past forests of aspen, spruce and fir for roughly 1,050 miles (1,690 km) before finally emptying into the Arctic Ocean. If you follow the river back to its headwaters in the distant mountains of British Columbia, however, it becomes a waterway of far greater size and importance. Then, from start to finish, the Mackenzie is 2,635 miles (4,240 km) of wandering waterway, draining an area of wilderness almost as large as all of

Mexico. In North America, only the Mississippi River drains a larger area.

About 140 miles (225 km) from the end of its course, the giant Mackenzie seems to get impatient, and small rivers begin to branch off the main channel and follow their own course to the sea. These rivers twist and curve, branch and connect, creating a vast 4,600-square-mile (12,000 km^2) maze of islands and intertwining channels called the Mackenzie River Delta, a place where a summer paddler can choose between being eaten alive by mosquitoes or being lost and eaten alive by mosquitoes.

Despite the hungry hordes of insects, the delta is a haven for wildlife. Muskrats, beavers, grizzlies and moose are almost as thick as the mos-

quitoes floating in your coffee cup. In summer, thousands of belugas migrate from Alaska to the outer delta to give birth to their calves. The delta is also home to a dozen kinds of geese, ducks and swans as well as both golden and bald eagles. In fact, the Mackenzie Delta is one of the few areas in the Arctic where the bald eagle regularly nests.

Magnetic North Pole

Contrary to popular belief, the bobbing needle on a compass does not point to the North Pole at the top of our planet. Instead, the magnetized needle of every compass points to a spot on the map just off the northern coast of Bathurst Island at 76.5 degrees north latitude in the Canadian High Arctic. This invisible spot, known as the magnetic north pole, is actually 965 miles (1,550 km) *south* of the geographic North Pole.

To make the situation even more interesting, the position of the magnetic pole wanders just a little each year. When it was first discovered in 1831 by Scottish explorer James Clark Ross, the magnetic pole was 465 miles (750 km) farther south than it is today.

For these reasons, a compass is almost useless in the Arctic, and travelers must use other methods for direction. Today, everyone relies on a GPS (Global Positioning System) instrument that bounces a signal off satellites orbiting Earth and then gives the exact location to within roughly 100 yards (90 m).

There's worse news coming for all you compass owners. Every 450,000 years or so, on average, Earth completely reverses its polarity. In that event, a compass needle would then point directly south instead of north. The last time this happened was about 700,000 years ago, so the change is overdue. Stay tuned.

Migration

Animals in the Arctic cope with the rigors of winter in one of three main ways: They *fight* it, staring the season straight in the eye in the manner

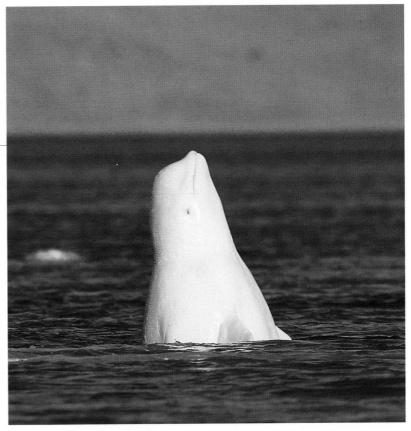

of the muskox, arctic hare and fox; they *hide*, either buried beneath an insulating mantle of snow, like a lemming or a pika, or curled deep in a den, hibernating as a marmot or a grizzly does; or they *flee*, using feathers, feet or fins.

To escape, arctic animals migrate, and their travel stories are as varied as they are.

The three arctic whales—the beluga, the narwhal and the bowhead—begin their retreat from the Arctic in early autumn, when permanent ice begins to form along the shorelines. The two smaller whales normally travel in groups, sometimes numbering in the hundreds. The larger bowhead is more often a solitary traveler, although with a single scan of my binoculars, I've counted as many as six bowheads traveling west in the Beaufort Sea in late September.

Of the three whales, the bowhead migrates the farthest to reach its wintering grounds. Bowhead whales from the Beaufort Sea, for example, flipper and fluke their way at least 5,600 miles (9,000 km) to reach the ice-free waters around the Aleutian and Kuril islands. Belugas and narwhals, on the other hand, stay farther north along the shifting and fragmented edge of the pack ice. Wintering belugas in the Bering Sea are usually sighted in areas with 70 to 90 percent ice cover. Some of these whales may also find sanctuary

After migrating north in spring, beluga whales gather by the hundreds at the mouths of shallow freshwater arctic rivers. There, they scratch their bodies on the gravel river bottoms, which may help them to molt their skin.

One of the earliest methods used to study the details of bird migration was counting migrants, such as these snow geese, as they flew across the illuminated face of the moon.

Beverly herd. In seven days, there was never a time when caribou could not be seen drifting gradually past. Although they stopped to graze and ruminate here and there, they were always slowly moving onward.

The caribou migration in autumn is slower and less direct, lacking the urgency of the northward race in spring to the calving grounds. At this time of year, the animals are fat and fit, and even though they can cover close to 40 miles (65 km) in a day, they often travel much shorter distances. For many, the migration will carry them over 500 miles (800 km), from the northern tundra to the protective fringe of the tree line where they will overwinter.

The migration routes of the great herds are not always the same from year to year. In the past, when caribou suddenly changed their autumn routes, the unsuccessful human hunters waiting for them often starved to death as a result. When viewed over thousands of years, however, the caribou have used their different routes time and again, wearing ruts into the tundra with their sharp-edged hooves. As a result, countless trails scar the Barren Lands, many of them visible from the air. I photographed one old set of trails that was actually worn into the bedrock.

The annual migrations of the Barren Lands caribou are one of the great animal movements in the Arctic. Even so, after decades of research, scientists still don't know why caribou choose a particular route or how they navigate over the flat, treeless tundra. Perhaps the Chipewyan people are right when they say that "no one knows the ways of the wind and the caribou."

Of all the Arctic's creatures, the birds undertake the most dramatic autumn migrations. Worldwide, I would estimate that 180 or so species fly north each summer for sex in the midnight sun. Of these, less than a dozen stay for the winter, and in many areas, it is difficult to find any bird other than a raven or a ptarmigan. Food is the issue, not the cold weather. Migrating birds leaving the Arctic may travel 60 miles (100 km) or 6,000 miles (9,650 km)—the length of the migration depends on where they find food. Virtually every bird that breeds in the Arctic could remain there for the winter provided they could find enough food to keep their body furnaces roaring. Since food is scarce, they must migrate, and the getaways they choose are not always that much warmer. Ptarmigan and redpolls, for

farther north in polynyas, areas of open water within the pack ice that remain ice-free throughout much of the winter. Seeking refuge there, however, can be a risky venture with the potential for tragedy for some wildlife (see "Polynyas: Oases in the Arctic Ice").

The caribou is the best known of the footed fugitives that flee from the Arctic each winter. Across mainland arctic Canada, two million or more caribou track the tundra. The animals are divided into roughly half a dozen large populations, whose members calve, migrate and overwinter together. These individual populations are referred to as herds, such as the Porcupine, Bluenose and Kaminuriak herds, and some may contain 400,000 caribou. When these herds migrate, they do it in a big way.

Caribou, unlike the wildebeests of Africa, do not sweep across the tundra in a vast continuous group. Rather, they migrate southward in a steady, leisurely trickle of small bands of animals, a few in this group, a dozen in that. One September, I camped at Damant Lake in the central Barren Lands on the migration path of the

example, may move only to the tree line, where the winters are just as long and cold as they are on the tundra. Arctic falcons, owls and hawks frequently escape no farther than the freezing windswept prairies.

Nevertheless, most arctic migrants still overfly winter, and they usually choose destinations in the warmth of the sun. In North America, arctic ducks, geese and swans overwinter in the southern United States, as do many sparrows and longspurs. The show-off shorebirds, though, really seem to overdo it. Most of them travel to South America.

One year, I journeyed to the High Arctic and then to the subantarctic within a four-month period. On the first trip, I watched an adult white-rumped sandpiper (*Calidris fuscicollis*) brood its chick against a sudden summer squall on Devon Island in the Canadian Arctic. A few months later, I photographed a flock of these same birds probing a mud flat in the Falkland Islands, 11,870 miles (19,100 km) away. What makes the migration of a white-rumped sandpiper even more amazing is that it travels the dis-

tance in just a few nonstop flights lasting up to 60 hours each and covering 2,500 miles (4,000 km) at a time—an impressive feat for a bird that weighs only 1½ ounces (45 g).

Mosquito Misery

The Thelon Game Sanctuary is a remote reserve in the Barren Lands of the Northwest Territories. On the migration route of half a million caribou, the sanctuary also offers habitat to muskoxen, grizzlies and arctic birds. What I remember most about the Thelon Game Sanctuary, however, is its mosquitoes—the largest squadron of blood-sucking insects I've ever battled. For 10 days, I inhaled mosquitoes with every breath, I swallowed them in every gulp of coffee, they seasoned my soup and my stew, and they challenged my courage every time I dropped my pants to relieve myself.

In Canada, there are reportedly 74 different kinds of mosquitoes, and much of the time, they drink plant nectar to survive. Luckily, only half of the mosquitoes—the females—have a taste for blood, and they use the nutrient-rich liquid to

A white-rumped sand-piper searches for insects in the cast-up seaweed on a beach in the Falk-land Islands, almost 12,000 miles (19,100 km) south of its arctic breed-ing grounds.

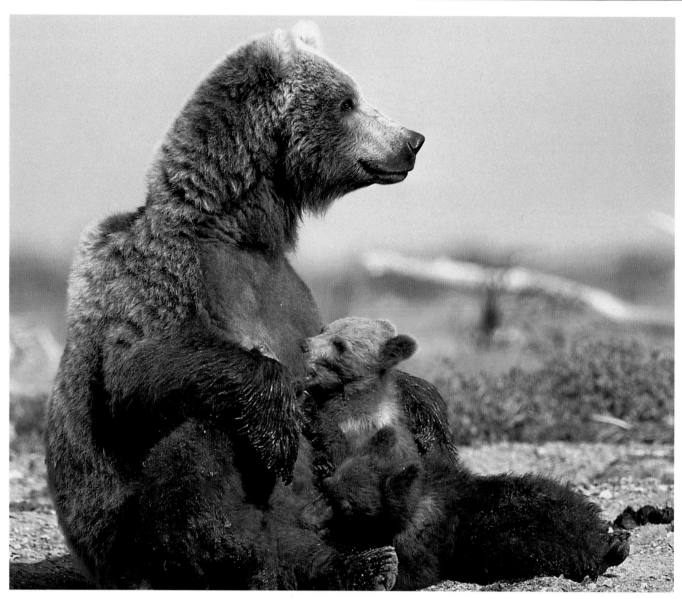

Typically, a mother grizzly nurses her cubs for about 10 minutes every three or four hours. At the height of the mosquito season, however, nursing sessions may be shortened to just a couple of minutes.

produce large batches of eggs. One writer suggests that if you pinch your skin where the mosquito is drinking, it will be unable to withdraw its mouthparts and so will keep drinking until it bursts. While I'm skeptical about the scientific accuracy of this method, it does sound like a satisfying way to get even with the bloodsucking little she-devils.

We all know how mosquitoes affect *our* lives when we are in the wilderness, but how do the hungry hordes affect wildlife? Bloodthirsty mosquitoes do not confine themselves to humans but hound everything from bears to birds.

In Alaska, a grizzly mother and her two cubs were observed daily during the July mosquito season. Anytime the bears were still for even a moment, the insects attacked the exposed skin on their nose and lips and around their eyes.

When the bears grazed on grasses, clouds of mosquitoes forced them to move at a fast walk. The mother bear nursed her cubs less often than usual because whenever she stopped, the insects bit her unmercifully, targeting the sensitive skin around her nipples. At times, the tormented cubs would break into a run, shaking their heads, and whenever the family rested, they always sought refuge on the few remaining patches of snow.

Polar bears along the western coast of Hudson Bay are also plagued by mosquitoes. In late July, when the last of the sea ice melts in the bay, the bears are forced ashore, where some dig deep earthen dens, up to 20 feet long (6 m), down to the cool permafrost. There, they are protected from the heat and the biting bugs.

Arctic waterfowl are also besieged by mosquitoes. The determined insects have been seen

crawling inside a cracked snow goose egg even before the gosling has broken free from the shell. When the wet gosling finally tumbles out, it is bitten repeatedly until its feathers dry out and fluff up enough to protect the little bird from the insects. At this point, the gosling turns the tables. Mosquitoes are an important source of nutrition for newly hatched waterfowl, and a young snow goose can snap up a mosquito every two or three seconds.

The arctic animal that seems most bothered by mosquitoes is the caribou. In spring, caribou leave the forests and migrate north to their calving areas. One reason they may do this is to avoid insect tormentors. Mosquitoes emerge a month later on the calving grounds than they do on the animals' wintering grounds. The extra month allows the caribou time to birth, nurse and bond with their calves before the blood-sucking swarms descend.

In the Arctic, mosquitoes can emerge explosively—millions of them in a single day. When this happens, the caribou that were spread out in small groups over hundreds of square miles suddenly clump together into enormous herds, sometimes containing tens of thousands of animals. The pestered animals snort and toss their heads, shake themselves and repeatedly flick their ears and tails as they trudge along facing into the wind.

Eventually, the humming hordes of biting insects are too much for the caribou, and a few of them begin to buck and run. The entire herd may then stampede. At the peak of the mosquito season, a herd may stampede a couple of times a day. Some animals are trampled during a stampede, calves may become separated from their mothers, and many caribou lose weight from the repeated exertion. When the weeks of mosquito madness finally end, the caribou have truly earned the cool, peaceful days of late summer.

Muktuk

A delicacy still eaten by indigenous peoples in many parts of the Arctic, muktuk is the thick skin and some of the underlying blubber layer from any of the three arctic whales: the bowhead, the beluga and the narwhal. The skin of these whales is six to eight times thicker than that of most other cetaceans and 100 times thicker than the skin of a typical land mammal.

Muktuk is either eaten raw when it is fresh or boiled and stored in plastic buckets. It "keeps" for about six to seven months before it becomes very strong-tasting. In Alaska and the Beaufort Sea, the people differentiate between the black muktuk from the bowhead whale and the white muktuk of the beluga; black muktuk is considered superior in taste and consistency. I've eaten fresh white muktuk, and the flavor was not objectionable, although it's definitely an acquired taste.

In 1991, researchers surveyed the households in the Inuit community of Aklavik, in the Mackenzie River Delta, to determine which foods the people liked and disliked and how important traditional foods were. Muktuk was preferred above all other foods except dried caribou meat. When asked about muktuk, one person replied that he had been "raised with it." Another admitted, "I can't live without it." One of the children questioned summed it up by saying simply, "It's fun to eat." Interestingly, the least-liked foods were white bread and wieners.

Narwhal: Arctic Unicorn

The popular way to kill an enemy in Europe some 700 years ago was with poison. At the time, commoners and kings alike were concerned about being poisoned, and it was believed that the horn of the unicorn was the only substance which, when dipped in food or drinks, could detect and destroy any poison that might have been added. If the horn turned black or the food bubbled or frothed, it was probably time to think about having something else for lunch.

The mythical unicorn was a horselike animal with a single spiral horn growing from its forehead. In reality, the unicorn never existed, but the spiral horn attributed to it was real, and it came from the head of an arctic whale, the narwhal (*Monodon monoceros*).

The Vikings were the first Europeans to see the mysterious narwhal (pronounced NARR-wall), which lives in the cold waters of the Norwegian, Canadian and Russian Arctic. The crafty Vikings kept the narwhal's identity and location a secret for more than 300 years. That way, they could charge more for its horn; people paid fortunes to acquire the spiral horn, believing that it came from the legendary unicorn.

Among whales, the narwhal is a lightweight, with adult males usually weighing less than 2,650 pounds (1,200 kg). The tusk on a large narwhal may be 8 feet (2.5 m) long, however, and

Muktuk Trivia

Gram for gram, muktuk contains more vitamin C than a lemon.

The heavy forehead bossing on the horns of a bull muskox help it to absorb the shock of the head-smashing battles that take place during the rutting season.

ice. Since blood vessels fill the center of the tusk, someone even speculated that the tusk might be used to eliminate excess body heat when the whale becomes overheated during spurts of fast swimming. Yet if any of these theories were true, female narwhals should likewise have tusks in order to perform these tasks.

As it turns out, the narwhal's tusk has the same function as do the horns on Dall's sheep and the antlers on caribou: they are a way for adult males to advertise their age and size to each other and to prospective mates. Two evenly matched males sometimes cross tusks and "fence" with one another. Consequently, male narwhals often have scars on their heads, and as many as 30 to 40 percent of them have broken tusks.

Many narwhals are killed each spring by Inuit hunters in the eastern Canadian Arctic. In 1994, the government quota for narwhals was 542 animals, although only 350 were harvested. The skin is eaten as muktuk, the flesh is used mainly as dog food, and the tusks are carved and sold to art collectors. In 1995, two uncarved tusks were sold as a pair for $2,782 (Cdn), roughly $217 per foot ($7/cm).

The North Pole

The North Pole has the shortest calendar of any location in the Arctic—there are only two days in the year, but each of them is six months long. For half the year, the sun just circles the sky, riding low on the horizon and sending long golden rays streaking across the roughened surface of the ice. Polar light has the warm color and the long shadows craved by photographers, and the rich glow lasts for months at a time, not merely for fleeting moments, as at the end of a Southern day.

Located near the center of the Arctic Ocean, the North Pole is some 450 miles (725 km) from the northernmost tip of Greenland. Although thick pack ice usually covers the Pole, the ice constantly drifts, fractures and refreezes, so at any given moment, there can be thin young ice or even open water in its place. At this point, the ocean floor is 13,400 feet (4,085 m) below the surface, one of the deepest spots in the entire Arctic Ocean. At the bottom, in perpetual darkness and cold, the soft, thick layer of ooze must surely be the most inhospitable place on Earth. Yet even here, arctic life thrives. Protozoans are abundant, and there are detritus-feeding worms and clams. But certainly one of the most bizarre

since the whale itself is usually less than 16 feet (5 m) in length, the tusk may be half as long as the whale's body. Only males have the famous spiral ivory tusk, which is actually an overgrown tooth that grows out of the left side of the animal's upper jaw. The narwhal has no other teeth besides the tusk, so when the whale catches the various fish, squid and shrimp that it normally eats, it either swallows them whole or gums them to death.

Many theories have been proposed to explain the purpose of the narwhal's unusual tusk. Some have suggested that it might be used to spear food or to stir up the ocean bottom in search of a meal. Others have said that it might be used as a weapon against sharks and killer whales or as an ice pick to open up breathing holes in the sea

creatures of the deep forgotten Pole has to be the pycnogonid, or sea spider.

The pycnogonid is not a spider at all, but it looks like one. Its small body is suspended above the soft mud by five or six pairs of long, bristly legs, spanning up to 24 inches (60 cm). The legs slowly finger their way across the bottom, searching for anything dead or alive. Pycnogonids are actually quite common animals that live at great depths in all the oceans of the world. Although many are drab in color, some of the deep-sea forms are bright red. Very little is known about the bottom-dwelling creatures of the Arctic Ocean. In an age when we eagerly probe the mysteries of distant planets, let's not forget that there is a compelling underwater realm to be explored here on Earth.

The Northwest Territories

Canada is the second largest nation in the world after Russia, and remarkably, one-third of this immense country is found within the vast borders of the Northwest Territories. Many things about the Northwest Territories are big besides its overall size. For instance, the Arctic Islands are the largest archipelago in the world; the Beverly herd of 500,000 caribou is the largest such herd in existence; the 65,000 muskoxen that roam the wilds of Banks Island are the greatest concentration of these woolly beasts found in any arctic nation; glacier-burdened Baffin Island is the fifth largest island in the world; and, finally, the Barren Lands of the Northwest Territories boast the greatest swarms of bloodsucking mosquitoes on the planet.

Wet sedge meadows, such as this one near Wager Bay, along the northwestern coast of Hudson Bay, are a common feeding area for phalaropes and other arctic-nesting shorebirds.

81

O

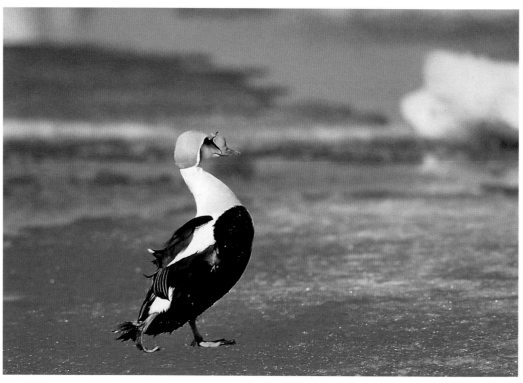

Thousands of seabirds died in Alaska when the Exxon Valdez *went aground in 1989 and leaked 11 million gallons (42 million L) of oil into Prince William Sound. An even greater nightmare would be a similar spill in the ice-choked waters of the Arctic, which would soil the breeding waters of king eiders and millions of other waterfowl and seabirds.*

Oil Beneath the Ice

According to a 1994 report from the National Energy Board of Canada, 25 percent of all the nation's recoverable light crude oil is located in the Beaufort Sea and the High Arctic Islands. Many experts predict that the recovery of this oil will be vital to Canada's economic future. At present, however, all the oil wells in the Beaufort Sea have been capped and temporarily abandoned, and there is just one well in operation on Cameron Island in the High Arctic, which produces only two tankerloads per year.

What everyone fears on the oil rigs of the Arctic is a blowout, something that occurs on a regular basis in every oil field in the world. If such an accident happened in the Arctic in late September, as the ice was forming, nothing could be done about it until the following summer. During those eight months, an average-sized blowout might pump 21 million gallons (80 million L) of crude oil into the cold, pure waters of the Arctic. If the blowout were a major one, two

to three times that amount of black goo could spread under the ice, contaminating the ocean for hundreds of square miles.

A tanker leak is another potential hazard of drilling and transporting oil in the Arctic. In March 1989, when the infamous *Exxon Valdez* plowed into a rock in Alaska's Prince William Sound, the gash in the tanker spewed 11 million gallons (42 million L) of oil that slicked and slimed over roughly 1,000 miles (1,600 km) of pristine coastline. Upwards of 300,000 seabirds perished, and 80 to 90 percent of the 4,000 sea otters living in the area also died as a result. The Alaskan disaster occurred in ice-free waters when clean-up operations could be undertaken immediately. A similar oil spill under the remote pack ice of the Arctic would be a catastrophe of even greater magnitude.

The effects of oil on seabirds are well known: the birds die. The main killers are the kidney, liver and lung diseases that result when the birds ingest or inhale toxins in the process of preen-

ing their soiled feathers. They also die from hypothermia. Oil destroys the insulating ability of feathers, and the birds rapidly lose body heat.

Seabirds live in Prince William Sound year-round, but few species overwinter in the Arctic. As a result, at certain times of the year, an oil spill in the Arctic might miss the seabirds, while such permanent residents as seals and polar bears would pay a profound price. When fouled with oil, ringed seals may develop a severe eye inflammation. If they swallow any of the oil, it can result in liver damage. Often, the eye and liver damage proves to be reversible, and the seals recover completely. Polar bears, on the other hand, are not so lucky.

Polar bears are clean animals, and they lick the oil from their fur when grooming themselves. The ingested oil poisons the bears, producing internal ulcers and hemorrhage, collapse of lung segments, anemia and kidney failure. The bears typically die within several weeks.

In addition to the direct effects of an oil spill on arctic wildlife, there is a potentially greater toll to be paid by victims from the indirect effects. The thick coating of algae that grows on the undersurface of the ice is the foundation of the marine arctic food web (see "Under the Ice"). Fouling by oil kills the plants, but we cannot yet gauge the repercussions throughout the ecosystem should an oil spill contaminate a large area of ice. What we can hope is that we won't have to learn these answers the hard way, but that may prove to be an unrealistic wish.

Oomingmak, The Bearded One

Inuit call the muskox *oomingmak*, a word that means the bearded one. These woolly beasts have always held a special appeal for me, mostly because they symbolize the wild and wonderful arctic tundra that I love so much. I have used the muskox (*Ovibos moschatus*) as a logo on my letterhead and business cards ever since I became a freelance photographer.

I've watched muskoxen at different times of

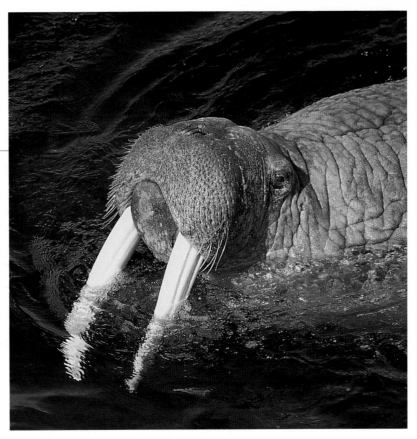

the year, but for my money, the best viewing takes place during the late-summer rutting season, in August and September, when big shaggy bulls bash their brains out in pursuit of sex. It begins when cow muskoxen come into heat and, for the first time in the season, allow an eager bull to nose around them, sniffing and licking their urine. Afterward, the bull usually lifts up his head and curls back his upper lip in the muskox version of a stupid smile. The scientific explanation for this so-called lip-curl is that the bull is intensely smelling the cow's urine, checking for the presence of hormones which will tell him whether or not the female is ovulating and ready to breed.

Every bull muskox wants to control and breed with a harem of cows, usually numbering fewer than 20. It's a fine strategy, until another bull muskox shows up and decides that he, too, wants to breed with these cows. Now the harem master must either fight or flee.

A challenging bull initiates an attempted takeover by slowly approaching the herd of cows. Often, he announces his intentions by issuing a deep bellowing sound that reminds me of the roaring of an African lion. (Interestingly, the word rut comes from a Latin word meaning to roar.) Veteran muskox researcher Dr. David

The whiskers on the upper part of a walrus's snout are shorter than those lower down. A walrus forages by rooting on the ocean floor, and its upper whiskers are subjected to the greatest amount of wear and tear.

A herd of muskoxen grazes leisurely on grasses and sedges on Banks Island, where over 60,000 of the animals live. Bull muskoxen commonly travel in bachelor herds of two to eight animals, as shown here. When the rut begins in August, a bull may leave his bachelor group to fight for a harem of females.

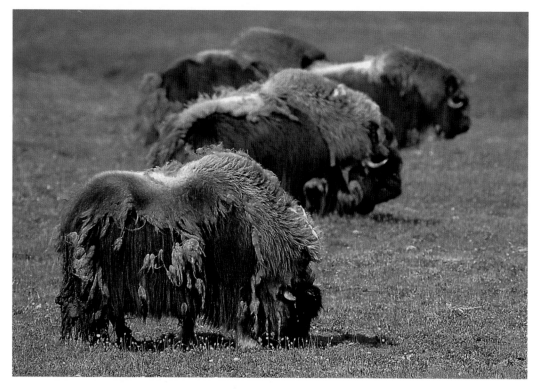

Owl Trivia

A snowy owl clutch of 14 eggs is the largest recorded for any arctic bird of prey.

Gray observed one bull challenger roar a total of 22 times. In response, the resident harem bull tore at the ground vigorously with his long, curved horns, digging up great clumps of tundra. He then bellowed an answer and walked out to meet the challenger.

When two bulls first meet, they usually parade around each other in an effort to show how big and powerful they are. They may butt heads a couple of times to test each other, just in case one of them is bluffing. Then the serious stuff begins.

The bulls face off and slowly back away, swinging their big heads from side to side as if they are winding themselves up. When they're about 150 feet (45 m) or so apart, they charge at a full gallop and collide with a head-smashing crack that can be heard 600 feet (180 m) away. The shock wave ripples through their fur, and they often hit each other so hard that their front legs lift off the ground from the force of the collision. Gray has estimated that the bulls may be galloping at 30 miles per hour (50 km/h) when they crash into each other.

As you would expect, the horns of a bull muskox are thickest over the animal's forehead, and underneath, its skull is also thickened. The thickened horns and skull cushion the collision and protect the muskox's brain from injury. You might be tempted to say that the muskox is the Arctic's original bonehead.

After the bulls collide, they stand and face each other for a few moments, almost as though they're pondering whether it was worth it and whether they should continue the battle. If the two combatants decide to give it another go, they back up once again. I've never seen a pair of bulls crack heads more than four times before one of them called it quits and fled, but Gray saw two evenly matched bulls clash 20 times in a row, with the first 10 head-on collisions occurring once a minute. The winner of all these battles gets the headaches and the harem, but the champion needs to get busy breeding. Chances are, there's another challenger on his way, and once he shows up, the head bashing will start all over again.

Owls Out to Lunch

The range of the snowy owl (*Nyctea scandiaca*) stretches from the bottom to the top of the arctic lands in both Eurasia and North America. This handsome owl, with its piercing yellow eyes, is one of the largest and most powerful of its kind. Like most owls and other birds of prey, the male snowy owl is considerably smaller than his mate, weighing about three-quarters as much as she does, allowing the pair to hunt different-sized prey. This may tend to lessen the competition between them.

The snowy owl preys on lemmings, and in-

deed, the bird may eat three to five of the small furry rodents a day, consuming 600 to 1,600 of them in a single year. In a four-month summer nesting season, a pair of adult snowy owls and their brood of six to eight chicks may gulp down as many as 2,600 lemmings and still be hungry for more. Somehow, though, this four-pound (1.8 kg) owl, with its large, powerful feet and strong, sharpened talons, seems a little overarmed to tackle the lightweight lemming, which is a skimpy 2½ ounces (70 g). But lemming populations are as unreliable as arctic weather, and although some years the rodents are plentiful, other years they're scarcer than ptarmigan teeth, and the owls are forced to hunt different prey. That's when the heavy weaponry is called into play.

A photographer friend of mine, Mike Wotton, observed a snowy owl nest for over three weeks on Victoria Island, and he was a little taken aback by some of the prey items he saw arrive at the nest. Besides the standard lemmings, the owls killed an adult female king eider that would have weighed almost as much as the owl did, an oldsquaw duck and a 12-inch-long (30 cm) lake trout plucked from a nearby river.

When lemmings are scarce, snowy owls prey on ptarmigan, small geese, shorebirds and even arctic hares, which would present a definite challenge for the owl. On the Aleutian Islands, the seaside owls hunt fast-flying auks. There, almost 70 percent of their diet is composed of ancient murrelets. A similar taste for seabirds has been shown by snowy owls on Little Diomede Island, in the Bering Sea. I was told by a native living there that the adaptable owls prey on crested auklets, which breed on the island in the tens of thousands.

Many snowy owls migrate to the northern prairies for the winter, regularly to my home province of Alberta, and it's here that the great white owls have the biggest chance to flex their muscles. In winter, they hunt jackrabbits, grouse, ring-necked pheasants, ducks and grebes, and they're not above snatching an unsuspecting long-tailed weasel.

Attacking another predator that is armed with tooth and claw or beak and talon would seem a bit more risky, but the bold, beautiful owl does it nonetheless. There are reports of snowy owls killing arctic foxes and preying on peregrine falcons. Near Barrow, Alaska, I watched an adult snowy owl fly off with a short-eared owl in its

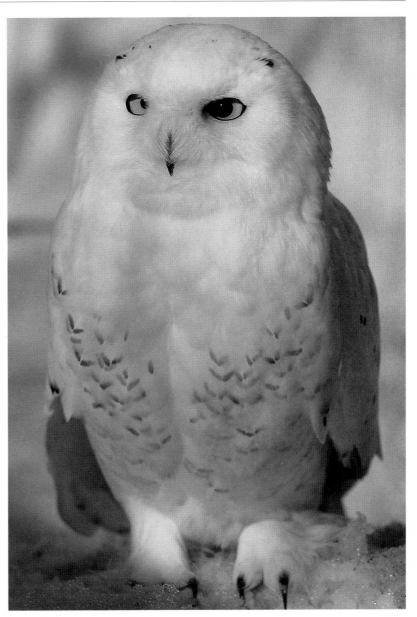

grasp. On the outskirts of Vancouver, overwintering snowies specialize in house cats.

With the snowy owl, you never know what to expect. My strangest sighting was of an adult female resting on a ridge of sea ice beside an open lead in Hudson Bay, about one mile (2 km) offshore. I couldn't stay to watch, but if I had, perhaps I would have been the first to see a snowy owl capture a seal. That's not as farfetched as it may sound. Recently, researchers in Norway's Svalbard Archipelago spotted a snowy owl feeding on a ringed seal pup out on the sea ice. The owl had transported the carcass from where the animal had been killed, so the researchers could not say for certain whether the owl had been the killer or had simply scavenged the remains from another predator.

The feathers on the face of a snowy owl extend almost to the tip of its beak, an adaptation to the cold winter temperatures in which the bird hunts.

85

P

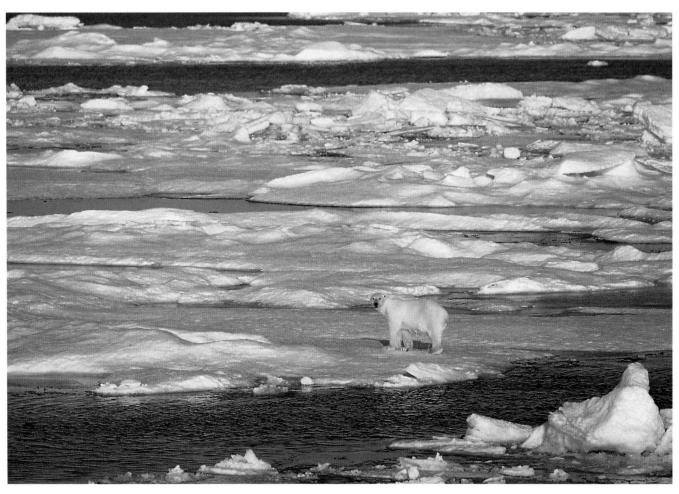

Pack ice, which covers 70 to 80 percent of the sea surface, is one of the hunting polar bear's preferred ice concentrations.

Pack Ice & Pressure Ridges

Much of the Arctic Basin remains frozen year-round. The multiyear pack ice found here is the oldest and thickest sea ice in the Arctic—some of it is 12 years old and 10 to 13 feet (3-4 m) thick. Unlike ice in a freshwater lake, pack ice moves. Driven by the wind and ocean currents, it drifts three to nine miles (5-15 km) per day, sometimes sailing along at 25 miles (40 km) per day. Such continuous movement causes the ice to fracture, and when large sections collide, the jumbled broken ice forms pressure ridges up to 50 feet (15 m) high and sometimes many miles long. Under the water, the ridges are three to four times the height they are above.

So much of the multiyear ice in the Arctic Basin has been worked over like this that pressure ridges now cover half of its entire surface. To anyone attempting to walk, ski or sled across the Arctic Basin to reach the North Pole, these vast fields of rough, broken pack ice are the greatest challenge.

Wildlife is also affected by the movements of the pack ice. The nurseries of most ice-whelping seals drift around wherever the pack ice carries them. One March, I saw a herd of several thousand harp seal pups and their mothers move 12 miles (20 km) one day, 9 miles (15 km) the next and 28 miles (45 km) the third day. The movement of the ice demands that mother seals be adept at underwater navigation and able to memorize the topography of the rough under-

surface of the ice so that they can relocate their breathing holes and their hungry pups.

Denning polar bears may get moved around even more than the whelping seals. In most areas of the Arctic, pregnant female polar bears dig their maternity dens on land, within 10 miles (16 km) or so of the coastline. The polar bears of the Beaufort Sea have a different strategy. There, 50 percent of the females dig dens in snowdrifts out on the shifting pack ice, up to 500 miles (800 km) offshore. The sea-ice bears enter their dens between mid-October and mid-December, emerging with their newborn cubs between early March and the end of April. During that time, the dens drift with the pack ice, moving an average 225 miles (360 km); one den studied actually traveled 620 miles (1,000 km). Drifting with the pack ice carries some risks for the denning females. One winter, six bears were swept past Barrow, Alaska, and into the Chukchi Sea. Because of unusually unstable ice, only one of the bears denned successfully.

Not all the pack ice is old ice that has thickened season after season. About one-quarter of it is young ice, known as annual ice, which is newly frozen each year. The annual ice begins to freeze in autumn, reaches its maximum thickness of three to six feet (1-2 m) in late winter, then melts again in the spring.

One of the most interesting aspects of the freezing process in sea ice is how the salt content changes dramatically with time. Unfrozen seawater contains about 35 parts per thousand (ppt) of salt. Once seawater freezes, the salt content drops immediately to 20 ppt; within a week, it falls to 10 ppt. As the water freezes, it excludes the salt from the crystal structure of the ice, and the salt becomes trapped in tiny pockets of brine. The brine pockets then coalesce and form channels that allow the salt to drain out through the bottom surface of the ice. After a year, the ice contains only 5 ppt of salt, but it still tastes salty. If the ice survives longer than two years, the salt content drops to 1 ppt. At this stage, it no longer

has a salty taste. The ice can be melted and is safe to drink—something Inuit hunters traveling on the sea ice have known for generations.

Peregrines in a Dive

The fast-flying peregrine (*Falco peregrinus*) shares the arctic skies with its larger relative, the gyrfalcon. Both falcons attack birds, but where possible, the gyr specializes in ptarmigan, while the peregrine seems to specialize in virtually anything that flies. The peregrine is a truly versatile aerial predator. At one time or another, this "bullet hawk" of the tundra sky has strafed and taloned every small and medium-sized bird known to the Arctic and many of the larger species as well, including arctic loons, snow

When a strong wind causes two fields of sea ice to collide, a pressure ridge such as this one can build to 26 feet (8 m) in height in a matter of an hour.

geese, brant, barnacle geese, even ravens and short-eared owls.

As British writer J.A. Baker observed: "[It is] the sudden passion and violence that peregrines flush from the sky that make these regal raptors so appealing," and indeed, it is the hunting style of the peregrine which has received more attention than any other aspect of the bird's biology. The peregrine hunts in one of two or three ways, the least dramatic of which is the sit-and-wait approach. With this strategy, the alert predator scans the countryside in all directions from an elevated perch. When it spots its potential victim, the peregrine dives and wings its way swiftly to within striking distance. Sometimes, it catches its quarry by surprise on the ground or flushes it at the final moment, ending the hunt with a glancing blow from its taloned feet.

Less often, the feathered target spots the plummeting peregrine, and a chase ensues. In level flight, few birds can outdistance the heart and power of a peregrine, which can muscle 60 miles per hour (100 km/h) from its strong, tapered wings. In a burst of brawn, the pursuing peregrine may swoop beneath its unfortunate prey, turn over and seize it from below. Of all its hunting tactics, the power dive, or stoop, epitomizes the height of peregrine prowess. It is this maneuver that has made the peregrine the glamor bird of falconers and has earned it the title "prince of birds."

In the classic stoop, the drama begins as the peregrine circles on rigid wings, quickly gaining height and vantage, soaring and searching. Suddenly, the bird noses over, tucks its wings and falls like a thunderbolt from the floor of the sky. The peregrine is the fastest bird on wings. As a boy, I was told that it can reach speeds in excess of 200 miles per hour (320 km/h). A German researcher measured a maximum speed of 175 miles per hour (280 km/h) when a peregrine dove at an angle of 30 degrees to the ground. The bird's velocity increased to 225 miles per hour (360 km/h) at an angle of 45 degrees. If you put pencil to paper, a bird the weight of a peregrine could theoretically plummet to Earth in a vertical stoop at a maximum speed of 235 to 250 miles per hour (380-400 km/h) from a height of 5,000 feet (1,525 m). One raptor biologist has vowed to settle the matter once and for all. He plans to use a radar gun, like those used by traffic police, to clock the speeding peregrines.

Plunging to Earth at the limits of avian flight, a peregrine strikes its victim for the briefest of moments. As a result, exactly *how* a peregrine kills is still a matter of some debate. Most experts agree that in the final seconds, the bird lowers its feet and throws them forward, striking its prey with partially closed feet and slashing it with the trailing rear talons. A high-velocity attack may decapitate the victim or sever its wing. When the prey is large, the falcon may only stun the bird, knocking it out of the air and leaving a cloud of feathers to mark the moment of impact. Other times, the peregrine may lock onto its prey and tumble to the ground with it.

If the victim is still alive, the falcon ends the ordeal with a lethal bite to the base of its skull using a specialized "tooth," called a tomial tooth, on the edge of its upper beak. The tomial tooth is used like a wedge to force apart the vertebrae, injuring or severing the spinal cord. This method of killing is unique to falcons. Peregrine researcher Dr. Tom Cade believes that this beak specialization allows the falcon to kill prey larger than it could otherwise tackle.

Permafrost

Underlying much of the Arctic is a layer of permanently frozen ground called permafrost, which may be more than 3,250 feet (1,000 m) deep in places. The presence of this frozen ground affects life in the Arctic in a number of different ways.

Each summer, the warmth of the sun thaws the top layer of the soil and melts the snow and ice that formed during the previous winter. The permafrost underneath this thawing layer acts like a barrier and prevents the meltwater from draining away underground. As a result, most of the water is trapped on the surface of the ground, where it soaks the tundra and settles in the numerous ponds and lakes so common to the Arctic.

It is the presence of permafrost that makes the Arctic as wet a place as it is, because the Arctic is, in effect, a cold desert that receives very little precipitation. Some parts of Canada's High Arctic Islands receive only three to four inches (7-10 cm) of precipitation a year, which is less than what falls on parts of the Sahara.

Permafrost influences the way people live in the Arctic as well. Today, homes in the North are typically built on top of three-foot-high (1 m) pilings sunk into the frozen ground. They do not

Peregrine Trivia

The adaptable bird-hunting peregrine, found on every continent but Antarctica, is the most widespread of the falcons.

have basements. The space under the house is then used as an outside storage area. If a house were built directly on top of the ground, as is done in the South, heat escaping through the floor of the house would melt the permafrost underneath, and the house would start to sink into the earth or tilt. Likewise, sewage and water pipes can't be buried underground either, so communities in the Arctic have elevated pipelines that run to all the houses.

Permafrost, though, is not all bad. To start with, it makes a handy inexpensive deep freezer. I once stayed with some scientists on Devon Island, in the High Arctic, who dug a hole into the permafrost to keep their food chilled and preserved during the warm summer months. On Little Diomede Island, in the Bering Sea, a native hunter showed me a supply of bearded-seal meat that he kept frozen in a similar natural freezer he had dug into the permafrost.

In fact, permafrost is such an effective deep freeze that many Ice Age mammals, including extinct horses, bison and the entire bodies of mammoths, have been found preserved in the frozen ground. In Siberia, there are probably thousands of woolly mammoths still buried in the permafrost. Recently, residents in that part of Russia have begun to search for the buried mammoths in hopes of recovering the animals' ivory tusks. Fossilized mammoth ivory now sells for

$60 (Cdn) per pound ($135/kg), a price tag equal to a month's wages for the impoverished people of Siberia.

Another case of permafrost preservation is even more astonishing. At the close of the last Ice Age in Yukon, some wild lupine seeds that had been stored in a neat little pile by a lemming were suddenly buried in a landslide. The seeds were uncovered from the permafrost during a mining operation in the 1950s, and a few years later, they were planted and watered to see whether they would grow. Amazingly, they sprouted into full-grown plants, no different from the blue-flowered lupines that grow in the Arctic today. The permafrost had preserved the seeds for possibly 13,000 years.

Phalaropes:
Those Liberated Ladies

The phalaropes are a trio of small shorebirds, two of which—the red-necked phalarope (*Phalaropus lobatus*) and the red phalarope (*P. fulicarius*)—nest in the Arctic. The third member of the trio, Wilson's phalarope (*P. tricolor*), nests in the prairies of North America. All three employ an unusual feeding technique: like a whirling dervish, a hungry phalarope spins rapidly around in a tight circle on the surface of the water. The spinning produces a miniature whirlpool that funnels insects and small aquatic invertebrates toward the surface, where they are

In the arctic-nesting red phalarope, the female does the courting and is larger and more brightly feathered than her mate—one of the rare examples of role reversal in the world of birds.

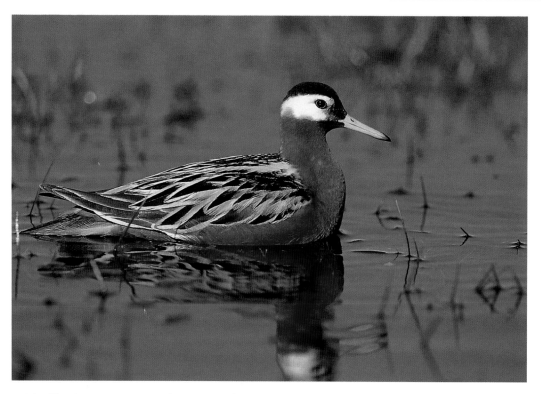

stabbed by the pirouetting predator. But its feeding habits are not the phalarope's only distinctive characteristic. Even more unusual is its mating behavior.

In general, shorebirds show the greatest variety of mating systems of any group of birds. Among them, a few species are monogamous for years at a time, but for many, fidelity is only a one-season phenomenon. Quite a few shorebirds are promiscuous. In some cases, philandering males breed in sequence or simultaneously with several females in a single season, and in other instances, it's the female that raises several families, each fathered by a different male. The phalaropes, however, carry the avian sexual revolution one step further: in these birds, the sexes have completely reversed their roles.

The liberated ladies of the phalarope clan are 13 percent larger than the males, and their plumage is more brightly colored and crisply outlined. When it comes to aggression, these female birds have what it takes. Typically, female phalaropes arrive on their arctic nesting grounds several days before the males. Females compete with each other for mates, and it is thought that the earlier-arriving females have, as a result, a greater chance of attracting and winning a male partner. In the words of biologist David Lank, "The early bird gets the sperm."

For more than a hundred years, observers have been aware of the fact that female phalaropes instigate all the courting, and 19th-century naturalists often described this unusual twist in behavior in colorful prose. In 1895, American biologist Daniel Elliot enthused:

"Early in May, [the red-necked phalarope] arrives at the breeding grounds, and the females commence to make love to the apparently indifferent males, using all the wiles and blandishments generally employed by one of the sterner sex (when bent on like purpose) to gain the favor and secure the affection of the object of its adoration."

In one study of red-necked phalaropes along the coast of Hudson Bay, researcher John Reynolds found that 17 percent of the female birds were unsuccessful in finding a mate, so it is not surprising that competition between the females can be quite intense. As he wrote in *Natural History*:

"Aerial chases with two or more female red-necked phalaropes noisily pursuing a harried male are common. They often culminate in violent fights, with females tumbling across land or water in a flurry of wings and dangling legs, jabbing each other with their bills. The combatant that gains the upper hand in these battles frequently covers the submissive male with her outstretched wings as she wards off the blows of the other females."

Courtship in phalaropes is typically a fast affair. A bond may form in as little as four hours; afterward, the female "jealously" guards her mate. Under her watchful eye, the male selects the nest site and lines the shallow depression on the tundra with fine grasses, pulling coarser grasses over the top of the nest as a protective canopy to conceal it from jaegers, foxes and other predators. Then it's the female's turn. Like all shorebirds, she lays four pear-shaped eggs. The male takes over once again, incubating the eggs alone with the use of two areas of bare skin called brood patches, which develop on his breast during the early stages of the nesting cycle.

Once the male begins to incubate the eggs, the female phalarope deserts him. She may then try to mate with a second unattached male or chase and harass a mated male that is already incubating a clutch of eggs. In this second instance, the perseverance of an aggressive female may cause the badgered male to abandon the nest or lose his eggs to a predator, in which case the female may be able to breed with him. More often, however, a mated female leaves the breeding grounds as soon as she has laid a clutch of eggs. In some areas of the Arctic, this may be as early as the last week of June or the first week of July. The female moves on to feeding areas, where she molts, then stokes up her fat reserves in preparation for the migration south. Her time in the Arctic is short and frantic.

Meanwhile, the male sits on his clutch of eggs for the 19 or 20 days it takes until they hatch. Young shorebirds of all species are precocious, and the four fluffy phalarope chicks leave the nest within hours of hatching. For the next three weeks or so, the male parent leads the young birds from one feeding area to the next, broods them when they get chilled, warns them with alarm calls when a predator is nearby and gathers them close to him when the danger has passed. Males with chicks constantly scan the sky for predators, and I once watched a male red phalarope react to a flying snowy owl more than a quarter of a mile (0.5 km) away.

Role reversal is extremely rare in birds, occurring in less than one-quarter of 1 percent of the Earth's more than 9,000 feathered species. Nevertheless, for the planet's three phalarope species, swapping gender roles is the only way to parent. It stands as yet another fascinating example of the adaptive flexibility of bird behavior.

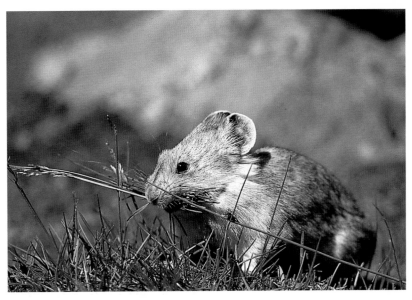

Pika: The Haymaker

When it comes to choosing a place to live, probably no other animal in the Arctic is as fussy as the collared pika (*Ochotona collaris*). Ranging across Yukon and central Alaska, the pika lives almost exclusively in isolated talus slopes formed by rock slides. The many cracks and crannies of such boulder fields offer refuge from predators, respite from heat, secure nesting sites and numerous food-storage areas.

Although the pika looks like a guinea pig, it's not a rodent at all but a lagomorph—the same family as hares and rabbits. The pika's family ties, as well as its choice of habitat, have earned it the popular name rock rabbit.

The pika is well suited to the chill of the North. In fact, it's remarkably sensitive to overheating—even a brief exposure to moderate temperatures in the range of 77 to 85 degrees F (25-30°C) can kill the animal. Since such temperatures may occur periodically in the Arctic, the cool depths within its jumble of boulders are vital to the pika's survival. During warm spells, the diurnal animal is active mainly in the cooler hours of early morning and late afternoon.

Like other lagomorphs, the pika does not hibernate during winter. But while hares and rabbits hop about on top of the snow, the pika hides beneath it, scooting along many of the same hidden passageways it uses during the summer. To prepare for winter, the pika assembles hay piles. Most talus slopes are flanked by areas of vegetation, and the rocky territory of every pika includes a block of this essential greenery. In late summer, the animal clips

A pika gathers a mouthful of sedges to store in a haystack in preparation for winter.

grasses, sedges and wildflowers and stacks the plants into piles among the rocks, making as many as 10 trips an hour.

Usually, a pika has one or two large haystacks, but some may have as many as five or six, each containing from 1 to 13 pounds (0.5-6 kg) of dried vegetation. Contrary to popular belief, a harvesting pika does not "cure" the hay it collects by purposely setting it in the sun to dry or by rotating it on the pile, but this may sometimes happen by chance.

Another common misperception is that these haystacks supply a pika with all the food it needs for the winter. But the haystacks are only a supplement to the animal's regular winter diet of lichens, roots, bark and other plant materials it finds under the snow. The haystacks may, in fact, act as an insurance policy against a particularly lengthy winter when the snow lingers longer than usual and delays the spring growth of new green plants.

Pingos: Pyramids on the Tundra

Pingo, an English word derived from the Inuktitut language, describes the cone-shaped hills that occur in areas of permanent permafrost in Siberia, Greenland, Alaska and Arctic Canada. By far the greatest number—more than 1,400—occur on the Tuktoyaktuk Peninsula near the mouth of the Mackenzie River in Canada's Northwest Territories. In this area, pingos even occur offshore on the bottom of the ocean, where they pose a hidden threat to passing ships.

Although no pingo is ever tall enough that it could be called a mountain, some rise 150 feet (45 m) above the surrounding tundra and are 985 feet (300 m) or more in diameter. No matter how big or small a pingo is, however, each one has a core of pure ice, and it is this heart of solid ice that distinguishes a pingo from an ordinary hill. The slopes of a pingo are often the only dry tundra for many miles around. Because of this, not only are pingos a fine place for a picnic on a sunny summer evening, but they also provide a breezy spot for a caribou or muskox to rest and good den sites for ground squirrels and foxes.

Plankton: The Ocean Drifters

Plankton does not boast the vivid colors of a male king eider, nor does it possess the grace of a swimming beluga whale or the power of a polar bear. In fact, without a microscope, you can't even *see* most types of plankton. Yet take away the plankton, and the rest of those arctic animals disappear as well.

The word plankton comes from the Greek word *planktos*, meaning to wander, and plant and animal plankton are indeed the wanderers and drifters of the sea, swept along by ocean currents for their entire lives.

Microscopic plant plankton, called phytoplankton, sit on the bottom level of the ocean food chain. If you want to build a polar bear, this is where you must begin. The amount of phytoplankton that can grow in a sample of water in a year determines how rich and nutritious an area of ocean is; that in turn determines how many animals such as fish, whales, seals and seabirds can live there. In this respect, the cold waters of the Arctic are the poorest in the world. Consider that over the course of a year, a sample of water in the Antarctic will grow 26 times more phytoplankton than the same amount of water in the Arctic. The difference is even more dramatic if you compare a sample of water from the Arctic Ocean with one from the Pacific Ocean, the richest ocean on Earth. The water of the Pacific produces 92 times more phytoplankton than that of the Arctic.

The reason the Arctic Ocean is so poor is simple: there is too much darkness and too much ice. Both of these factors reduce the total amount of sunlight that reaches the water in a year, and without sunlight, phytoplankton cannot grow.

The other half of the plankton team is animal plankton, or zooplankton. These tiny creatures are the second level in the ocean food chain, sometimes acting as grazers feeding on the phytoplankton, sometimes scavenging on the dead and dying and sometimes eating each other.

If you want to continue to build the polar bear, then zooplankton are the next ingredient. Each ingredient after this eats the one that came before it. Thus amphipods eat the zooplankton, then arctic cod eat the amphipods, and the seal eats the cod. At the end of the line, the polar bear eats the seal, and the building project is complete. Without the humble plankton, however, we could never have started to build the bear in the first place. As one botanist said half-jokingly: "I don't see why everyone gets so excited about a polar bear. After all, a polar bear is really just a whole lot of phytoplankton that's been shuffled around a little bit."

Pingo Trivia

Most pingos occur between 65 and 75 degrees north latitude.

Polynyas: Oases in the Arctic Ice

Polynya (pronounced pole-IN-yaa) is a Russian word for an area of open water that is surrounded by sea ice. In the Arctic, there are only a few dozen polynyas, representing just 3 to 4 percent of the Arctic Ocean's surface, yet these areas are crucial to the survival of northern wildlife. Polynyas are often compared to tropical coral reefs and palm-fringed water holes in the desert, because all are biological hot spots where wildlife concentrates.

Polynyas occur in roughly the same location every winter, although they may vary in size over the course of the season. Some of the smallest, such as the tiny hole at Cambridge Fjord off Baffin Island, may be just 300 feet (90 m) in diameter. Others can be much, much larger. North Water, located at the upper end of Baffin Bay, is the largest polynya in Canada, and possibly the world. The immense North Water may be up to 40,000 square miles (104,000 km²)— an area larger than Lake Superior.

Leads are often discussed at the same time as polynyas, since the only difference between

them is one of shape. A polynya is a nonlinear opening in the ice, while a lead is a linear opening, often paralleling the coastline. There are major leads around the entire perimeter of Hudson Bay and James Bay, as well as along the southern coast of Baffin Island and in the eastern Beaufort Sea. Another important lead rims the entire Arctic Ocean and has been called "the arctic ring of life" by Russian researcher Dr. Savva Uspenski to emphasize its vital role to polar wildlife.

One year in late April, I flew north over the sea ice by helicopter from the arctic community of Resolute, Northwest Territories. For two hours, I saw nothing but azure sky and white ice. The air temperature was minus 15 degrees F (–26°C), so I was completely surprised when we suddenly spotted open water ahead. It was the Baillie-Hamilton Polynya. A light veil of mist, called sea smoke, rose from the water. Walruses and bearded seals lounged along the edge of the ice, and the tracks of polar bears and arctic foxes crisscrossed the snow everywhere.

I wondered then what kept the water from

Alexandra Fjord, in eastern Ellesmere Island, is ice-free for less than two months of the year. Nearby Flagler Polynya offers an open-water refuge for resident seals and walruses.

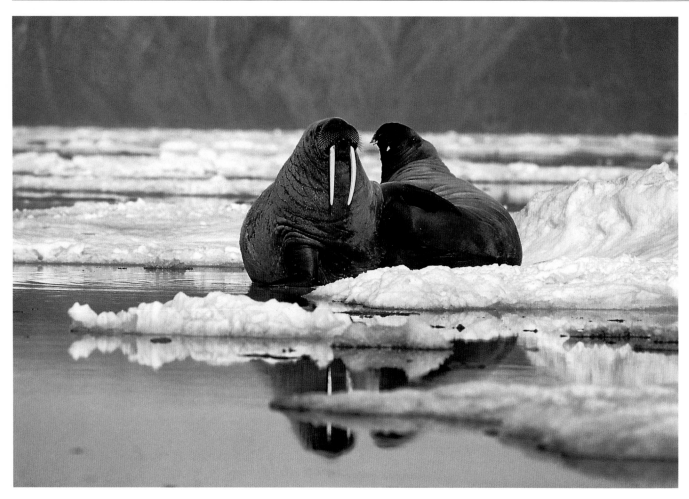

For a pair of walruses, hauling out onto a small piece of floating pack ice lessens the risk of being surprised by a stalking polar bear.

freezing despite the numbing cold. As I found out, the most common cause of such open water is wind. Strong winds skim off the new ice as soon as it forms, so a thick, permanent layer rarely has a chance to develop. Winds in North Water, for example, have been clocked at up to 85 miles per hour (140 km/h).

In some polynyas, strong currents prevent the water from freezing. Norwegian explorer Otto Sverdrup, who witnessed one such polynya —the Hell Gate-Cardigan Strait Polynya—in March 1900, wrote: "None of us had ever seen waters so utterly impossible to navigate as the sound here...great hummocks were drifting along at terrific speed in a violent whirlpool caused by the strong tidal current."

Polynyas and leads are important to arctic wildlife at different times of the year. In winter, the areas of open water attract walruses, bearded and ringed seals and the polar bears that prey on them. Most seabirds and sea ducks have fled south, and whales are generally absent at this time of year, although a few hundred belugas may overwinter in North Water. But the situation

changes dramatically with the return of spring.

In May, polynyas and leads lure migrating belugas, narwhals and bowheads into the ice-covered Arctic well in advance of summer. At the same time, waterfowl and seabirds funnel in by the millions. Among these feathered migrants are black-legged kittiwakes, thick-billed murres, northern fulmars, eiders and oldsquaws. For each, the Arctic represents a brief opportunity to raise a family, and the sooner the birds can begin to court and nest, the greater their chances to rear their young successfully. Polynyas and leads are crucial for these birds, because their presence enables the birds to occupy nesting cliffs many months before the sea ice finally melts. According to researchers Dr. Richard Brown and Dr. David Nettleship, these areas of open water are so important to arctic seabirds that "with one exception, there are no major seabird colonies in the Canadian Arctic that are not adjacent to recurring polynyas."

Occasionally, a polynya may freeze over, and the consequences to wildlife can be disastrous. When the Cape Bathurst Polynya in the Beaufort

Sea froze one spring, 100,000 migrating common and king eiders died. There was no open water when the birds arrived after their long migration flight from the Bering Sea, and they starved to death on the ice.

In 1979, Nettleship witnessed a similar tragedy in Lancaster Sound. That year, there was no open water until quite late in July. On nearby nesting cliffs, only 10 to 20 percent of the glaucous gulls, kittiwakes and fulmars attempted to breed. Many of the thick-billed murres bred nonetheless, but much later in the season than usual. As a result of the late start, most of the murre chicks died.

Disasters relating to the freezing of polynyas are not limited to the ducks and seabirds of the Arctic. In the winter of 1973-74, heavy ice conditions had a devastating impact on the seals and polar bears of the Beaufort Sea. In a single year, the number of ringed and bearded seals dropped by 50 percent, and they produced only one-tenth the normal number of pups. Polar bear declines lagged behind those of the seals. After two years, the bear population had dropped by one-third, and they produced only half as many cubs as usual. It took five years for the polar bear population to recover.

For generations, humans and wildlife have been associated with polynyas. Several summers ago, I explored Skraeling Island along the eastern coast of Ellesmere Island, near the edge of North Water. There, I found the ruins of over two dozen whalebone houses, as well as food caches, tent rings and stone kayak racks. The remains were those of Thule Eskimos. Archaeologists have found many early native settlements located near polynyas, some of them dating back 3,000 years.

Pturncoat Ptarmigan

For 14 years, I have traveled to Churchill, Manitoba, every October to observe and photograph polar bears. Although the bears are the main reason for my trips, I always enjoy watching the other wildlife in the area, especially the rock ptarmigan (*Lagopus mutus*) and the willow ptarmigan (*L. lagopus*).

When I arrive in Churchill, the feathers of the ptarmigan (pronounced TAR-mi-gen) are mostly white, with just a few scattered brown feathers remaining from their summer plumage. When there is snow on the ground, the birds' white feathers blend well with the background, and they are quite difficult to see. If it hasn't snowed yet, the birds are easy to spot even hundreds of yards away. Most people think that snowfall is the signal for ptarmigan to change their feathers, but that is not the case.

As autumn turns to winter, the hours of daylight grow shorter. It is the decreasing number of daylight hours that signals the birds to shed their brown feathers and replace them with white ones. Neither the temperature nor the snowfall affects the timing of this, which explains why ptarmigan may turn white before it has snowed.

Once the winter is over, ptarmigan molt a second time, replacing most of their white feathers with more camouflaged brown and gray ones. This time, it is the *increasing* number of daylight hours that acts as the signal.

The hours of daylight, known as the photoperiod, also control other important winter events in the life cycle of ptarmigan, namely the sprouting of fluffy feathers on the feet and the growth of longer toenails. The feathered feet function like snowshoes, increasing the surface area of the feet by about four times, and the longer toenails are used to dig tunnels into the crusty snow, where the birds rest each day.

The photoperiod coordinates not only the molt of ptarmigan but also that of arctic hares, short-tailed weasels and arctic foxes. It regulates the timing of migration in birds, the growth and shedding of antlers in caribou and the hibernation of marmots and bears. The amount of daylight, in fact, is the most common cue used by all wildlife in the Arctic.

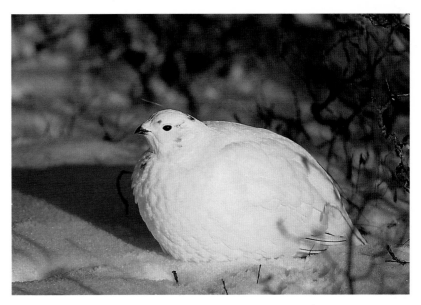

By late October, a willow ptarmigan has only a few brown feathers on its head and neck remaining from its summer plumage. The entire molt may take more than two months to complete.

Ptarmigan Trivia

The willow ptarmigan is the state bird of Alaska.

The rock ptarmigan winters farther north than any other land bird.

Rock and willow ptarmigan occur in every country rimming the Arctic Ocean.

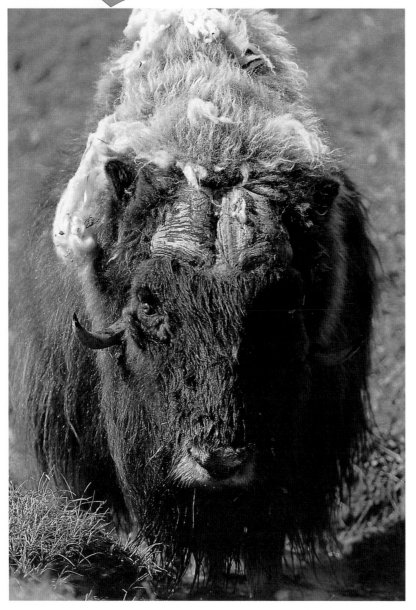

The soft underwool of a muskox's coat, called qiviut, may cling to the animal's shoulder hump throughout the winter.

Qiviut

Actually two coats in one, the shaggy coat of the muskox is made up of a thick undercoat of soft, fine wool called qiviut (pronounced KIV-ee-ute), which grows close to the animal's skin, and a heavier outer coat of coarse guard hairs, some of which are 25 inches (62 cm) long and almost reach the ground. Every summer, muskoxen shed the soft wool, and for a month or so, the animals wander about with a distinctly tattered appearance, great clumps of wool clinging to their outer coat. Eventually, the wool becomes snagged in willow bushes or blows loose in the wind. While small songbirds, such as snow buntings and longspurs, may gather bits of the soft, warm wool to line their nests, most of it goes unused.

In the mid-1960s, a small herd of Alaskan muskoxen was domesticated, and for the first time, it was possible to collect qiviut systematically rather than haphazardly gathering it from the tundra. Much softer than sheep's wool, qiviut is also reputed to be eight times warmer. Today, there are about 100 captive muskoxen on a farm near Anchorage, Alaska, and each adult animal produces between four and seven pounds (2-3 kg) of qiviut a year. The high-quality wool is spun into yarn and then used to knit expensive clothing. In 1995, a winter cap made of qiviut sold for $120 (U.S.), scarves cost $175 to $190 and a sleeveless tunic was priced at $450.

Ravens at Play

Although few scientists believe that animals play just for the fun of it, I've watched birds and mammals play on many different occasions, and I find it hard to believe that they *don't* sometimes play simply for sheer enjoyment. A number of more scientifically acceptable explanations have been proposed to explain why animals play.

When muscles are exercised during play, it helps to promote healthy bone growth. At the same time, play can be an opportunity to practice survival skills and to learn and refine social behavior. Play may also reinforce the bonds between partners and those between the members of a group.

The most playful birds belong to the corvid family, which includes ravens, crows, magpies, jays and nutcrackers. Among corvids, the common raven (*Corvus corax*), in particular, is known for its complex play, and the big, black, shiny birds will at times even play with other species. Sometimes, they include objects in

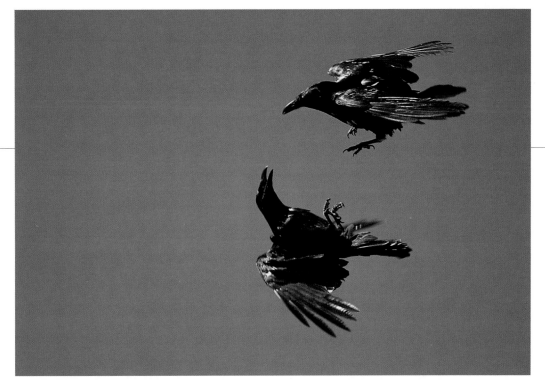

A raven momentarily rolls upside down to face its companion. This masterful stunt was part of a long aerial play session that included repeated swoops and rolls.

their aerial play. Most commonly, the birds carry twigs or branches aloft, drop them, then swoop down and catch them in midair.

There's a ridge near Yellowknife, Northwest Territories, from which I've watched ravens ride and roll in the updrafts over and over again. Researcher Dirk Van Vuren has seen these accomplished aerial acrobats in a similar situation. He observed that most of the time, the birds did a half roll, wherein they folded their wings, flipped upside down for a second or two, then opened their wings and rolled upright again. They might roll again and again, as often as 19 times in a row, sometimes rolling left, sometimes right. Three percent of the time, the ravens did a full roll; in a few instances, they even did a double roll.

Raven play doesn't always happen when the birds are on the wing. One summer in Inuvik, Northwest Territories, I watched a solitary raven that could easily have been auditioning for the circus. When I first noticed it, the bird was quietly perched on a telephone wire. Suddenly, it spun forward and dangled upside down on the wire with its wings outstretched. After a moment or so, it let go—first with one foot, then the other—and flew away.

One winter, a British researcher spied a raven engaged in a different sort of play. The bird was on a hillside and was fluttering in the snow as if it were bathing. It rolled onto its side, then its back. Because of the steepness of the slope, the bird began to slide headfirst down the hill, its feet straight up in the air. After gliding about 10 feet (3 m), it stopped, hopped back up the hill and tobogganed down the snowy slope three more times. Afterward, the bird's mate, which was perched nearby, flew over, joined in on the snow bath and then also slid down the hill on its back.

Another observer spotted a group of ravens cavorting in the snow. The amused onlooker watched as four common ravens took turns sliding down a snowbank feet first, riding on their tail feathers.

Ravens are one of the few animals to play with other species. Veteran wolf researcher Dr. David Mech described this scene in his classic book *The Wolf*:

"As the pack traveled across a harbor, a few wolves lingered to rest, and four or five accompanying ravens began to pester them. The birds would dive at the wolf's head or tail, and the wolf would duck and then leap at them. Sometimes the ravens chased the wolves, flying just above their heads, and once, a raven waddled to a resting wolf, pecked its tail and jumped aside as the wolf snapped at it. When the wolf retaliated by stalking the raven, the bird allowed it within a foot before arising. Then it landed a few feet beyond the wolf and repeated the prank."

Ravens have also been observed playing with brown bears. Young bears will chase just about any bird bold enough to land near them, but

Raven Trivia

The raven is the official bird emblem of Canada's Yukon Territory.

Many ravens live to be 20 years old. The record for old age goes to a bird that died at 69.

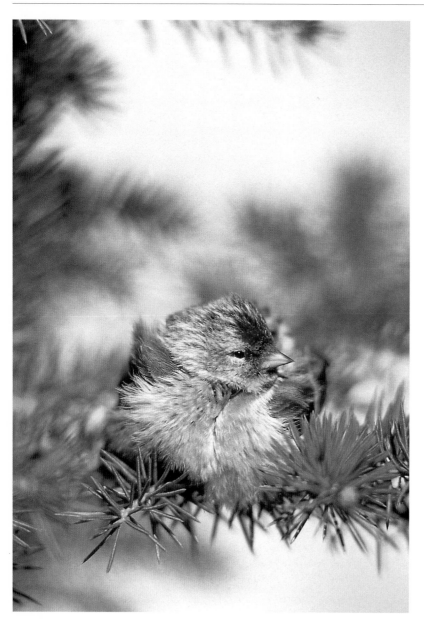

A common redpoll fluffs up its feathers to warm itself in the chill of an early-spring morning in the Arctic.

handle food, such behavior may prepare the birds to cope with different habitats.

Redpoll Nights

If you were to pluck all the feathers from a redpoll's body, the bird would be no larger than the end of your thumb. The common redpoll (*Carduelis flammea*) and the hoary redpoll (*C. hornemanni*) each weigh about half an ounce (14 g), making them the smallest birds or mammals to overwinter in the Arctic. Since small birds and mammals are particularly vulnerable to the cold and become chilled far more easily than larger species, how do these tiny finches keep from freezing to death during an arctic winter?

In winter, a redpoll increases the weight of its feathers by 31 percent. By fluffing out the feathers, and thereby trapping more air, the bird augments their insulating value by a further 30 to 50 percent. When a redpoll is roosting, it buries its head in its shoulder feathers to lessen the loss of body heat through its eyes and bill, both traditional heat-loss sites for birds. For the same reason, it tucks in its toothpick-sized legs and feet.

Birds are mainly daylight feeders, and the short days of winter test a bird, because there is less time to forage and food is often harder to find. The problem is even worse north of the Arctic Circle, where the sun may not rise at all for months at a time. Even in this situation, however, there still seems to be enough twilight each day to allow the redpoll and other daylight-dependent birds to find adequate food.

The shortage of daylight in winter naturally means that the nights are especially long. Because of this, a redpoll is forced to fast and to draw on its energy reserves for many hours every day. Maintaining enough energy to keep the fires of life burning can be the greatest challenge to the bird's survival.

The use of snow cavities at night is a well-known tactic employed by ptarmigan and other grouse to keep warm. The birds dig tunnels into the snow, where the temperatures may be 40 Fahrenheit degrees (22C°) warmer than the outside air. Russian researchers have found that redpolls may also spend their nights beneath the snow. The small birds use lemming tunnels or climb down the branches of willow shrubs until they are under the snow. They may stay hidden for 16 hours at a time, using the same refuge on several consecutive nights.

only ravens actually invite play. After a bear cub has chased a raven and forced it into the air, the bird frequently circles around and lands again nearby, taunting the bear into another round of chase-and-fly.

Why are ravens so playful? No one is certain, but part of the answer may lie in the birds' superior intelligence and their ability to learn. The famous animal behaviorist Konrad Lorenz called ravens "specialized nonspecialists." Because the birds are so clever and adaptable, they have managed to inhabit a great diversity of environments, ranging from arctic tundra to cactus deserts. The tendency for ravens to play may be simply another manifestation of the birds' behavioral flexibility. Since play in ravens often involves skills normally used to acquire and

Typically, redpolls travel in flocks in winter so that they have a ready supply of partners to huddle with at night. No one has examined how much they benefit from roosting together, but in the tiny European goldcrest (*Regulus regulus*), a bird smaller than the redpoll, pairs that huddled together at night reduced their individual heat loss by 23 percent, while trios lessened their losses by as much as 37 percent.

Another way to survive the energy drain of a long, cold night is to pack a lunch. Toward the end of the day, a foraging redpoll normally stores extra food, particularly birch seeds, in a specialized pouch in its esophagus. During the night, when the bird is roosting, it can regurgitate the seeds if it needs extra energy. Researchers found that once a redpoll had filled up on birch seeds, it could survive a night when the temperature dropped to minus 80 degrees F (−62°C). Without access to the calorie-rich seeds, however, the bird's limit was minus 22 degrees (−30°C). In fact, birch seeds are so crucial to the redpoll's survival that the winter distribution of this tough little bird closely matches the distribution of dwarf birches (*Betula* spp).

When food is scarce and the redpoll's energy reserves are depleted, this resourceful bird has one final strategy to help it get through the night. It chills out—literally. Birds normally maintain a body temperature of 104 degrees F (40°C), but it is costly to keep the heat turned up that high. In order to conserve energy, many birds lower their internal thermostats at night. The smaller the bird, the more energy it can save by cooling down and the quicker it is able to warm up again the next morning. The nighttime body temperature of a roosting redpoll may drop 18 Fahrenheit degrees (10C°), thereby earning the bird an energy saving of up to 30 percent.

One March, I traveled to the western coast of Hudson Bay with a biologist friend who was studying polar bears. The temperature that sunny day was minus 44 degrees F (−42°C), making it too cold for our helicopter to fly safely. While we were grounded, I went for a walk to pass some time, keeping an eye out for anything that might be bold enough to be moving about in the frigid temperatures. I was surprised to find a small flock of hoary redpolls twittering among the willows. I watched the birds for about five minutes before the intense cold drove me indoors. My outdoor-survival lesson was obvious: despite the sophistication of my arctic clothing, my ample abdominal fat reserves and the energy-rich chocolate bars stashed in my pocket, I was still no match for the tenacity and toughness of the tiny redpoll.

Reindeer Wrangling

Reindeer (*Rangifer tarandus tarandus*) are the domestic form of the free-roaming caribou. Since the two deer readily interbreed in the wild, they are considered to be simply different races of the same animal. The names, however, can be confusing. In the Scandinavian and Russian Arctics, the name caribou is rarely used. There, the people refer to the two animals as wild and domestic reindeer.

It's difficult to determine exactly when reindeer were first domesticated, but the event certainly happened in Eurasia, and it probably occurred thousands of years ago. At first, prehistoric hunters followed the migrating herds of wild reindeer, stalking the animals as they moved from one tundra area to the next. It would have been a relatively easy transition for the early hunters to shift from being strictly followers of reindeer to becoming herders. Once the animals grew accustomed to the presence of humans, the people would have been able to drive the reindeer in preferred directions, even scraping away the snow to help them find food more easily. Eventually, the animals would have become tame enough to confine, and once they had bred in captivity, the process of domestication would be complete.

Today, over a million domestic reindeer are herded in northern Scandinavia and northern Russia, and there is a sizable herd in the Canadian Arctic as well. For northern people, domestic reindeer play the same role in the Arctic as do cattle in the warmer climates of the South. As a result, wherever reindeer are raised, they are ridden, herded, harnessed to sleighs, saddled with packs, milked, eaten and skinned, their hides used for any number of purposes.

The tractable reindeer has been introduced to many regions of the Arctic, including Iceland, Greenland and Spitsbergen. I've even spotted them at the bottom end of the world on the remote island of South Georgia, off the coast of Antarctica, where they share the wind-battered landscape with boisterous elephant seals and throngs of trumpeting king penguins. Caribou

Reindeer Trivia

Traditionally, arctic peoples ate every part of the reindeer. The stomach contents are rich in B vitamins and carbohydrates, the soft ends of the bones are a source of phosphorus and calcium, the brain is rich in protein, fat and vitamin C, and the eyes contain vitamin A.

99

were never domesticated in North America. Even so, domestic reindeer were introduced a number of times to different areas, and one of my favorite arctic tales is the story of one such introduction.

By the close of the last century, trappers had decimated the native herds of caribou along the northern coast of Alaska and the nearby regions of Canada. The indigenous peoples of the Mackenzie River Delta were especially hard-hit. To alleviate the food shortages, the Canadian government decided to introduce reindeer to the area and turn the local hunters into herders. So in 1929, the government reached an agreement with the Lomen Reindeer Company of Alaska to supply 3,000 reindeer and to drive the animals from the Seward Peninsula in Alaska to the Mackenzie River Delta, a straight-line distance of no less than 750 miles (1,200 km). In the end, the reindeer drive took five summers and six winters to complete. The reindeer wranglers had to contend with fierce arctic blizzards, predatory wolves, impassable mountains and perpetually straying animals. When the herd finally arrived in the delta in the late spring of 1935, there were only 2,400 animals, 80 to 90 percent of which had been born on the trail. Within a month of their arrival, however, 800 calves were born, bringing the total to more than 3,000 and thus satisfying the terms of the delivery contract.

Today, the Canadian reindeer herd—descendants of the original reindeer driven from Alaska—numbers between 5,000 and 10,000; the exact number is a closely guarded secret. The animals belong to a single owner and are used mainly to supply antlers to the Asian medicine market. The racks are removed in July when they are still covered with velvet and engorged with blood. The antlers are then dried in kilns and sliced into thin wafers that can be chewed, fried or mixed into soups. Concoctions made from antlers are second only to ginseng as a purported restorative of body and mind, and they have been prescribed for a multitude of ailments, including impotence and loss of libido. No reliable scientific studies have ever shown that antlers contain any therapeutic ingredient.

Ringed Seal: Runt of the Bunch

A recurrent theme throughout this book is that small animals lose more body heat for their size than do large animals. Because of this, small animals are at a disadvantage in the Arctic and have had to develop a variety of strategies to level the playing field.

At 110 to 155 pounds (50-70 kg), the ringed seal (*Phoca hispida*) is roughly half the weight of other northern seals, easily making it the smallest seal in the Arctic. The five-foot-long (1.5 m) seal, like other diminutive northern species, manages the burden of being small by modifying its survival tactics. As a result, it behaves differently than do other arctic seals, using a separate area of the sea ice and, in winter, spending time in snow caves.

Typically, the ringed seal lives in the sea ice anchored to the coastline. This shore-fast strip of ice may be several miles wide, and it is a relatively stable and stationary platform compared with the offshore pack ice that fractures and drifts continuously throughout the winter (see "Pack Ice & Pressure Ridges"). The pack ice, where there is ample open water in which the animals can surface to breathe, is home to the other arctic seals. But the little *netsiq*, the ringed seal's Inuit name, is able to live in the shore-fast ice because, unlike the other seals, it can make its own breathing holes and therefore does not rely on the presence of naturally occurring open water.

With its sturdy front claws, the ringed seal is able to scratch holes through the ice. Each seal maintains a cluster of three or four breathing holes, usually within 330 feet (100 m) of each other, in ice as thick as 6½ feet (2 m) or more. Many breathing holes open under a snowdrift, where the seal can dig a cozy cave and haul out and rest, protected from the worst of the wind and the cold.

Many subnivean caves are quite roomy inside, up to 11½ feet (3.5 m) long and 8 feet (2.5 m) wide, although they usually have a fairly low ceiling, just a foot (30 cm) or so high. A snow cave not only shelters the adult seals but makes a relatively warm nursery, since the temperatures inside often hover around the freezing point.

Weighing only 11 pounds (5 kg), newborn ringed seals are the smallest pups of any true seal, and they have relatively little blubber to insulate them from the cold. The shelter provided by a snow cave is therefore more than a luxury for them—it's a necessity. Ringed seal pups also grow at a slower rate than other northern seals and nurse longer, commonly four to six weeks. Compare this with the harp seal pup, which is

Ringed Seal Trivia

Ringed seals are the most abundant arctic marine mammal, and because of that, early whalers called them floe rats.

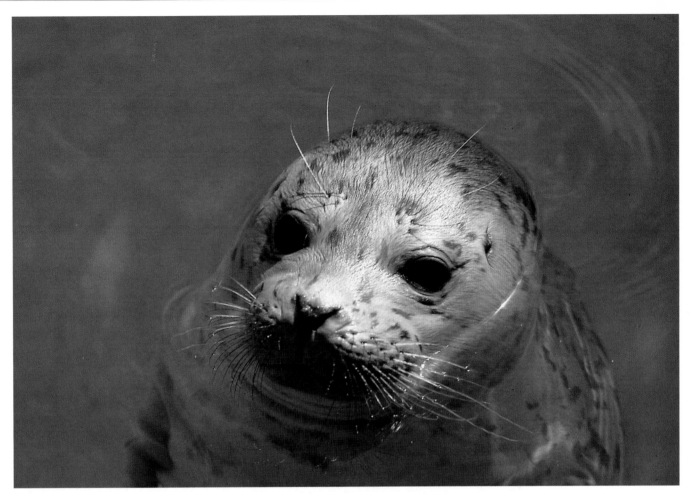

weaned after only 12 days, or with the young hooded seal, which nurses for just four days. Because the shore-fast ice is normally such a stable environment, the vulnerable ringed seal pup can suckle and grow in the shelter of its nursery cave for an extended period without the risk of the ice shifting and breaking up, thereby dumping it into the icy water.

A snow cave protects a ringed seal not only from the cold but also from the hungry. Ringed seal pups are born between late March and the middle of April, and in years when there is not enough snow, the small pups are born out in the open, where they are vulnerable to attacks by glaucous gulls or ravens. But even when hidden inside a snowy lair, a seal is not safe. In the Beaufort Sea, up to 45 percent of all newborn seal pups are sniffed and snuffed out by keen-nosed arctic foxes.

When it comes to predators, however, the ringed seal's greatest enemy is the polar bear. Researcher Dr. Ian Stirling believes that an experienced polar bear can not only detect the location of a snow cave with its sensitive nose but also determine whether the cave is occupied by a seal and whether that seal is a pup or an adult. Although a snow cave may be more than 11½ feet (3.5 m) long, Stirling has frequently watched bears break into a cave directly over the seal's breathing hole. He believes that such accuracy, based entirely on smell, is probably essential to hunting success.

Usually, a polar bear is able to crash through the ceiling of a ringed seal cave in a single pounce, but whether or not it accomplishes this feat depends on the weight of the bear and the depth of the snow. The hard-packed snow on the roof of some seal lairs may be five feet (1.5 m) thick, so it might take the bear several attempts to break through. In Lancaster Sound, I watched one small bear pounce seven times before the roof of the snow cave collapsed. Another time, I saw a juvenile bear climb up a pressure ridge and leap from the top to break through the ceiling of the lair. In both cases, the ringed seal managed to escape. At times like these, a ringed seal is fortunate to have one or more other snow caves in which it can seek refuge.

A seal requires vision both above and below the water, but the vision of the seals that have been studied seems primarily adapted for underwater. As a result, seals have large eyes that gather light in dim conditions yet have limited color vision and relatively poor acuity.

S

A cluster of black-and-white common murres crowds a small rocky ledge. When they are in the water, the contrasting feather pattern of these and other such seabirds may serve to camouflage them from predators. From above, the birds' black back feathers blend with the dark water beneath them, and from below, their white bellies make them less visible against the brightness of the sky.

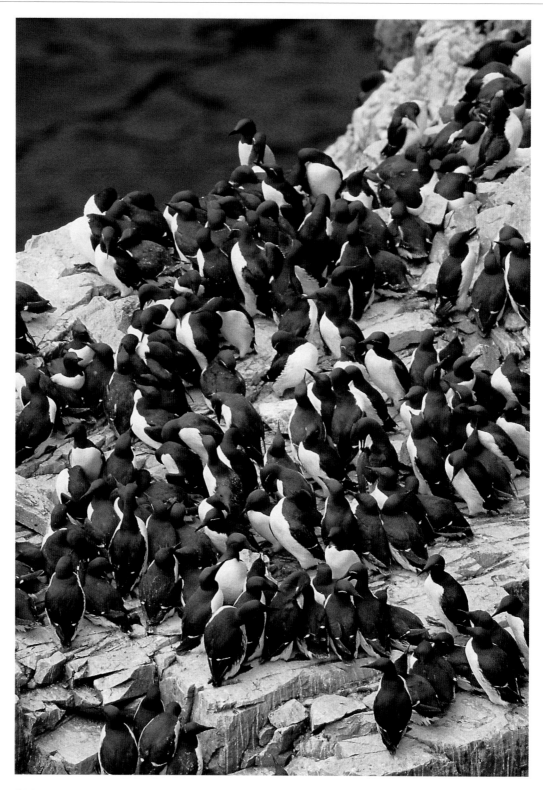

Seabird Subdivisions

Most seabirds love noisy, crowded neighborhoods, and these gregarious birds live in large, raucous colonies throughout the world. The Arctic is no exception and boasts many huge seabird colonies, a few of which include the 10,000 northern fulmars clustered on Cape Liddon, along the southern coast of Devon Island; the 29,000 screaming pairs of black-legged kittiwakes on Prince Leopold Island; the 250,000 thick-billed murres lining the ledges of Bylot Island, at the mouth of Lancaster Sound; and the 10 to 15 million tiny dovekies crowding the cliffs of the Thule region of northwestern Greenland.

Although many seabird colonies support great numbers of birds, the diversity of the avian tenants is relatively low, averaging between 10 and 15 species living together. In a number of places in the Bering Sea, I've seen 11 different kinds of seabirds cramming the cliffs of a single colony. With so many tenants vying for space, every nook and cranny, ledge and outcrop was occupied by a pinching beak with wings. Even so, the different types of seabirds were not scattered across the cliff face helter-skelter but were located in fairly predictable sites. A closer look at a hypothetical colony in the Bering Sea will illustrate how the seabirds in this area of the Arctic frequently divide up the space when conditions are crowded.

At the base of many seabird cliffs, there is often a jumble of large boulders and rocks. In the darkened cracks and crevices above the spray of the pounding surf, pigeon guillemots (*Cepphus columba*) shuffle in and lay their two eggs on the bare rock. The simple black-and-white plumage of these seabirds gets an instant visual boost whenever they take flight and their conspicuous crimson legs and feet are exposed.

Sharing the shadowed boulder maze with the guillemots may be the handsome crested auklet (*Aethia cristatella*), a bird with a stylish feathered topknot. The auklet usually nests quite close to the high-water mark. It shows an uncanny knack for estimating the height of the tide, and surprisingly few auklets get flooded out.

The first several ledges above the splash zone are usually taken over by the gangly-necked cormorants, either the pelagic (*Phalacrocorax pelagicus*) or the red-faced (*P. urile*). These long-beaked birds with the shiny black plumage squabble over the nesting sites on the lowest ledges because of their easy access from the water. A cormorant's wings are relatively small to begin with, and once the birds have been fishing for a while, their wing feathers become waterlogged as well. For these reasons, cormorants often monopolize the low-level landing spots on many nesting cliffs.

The greatest competition for space among seabirds occurs in the middle levels of a colony. The common murre (*Uria aalge*), one of the Arctic's penguin look-alikes, doesn't like to spread out much, so the loquacious birds cram together along level ledges, where they can bow and trumpet to each other and still remain wing to wing. When a group of these seabirds begins to bob in unison, they resemble a convention of old-time Chinese mandarins.

Black-legged kittiwakes (*Rissa tridactyla*) and red-legged kittiwakes (*R. brevirostris*) also show a preference for the middle levels of a nesting cliff. These gulls are master masons that have perfected the ability to cement their nests onto the smallest or most inclined ledges and onto the tops of the slimmest of rocky projections (see "Kittiwakes: Out on a Ledge"). Because kittiwakes can take advantage of so many different areas of a cliff, they have the greatest variety of nesting sites from which to choose.

Between the jostling throngs of kittiwakes and murres, still another seabird finds a place to settle in. The midsized parakeet auklet (*Cyclorrhynchus psittacula*), with its stubby, red parrot-like beak, finds its home by crawling into recesses in the cliffs. There, it cradles its single white egg away from the keen-eyed gaze of marauding gulls and ravens. Like a number of other arctic

Seabird Trivia

While only 15 percent of all birds live in colonies, 95 percent of seabirds do.

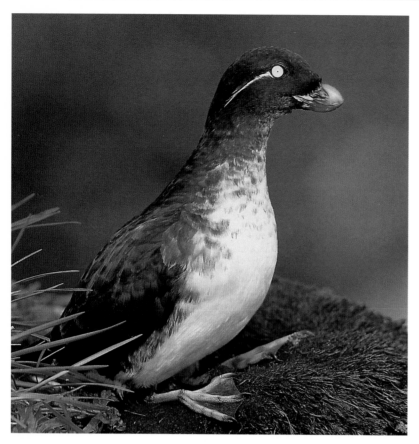

The parakeet auklet of the North Pacific has the well-chosen but tongue-twisting scientific name of Cyclorrhynchus psittacula, *which means the little parrot with the round beak. Although the bird belongs to the auk family, it might easily be mistaken for a parrot.*

seabirds, the fluffy chicks of the auklets launch themselves from their cliff-face nurseries well before they can fly, fluttering and floating down to the surface of the sea, which may be over 1,000 feet (300 m) below. Most of them land unharmed and are escorted away by their parents.

On the upper rim of a nesting cliff, the crowds tend to start thinning out. This section of the cliff is frequently covered with grass and turf, and here, the horned puffins (*Fratercula corniculata*) and tufted puffins (*F. cirrhata*) hold domain and dig their nesting burrows. Once the puffin chicks hatch, the parents bring a steady supply of fish to feed them. Most species of seabirds carry only one or two fish at a time. A big-beaked puffin may land on the lip of the cliff with more than 20 fish in its mouth. I still haven't figured out how a puffin can catch another fish without losing those it already has in its mouth.

On the top of our hypothetical nesting cliff are the last of the seabirds in the crowded colony: the glaucous-winged gulls (*Larus glaucescens*). Here, the tenants space themselves out on the level ground, often numbering no more than a couple of dozen pairs in all.

It's often said that seabirds nest in such large colonies because there is a limited number of nesting sites, so they must squeeze together. Sometimes, this is indeed the case, but there are other important reasons that seabirds like to crowd and cram.

Information sharing is one benefit. When food is as scattered and its location as unpredictable as fish commonly are in the Arctic, a few birds searching separately may easily miss them. When a group of seabirds is foraging over a large area, however, there is a much better chance that at least some of the birds will discover where the fish are schooling. Once they have done so, other members of the colony simply watch the direction taken by the birds that have found food and follow them to its source.

Large groups of seabirds are also more effective at detecting the approach of predators, confusing them with their numbers and distracting and sometimes mobbing them into retreat. A few seabirds on their own are much less successful at doing any of these things.

Finally, groups of seabirds seem better able to synchronize their breeding behavior, and the flurry of courtship calls and displays probably helps an individual bird come into final reproductive condition. This synchronization also means that the majority of chicks will hatch at roughly the same time, saturating the predators in the area and lessening the chances that any one particular individual chick will fall victim.

On the surface, seabird colonies appear to be largely characterized by an exciting confusion of activity, but in truth, a remarkable degree of order and design emerges from the apparent chaos. By watching the behavior of birds in many such colonies, I've discovered that nature has a seemingly endless capacity to remedy every situation and to take advantage of every opportunity. Of course, some people still conclude that a seabird colony is little more than a large, noisy collection of guano-squirting marine fowl. *Vive la différence!*

Sharks North of Sixty

The common image of the shark is one of a bloodthirsty predator with more teeth than brains and with cold, unblinking eyes imbued with the blank stare of death. Though dramatic, this image of the shark is more fiction than fact.

Worldwide, there are 344 different kinds of sharks. They range in size from the 8-inch (20 cm) dwarf shark (*Squaliolus laticaudis*) to the 60-

foot (18 m) whale shark (*Rhincodon typus*), the largest fish on Earth, weighing up to 88,000 pounds (40,000 kg). The whale shark cruises the Tropics sieving plankton and tiny fish with its cavernous mouth, and like so many of its kind, it could hardly be called a rapacious predator.

Virtually all sharks live in temperate and tropical waters, and only two species—the Greenland shark (*Somniosus microcephalus*) of the northern Atlantic and the Pacific sleeper shark (*S. pacificus*) of the Bering Sea—range into arctic latitudes. Both of these sharks are larger than average. The Pacific sleeper grows up to 12 feet (3.7 m) long and can weigh 800 pounds (365 kg). The Greenland shark may be twice as large as its Pacific relative, reaching a maximum of 21 feet (6.5 m) and 2,250 pounds (1,020 kg).

Both sharks are sluggish, slow-swimming deep-water predators that hunt the darkened depths of the ocean down to nearly 4,000 feet (1,220 m). Commonly, they prey on octopuses, fish, crabs and seals. They also have a taste for things dead and dying. Like so many sharks, the Greenland and Pacific sleeper can detect the faint presence of blood, and the arctic whalers of earlier times related many instances when these sharks swarmed in numbers to the bloody carcasses of butchered whales, tearing out chunks of flesh and feeding with such single-mindedness that beating them with clubs and stabbing them with lances could not drive them away.

Although most sharks are edible, the flesh of the Greenland shark is poisonous, an unusual trait that it shares with a few other tropical species. The toxin in the flesh of this northern shark has not yet been identified, although it may be ammonia. One intrepid Icelandic gourmand compared the experience of tasting the flesh to eating smelling salts. According to arctic expert Fred Bruemmer, Inuit dogs that eat fresh Greenland shark meat invariably become delirious and have diarrhea. If they eat too much of the meat, it can kill them. The toxin affects wild animals as well. Ravens picking at a fresh shark carcass have trouble flying afterward and squawk and flop around until the poison eventually wears off.

Despite this dangerous reputation, polar Inuit of the Thule region in Greenland have fished for sharks for centuries, feeding the meat to their sled dogs. Bruemmer explains that the meat is "cured" first, which makes all the difference: "They bury the flesh for a while, a month or two,

then mix the putrid meat, 50-50, with seal oil and blubber. It makes a pretty awful mess, but the dogs seem to love it."

Even today, modern Inuit of Baffin Island fish for Greenland sharks through a lead in the wintertime ice. Unlike walruses, seals and arctic whales, all of which store energy in the form of blubber wrapped around the outsides of their bodies, sharks store energy in their livers. The liver of a shark may occupy most of the animal's body cavity and constitute nearly one-quarter of its body weight. In a large Greenland shark, that's roughly 500 pounds (225 kg) of liver, more than half of which consists of valuable oil that is sold as a rich source of natural vitamin A.

I'm always excited to discover little-known facts relating to wildlife, and one of the best tidbits I have found about sharks was in the August 19, 1961, issue of the prestigious scientific journal *Nature*. In that issue, a researcher reported on the presence of an unusual parasite that had been found on the surface of the eyes of sharks from eastern Greenland.

The parasite, a copepod that looked like a whitish worm, would attach itself to the cornea of the shark with a small disk. Of 1,505 sharks examined, 84 percent of them were infested in both eyes, usually one copepod to each eye. Norwegian fishermen believe that this peculiar parasite benefits the shark in an unexpected way. The fishermen contend that the copepod is luminous, and when small fish swim over to investigate, they are scooped up by the shark.

Unfortunately, in the intervening years since this report was published, the theory of the Greenland shark and its helpful companion copepods has never been confirmed. Although I'm quite skeptical that such a relationship exists, farfetched theories and explanations abound in the natural world, and a surprising number of them turn out to be true.

Shorebird Beak-Fest

Nearly one-third of all the birds breeding in the Arctic—roughly 50 species—belong to the so-called shorebird group, which includes, among others, a mix of sandpipers, plovers, godwits, phalaropes and curlews. Most are rather plainly colored in buff, grays and browns, and although they differ greatly in size, the obvious difference between many of them is in the shape and length of their bills. The semipalmated plover

Shark Trivia

In the past, Inuit used the rows of the sharp lower teeth of the Greenland shark as knives for cutting hair.

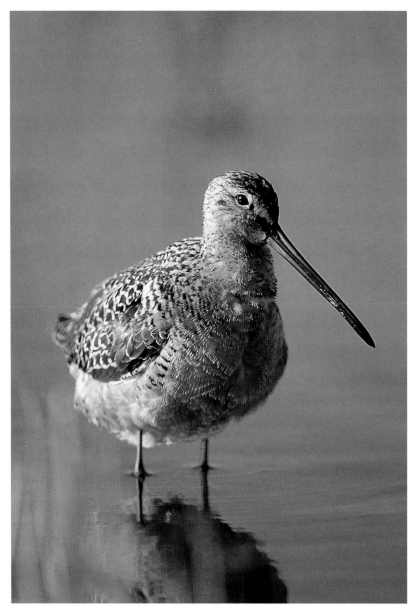

*At 2¾ inches (7 cm), the beak of the long-billed dowitcher (*Limnodromus scolopaceus) *is one of the longer bills to be found on an arctic shorebird.*

(*Charadrius semipalmatus*), for example, has a short, stout bill; the stilt sandpiper (*Calidris himantopus*) has a slender, pointed bill; the phalaropes (*Phalaropus* spp) are needle-nosed; the bar-tailed godwit (*Limosa lapponica*) has a long bill that turns upward; and the 3½-inch (9 cm) bill of the whimbrel (*Numenius phaeopus*) curves downward.

In my early years in the Arctic, I often wondered why these birds had such distinctly different bills, since they were found in roughly the same stretch of tundra (although, admittedly, some were in areas that were soggier than others). The explanation came to me in a most unusual location. I was boating in a mangrove swamp in northern Australia, searching for saltwater crocodiles. As the tide went out, large mud

flats were exposed, and scuttling across the mud were hundreds of shorebirds of several varieties, many of which I'd spotted in the Arctic.

Arctic shorebirds spend less than three months a year on their northern breeding grounds, so they are not actually birds of the Arctic at all; rather, they are birds of the tropic and temperate zones that honeymoon for a short time each year in the Arctic. For nine months of the year or more, these feathered wanderers are either migrating or recovering on their wintering grounds, and the habitats they choose in both of these cases are estuaries and shorelines, especially where there are extensive mud flats.

Mud flats are targeted by shorebirds because they can be extremely rich feeding grounds. Researchers examined an estuary in northern England to determine how much potential food there was for migrating shorebirds. In an average cubic yard (0.8 m³), they found 22,000 amphipods, 10 shore crabs, 132 clams, 596 ragworms, 128 lugworms and 47,000 snails. To top it off, in most intertidal areas, the number of invertebrates is highest in late summer and early autumn, just when the shorebirds are stopping to fuel up for their southward migrations. Clearly, the competition among shorebirds to harvest these mud flat areas has been one of the prime evolutionary forces influencing and shaping the varying designs of shorebird bills.

Let's take a closer look now at how some of these birds and their beaks share the shoreline. The big-eyed plovers hunt by sight, watching for invertebrates squirming on the surface and searching the tiny bubbly streams and dimples in the top layers of the mud that might be clues to a hidden burrow. These stylish birds with the relatively short bills are dash-and-stab predators, sprinting here and there across the mud flats.

Plovers also use a feeding technique called foot trembling, in which the hungry bird rapidly stomps on the wet mud with one of its feet. It is thought that this behavior may mimic the vibration of an incoming tide, fooling the invertebrates buried in the mud into moving and exposing their location.

The long, pointed bills of the sandpipers are ideally suited for probing the mud. And because their bills are of varying lengths and shapes (sometimes straight, sometimes curving upward or downward), the birds sample different levels of the mud and thus compete far less with each

other. Some of the sandpipers probe so rapidly that it is a difficult activity to follow with the eye. This feeding style, called stitching, is reminiscent of the action of a sewing machine needle and leaves multiple tiny holes in the mud.

Some of the larger birds with the longest bills, such as curlews and godwits, are able to probe to the deepest levels of the intertidal mud flats. Because these shorebirds can't see the invertebrates hidden three to four inches (7-10 cm) deep in the mud, they must "feel" their way around, using hundreds of sensitive touch receptors at the tips of their beaks.

Once these shorebirds locate a lugworm or a clam, how do they manage to open their beaks, which, in the case of the bar-tailed godwit, may be 4½ inches (12 cm) long and rammed up to its base in sticky mud? To get an idea of how much power it would take, jab a pair of sewing scissors into the mud and then try to open the blades. Shorebirds with long bills sidestep the problem. Through a feat of adaptive engineering, they are able to open just the tip of the bill while the rest remains closed. The bone inside the upper part of the beak slides forward, causing the tip to bend upward. *Voilà.* The bird pinches its prey in the movable tip, and out it comes.

The evolution of shorebird beaks has thus allowed a richer diversity of species to exploit the mud flat environment than would otherwise be possible were each bird to have a beak that was similar in length and shape. In fact, if there were only one type of shorebird beak, there might be only one type of shorebird stalking the mud flats. If you are a fan of invertebrates, of course, that would be a desirable scenario. Far fewer of these little animals would be caught and consumed, since an all-purpose generalized shorebird beak could not possibly probe, peck and filter as many levels of the mud.

Fortunately for bird lovers, there are dozens of shorebirds with dozens of different beaks, but they wreak havoc on the world of the invertebrate. In a six-week period at a migration stopover in Massachusetts, for example, the mixed-shorebird population removed up to 90 percent of the adult invertebrates that were burrowing and hiding in the mud, persuasive testimony to the workings of biodiversity.

Siberia: The Sleeping Giant

Siberia encompasses virtually all of Russia east of the Ural Mountains. From west to east, this vast land stretches well over 3,000 miles (5,000 km), bulging in its center to a width of 1,550 miles (2,500 km). At nearly five million square miles (13 million km²) in area, Siberia is 8½ times the size of Alaska and contains nearly the entire lengths of four of the largest rivers on Earth—the Amur, the Lena, the Ob' and the Yenisey.

Shorebird Trivia

More than 20 million shorebirds migrate to the North American Arctic every year.

Some migrating shorebirds, such as semipalmated sandpipers, sleep shoulder to shoulder in huge flocks that sometimes contain more than 100,000 birds, with 80 to 100 birds packed into every square yard (0.8 m²).

Much of Siberia is cloaked in a continuous forest of spruce, pine and larch. It holds the Asian stretch of the vast boreal forest that also cloaks the northlands of Scandinavia and cuts a great swath across the breadth of Canada and Alaska, completely encircling Earth like a "gigantic emerald crown." Only the most northern edge of Siberia lies beyond the tree line, where a belt of tundra separates the forests from the pack ice of the Arctic Ocean. This relatively narrow strip of tundra and the various clusters of offshore islands are Siberia's only contribution to the Arctic.

Siberia has always been notorious for its long, frigid winters. In fact, the modest town of Oimyakon, in eastern Siberia, has the distinction of being the coldest settlement on Earth, where winter temperatures can plunge to minus 94 degrees F (–70°C). Three guesses as to why the town's population is small.

During the Soviet regime, the isolation and climatic harshness of Siberia made it ideal as a place of forced exile for political dissidents and criminals. It was synonymous with deprivation, despair and desolation. Today, the covetous gaze of many Western nations is fixed on this sleeping giant. Siberia is a storehouse of riches. Its hinterlands hold enviable deposits of petroleum and natural gas, diamonds, gold and timber, all of which have companies scrambling to get their share of the goods before the giant awakens. With Russia so desperately in need of foreign capital and investment, our hope must be that the sleeping giant will not become the ravaged giant.

Sik-Sik: Dinner on the Run

The 1½-pound (0.7 kg) arctic ground squirrel (*Spermophilus parryii*) spends most of its life curled in a ball hibernating deep inside its burrow. Called sik-sik by Inuit, the squirrel is active for just four months each year, and while it is out and about, everything with talons or fangs seems to be after it. Snowy owls, rough-legged hawks and gyrfalcons swoop at the squirrel from above, foxes and wolves chase it across the tundra, and hungry ermine stalk it underground. However, the grizzly bear poses the greatest threat to these squirrels, and the powerful bruins will tear the tundra apart to catch them.

As soon as a ground squirrel spots a grizzly, it gives a shrill alarm whistle. Once one sik-sik begins to shriek, others in the colony join in the chorus, all of them standing like picket pins at the mouths of their burrows. As soon as the bear gets close, they all zip down their holes.

A ground squirrel colony may be honeycombed with tunnels and holes. A hunting bear moves from hole to hole, sniffing each one carefully. When a hole smells promising, the bear begins to dig. A grizzly may spend over an hour trying to dig out one small ground squirrel, and the hole may get so large that the bear is completely hidden from view.

While the bear is digging, it stops frequently to sniff the hole, possibly gauging how close it is to its prize, and it constantly looks around to make sure that the squirrel doesn't escape out another hole. Sometimes, the squirrel makes a run for it, and the bear follows in hot pursuit. Despite its short legs, the ground squirrel is surprisingly quick and agile, and it often leads the bear on a zigzag chase that ends with the squirrel diving down another hole. Of course, many ground squirrels do not escape, and in some areas of the Arctic, ground squirrels are a major part of the grizzly's diet. One female bear in northern Alaska, for example, dug out 396 arctic ground squirrels in one summer season.

Snow Tales

When I checked the 1985 edition of *The Canadian Encyclopedia* for an entry for snow, there was no subject listing. Perhaps the publisher shared the same belief that many Canadians do: if you don't talk about it, maybe it will go away. Wishful thinking aside, Canada is no stranger to snow. Nor are any of the other arctic nations.

Although the Arctic is often maligned as nothing more than a perpetual land of cold and snow, it actually receives relatively little snow. In fact, in one year, more snow falls on the summit of Mount Kilimanjaro, in equatorial Africa, than falls on many parts of the Arctic. Just to keep the record straight, the *Guinness Book of Weather Facts* lists the tiny hamlet of Paradise, nestled on the flanks of Mount Rainier in the Cascade Range in the state of Washington, as the snowiest recorded place on Earth. Every year, Paradise is buried under an average 575 inches (1,460 cm) of the fluffy white stuff. The greatest snowfall in a single year occurred between February 1971 and February 1972. That year, the local ranger reported a record snowfall of 96½ feet (29.4 m).

Snow Trivia

When danger threatens, the arctic snow flea, a tiny wingless insect less than ¼ inch (6 mm) long, escapes by releasing a latch at the tip of its abdomen that launches the insect into the air. Hence its other name, springtail.

Much of the North American Arctic receives only 40 inches (100 cm) of fresh snow a year, with the greatest amounts—somewhere between 66½ and 75 inches (170-190 cm)—falling on northern Labrador and Quebec and on the eastern coast of Baffin Island. The problem with these numbers is that snowfall in the Arctic is frequently underestimated, because the instruments used to measure it are designed to measure vertical snowfall. The strong winds of the Arctic often drive the snow horizontally, which makes it far more difficult to measure.

Although many locations in the Arctic receive relatively little snowfall, what they do get has a tendency to linger for some time. In the lower Arctic, snow covers the ground for at least seven months of the year, and in more northerly areas, it can last up to 10 months. On some arctic ice-caps, of course, the snow may never disappear, and the year-to-year accumulation contributes to the growth and movement of glaciers (see "Glaciers: Rivers of Ice").

The culture of many northern peoples has been influenced by snow, and none more so than that of arctic Inuit. The Inuktitut language has a wonderful collection of names for snow. There are special words to describe how snow falls, others to distinguish the subtle differences in how it appears on the ground and still others for snow's many different uses. The 1994 *Canada Year Book* lists 22 Inuktitut names for snow. Three of the most pleasing to my ear are: *katakartanaq*, which describes crusty snow that breaks underfoot; *qannialaaq*, which is light falling snow; and *pukaangajuq*, which is the best snow for building an igloo.

In half an hour, a mother arctic ground squirrel transferred her four youngsters from their natal burrow to another burrow 150 feet (45 m) away, possibly because the family home had become flea-ridden.

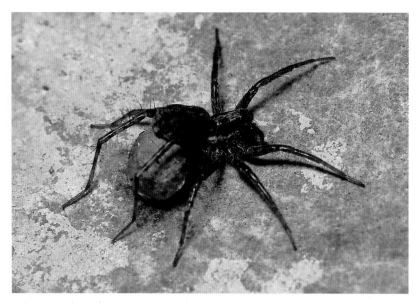

For the several weeks it takes for her eggs to hatch, a female wolf spider carries her large silken egg case on the underside of her abdomen wherever she goes.

Spiders: Wolves With Eight Legs

All spiders are predators, killing their prey by injecting it with deadly venom through a set of large hollow fangs. If you are fascinated by predators, as I am, it's worthwhile learning about spiders. These miniature carnivores are much easier to see in the Arctic than wolves, weasels or bears, and their lives are just as interesting.

Spiders can be divided into two groups: the web builders, which ensnare their victims in a net or a tangle of sticky silk, and the hunters, which lie in ambush and pounce on their prey when it wanders nearby. Web builders have a problem in the Arctic. There's too much wind, and there are very few tall grasses and bushes on which to hang a web, so web builders are relatively rare. Hunting spiders, on the other hand, are far more common in the Arctic, and the ones that are most often seen are wolf spiders. In fact, it's hard to take a 10-minute stroll on the tundra in summer and *not* see at least one or two wolf spiders. These miniature predators inhabit the most extreme arctic areas. Arachnologist Dr. Robin Leech even found two species along the shore of Lake Hazen, at the northern end of Ellesmere Island.

Most spiders have eight eyes, arranged in two rows of four each. Web-building spiders have small, relatively weak eyes, because these predators rely instead on vibrations transmitted through the silk strands of their web to alert them when a morsel has stumbled in for lunch. Wolf spiders, by contrast, don't spin a web, and they depend more on their eyesight to locate their next meal. Two of their eight eyes are greatly enlarged to improve their vision, and if you exam-ine a wolf spider closely, you will see the large eyes at the top of its head.

Among all spiders, female wolf spiders invest the most energy in the care of their eggs and young. While most female spiders hide their silk egg cases under a rock or vegetation, the female wolf spider attaches hers to the tip of her abdomen and carries the sac with her at all times. The tan-colored egg sac, which may be as large as she is, makes the spider easy to spot when it scuttles across the tundra.

Spider eggs hatch inside the sac after several weeks, and the female wolf spider uses her jaws to chew a hole through the tough silk to release the young spiders, which then crawl out and immediately climb onto her back. There may be more than 100 spiderlings, so they can be stacked several layers deep on their mother's back. The young ride on their mother like this for about a week, then leave home forever.

One of the first things a newly independent spiderling may do is to climb a rock or a bush, face into the wind and spin out a long thread of silk from the silk glands at the tip of its abdomen. Once the thread is long enough, the wind picks it up like a sail and "balloons" the young spiderling on the first journey of its life.

Swans: Fowl Aggression

The swan is unmistakable to anyone, and a single common species ranges throughout the circumpolar Arctic, although it has several different names. In North America, we call the bird the tundra swan (*Cygnus columbianus*), and in Asia, it is known as Bewick's swan, after Thomas Bewick, an 18th-century English artist and friend of John James Audubon.

The tundra swan is the largest bird in the Arctic, with males weighing up to 23 pounds (10.5 kg). These short-tempered birds are bold defenders of their nests and young. As a result, intruders are often attacked unmercifully. Swans readily chase geese out of their territories, and if they catch the trespassers, they may trample and bite them repeatedly. In two reported cases, swans killed 6-week-old white-fronted goose goslings that accidentally strayed into their territories.

Swans attack others of their own kind with equal ire. In the Colville River Delta of Alaska, a wandering swan inadvertently came too close to a nesting pair. When the unfortunate swan tried to escape, it stumbled in some snow and slipped

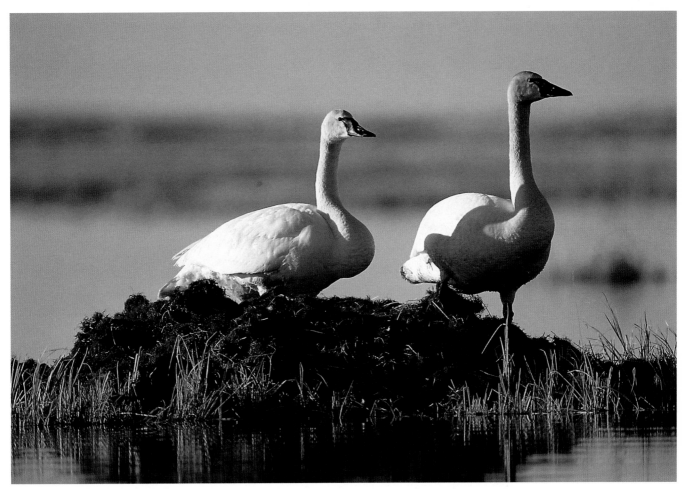

on ice and was immediately tackled by one of the resident birds, which beat it with its strong, bony wrists and repeatedly pecked its head and body. The intruder was then knocked over, and the attacking swan stomped it vigorously with its feet. The bloodied victim was flightless from its injuries for several days afterward.

Like all arctic waterfowl, the tundra swan nests on the ground, where it is most vulnerable to predators. The aggressive nature of the large, powerful bird serves it well in protecting its offspring from many of the predators that pose a threat. Foxes, eagles, jaegers, ravens and gulls are unlikely to succeed in snatching a swan egg or a hatchling if either parent is in attendance. Typically, only the largest predators—namely, wolves, bears and humans—are successful in raiding a nest or catching a chick.

In Alaska's Arctic National Wildlife Refuge, brown bears are responsible for nearly half of all the swan-egg losses. On the Alaska Peninsula, brown bears are even more of a threat, and they are the main culprit in nearly *all* nest predations. Some years, as many as 82 percent of all the swan nests are emptied by egg-brunching bruins.

Whenever I have stumbled upon their nests in the wild, the resident swans have beat a hasty retreat. In captivity, however, the protective birds lose their natural fear of humans. Then it's a completely different story.

I once made a valiant attempt to photograph a pair of captive nesting tundra swans. When I was about 100 feet (30 m) from the nest, both birds stood up and hissed loudly at me. Then the large male suddenly raced toward me with his wings outstretched to their full length. He lunged at me, pecking and grabbing the crotch of my pants and thrashing my legs with the hard edge of his bony wings. When I tried to back away, desperately clutching my cumbersome camera and tripod, the irate bird launched another attack. I finally halted the assault by grabbing the swan by the neck and pushing it away.

Safely back in the car, I asked my wife Aubrey if she had at least captured a photographic record of the attack as a reward for my bruises and damaged pride. She admitted that she'd been laughing so hard, she'd forgotten to release the shutter.

The young of most waterfowl, including the tundra swan, take several months to grow, so the birds begin to nest in May and June, when temperatures are still cool enough that it often snows.

Swan Trivia

A male swan is called a cob; a female is a pen; a chick is a cygnet.

TUV

Terns: Ice Age Relicts

In a curious time-share arrangement which requires that it make an annual round-trip flight of some 18,500 to 30,000 miles (30,000-50,000 km), the arctic tern (*Sterna paradisaea*) spends the summer months breeding throughout the northern tundra but winters in the Antarctic. That infamous little jaunt makes the tern's migration the longest of any creature on Earth. What interests me most about this phenomenal avian achievement, however, is not *how* the terns do it but *why* they do it.

The arctic tern spends the northern winter months in the pack ice of the Weddell Sea along Antarctica's frozen coastline. But if it's pack ice these birds are seeking, they could more easily overwinter along the southern edge of the arctic pack ice, as do so many northern seabirds. The prospect of increased competition may explain the tern's determination to head farther south—much farther south. There may be another explanation, though, for why the arctic tern is such a marathoner.

Why birds migrate and the reasons underlying their destinations are still among the most challenging questions in ornithology. Some of the answers may lie in the recent history of Earth itself, since most of the present-day avian migration patterns are the product of the last glaciation.

Let me first try to put certain aspects of bird migration into perspective. Today, hundreds of species of northern-hemisphere land birds migrate to the southern hemisphere every winter, yet not a single southern-hemisphere land bird migrates to the temperate or arctic regions of the northern hemisphere. Why? One explanation has to do with the geological history of the two hemispheres and with the different way the two areas were affected by glaciation.

Fifteen thousand years ago, large areas of northern Eurasia and North America were buried under massive continental ice sheets. At the same time, there was no ice at all in southern Africa. In southern South America, glaciers were limited to the Andes and its foothills. As a result, southern-hemisphere birds didn't need to search for greener pastures as the glaciers advanced; consequently, lengthy migrations were never part of their evolutionary history.

That was not the case for birds in the northern hemisphere. Scientists speculate that many of today's arctic birds have simply remained faithful to their ancient wintering grounds, despite the fact that there may now be appropriate areas much closer to their summer breeding grounds. In computer jargon, it appears that the migration behavior in these birds is "hard-wired" into their brains and not easily abandoned.

Many present-day arctic species either make migrations that seem much longer than necessary or follow unusually circuitous routes, and both strategies may be instances of this apparent bird-brain hard-wiring. For example, consider the arctic warbler (*Phylloscopus borealis*) that nests throughout Siberia and in a narrow belt of western coastal Alaska. In autumn, the southward migration of the Alaskan warblers begins when they fly west to Siberia, turn south and wing their way toward Southeast Asia. The arctic warbler has continued to maintain the old migration pattern of its parent population in Siberia. This routing is dramatically different from that of the five or six species of native wood warblers that nest in the same area of Alaska. The native warblers fly directly south to Central America.

Northern wheatears (*Oenanthe oenanthe*) that nest on Canada's Baffin Island are another example of this phenomenon. In a migration quiz, you would probably predict that these flycatchers would migrate directly southward, overwintering somewhere in Central America. In fact, they make a long, hazardous flight eastward across the icecap of Greenland and the open water of the North Atlantic, then travel down the western coast of Europe to western Africa. In all, it's a 5,000-mile (8,000 km) migration. Although a relatively recent immigrant to the Canadian Arctic from Europe, the hard-wired wheatears

Tern Trivia

The oldsquaw duck often nests within an arctic tern colony and benefits from the tern's aggressive dive-bombing of arctic foxes.

Thule Trivia

The name Thule was derived from the name of a district in north-western Greenland where stone houses and artifacts have been found.

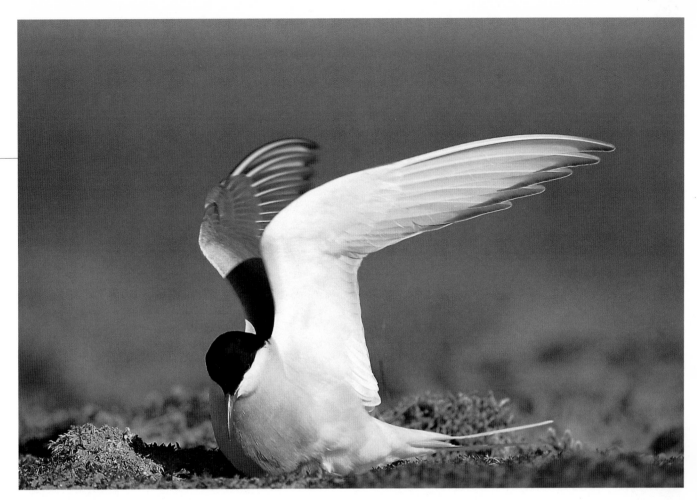

continue to migrate to western Africa, even though the migration is now more than twice as long as it was when they made their summer home in Europe.

While many arctic birds have inherited migration routes which emerged in response to the Ice Age, a few species have shown that they can adapt to new circumstances. The sanderling (*Calidris alba*) is one of the small Arctic-nesting shorebirds. Today, some sanderlings overwinter along the coast of Washington State, while others migrate to Chile, 3,700 to 4,300 miles (6,000-7,000 km) farther south. It's possible that all sanderlings originally migrated to South America, but over the course of thousands of years, suitable overwintering habitat opened up in coastal areas that were closer than South America. The end result is that some populations of sanderlings have established a new tradition by overwintering in the coastal United States, while others maintain the old long-distance tradition, a carry-over from the Ice Age.

What does this mean for the arctic tern, which spends most of its 25-year life span flying from one end of the Earth to the other? We may never know why this graceful arctic bird flies all the way to the Antarctic, but for now, we can safely theorize that the tern is a bird of the old school —the Ice Age school—and has simply never learned to live any other way.

Thule Culture

The first people to invade the Canadian Arctic came from Siberia and Alaska around 4,000 years ago. This bow-hunting culture, which became known as the Dorset Culture, survived until about 1,000 years ago, when it was suddenly replaced by a second wave of arctic immigrants, the Thule Culture.

The Thule (pronounced TOO-lee) were coastal peoples who came from Alaska, and they were skilled hunters of large marine mammals, in particular the gigantic 55-ton (50,000 kg) bowhead whale—the largest mammal in the Arctic. Like the Dorset peoples, the Thule hunted with bows, but they also used harpoons and spears and stalked their prey from kayaks and large skin-covered boats called umiaks.

The whale hunters lived in houses dug into the ground and lined with large stones. The ceilings

An arctic tern settles on its cryptically patterned clutch of two eggs. Male and female terns look identical, and the pair take turns brooding the eggs during the three-week incubation period.

113

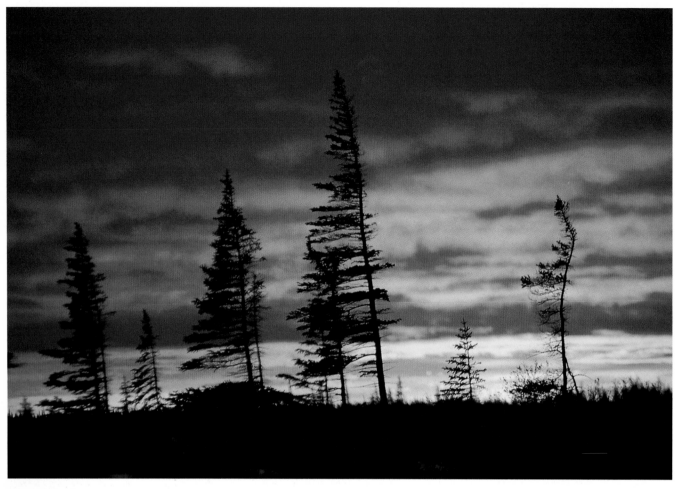

White and black spruces are the hardy tree species that grow along the tree line throughout most of its length.

were made of sod laid on top of rafters of whale ribs; the floors were usually covered with driftwood, whale bones or stones. Outside, the umiaks and kayaks were stored on boat racks, out of the reach of the gnawing jaws of stray dogs.

The migration of the Thule into Canada's northland took place at a time when there was a widespread warming trend in the Arctic. The warmer climate allowed bowhead whales to penetrate deeper into the Arctic Islands, and the Thule whale hunters followed them to their new habitat. Archaeologist Dr. Robert McGhee of the Canadian Museum of Civilization believes that the invasion of the Thule peoples may also have occurred as part of the search for iron, which was used to make weapons that were superior to the traditional ones tipped with stone or bone. In support of this theory, McGhee points out that eastern Ellesmere Island and the adjacent shores of Greenland are particularly rich in Thule sites. It happens that these same areas are known to have been showered with iron meteorites in the past.

Between 1450 and 1850, a period of cooler weather known as the Little Ice Age returned to the Arctic. In its wake, the ice cover increased and the number of marine mammals, especially whales, declined. As a result, much of the High Arctic was abandoned by the Thule peoples, who adopted a more nomadic life style, living in igloos and hunting caribou, seals and fish. The people of this new culture are the ancestors of modern Canadian Inuit. Although the whale-hunting Thule life style disappeared in Canada, it survived in coastal Alaska until modern times.

The Tree Line: Gateway to the Arctic

"Beside me was a cluster of tattered and stunted black spruces, their lower branches pruned bare of needles by a million microblades of flying ice and whipped by the wind. The crystals of ice stung my cheeks, reddened my eyes and made me long for the warmth of home. This was winter on the tree line, and beyond, there was only frightening flatness, numbing cold and the seductive depths of the Arctic."

One bright blue day in March, I recorded

those words in my journal as I huddled in the cold looking across the Barren Lands of the Northwest Territories. The tree line has always held a special appeal for me, perhaps because it marks the gateway to the Arctic, the land that has captured my heart.

The tree line marks the boundary between the congested spruce and larch forests of the taiga and the openness of the arctic tundra. In eastern North America, the tree line begins its circumglobal journey at the northern tip of Labrador. From there, it cuts across the Ungava Peninsula of Quebec and runs to the southeastern shore of Hudson Bay. It begins again on the western shoreline of Hudson Bay near the northern border of Manitoba, then staggers and weaves on a diagonal course across the wildness of the Northwest Territories to the Mackenzie River Delta. Sobered, it continues west around the entire coast of Alaska. Jumping across to Siberia, it captures the Kamchatka Peninsula and swaggers west, only to be bullied by the taiga almost to the edge of the Arctic Ocean. From here, it tires, and in just a few places does it wander farther than 250 miles (400 km) from the polar sea. Once it reaches northern Scandinavia, the weary tree line finally peters out along the frayed coastline of Norway.

Unlike the sharp alpine tree line of many mountainsides, the arctic tree line is a broad boundary; in places, it is many miles wide. Typically, as you move northward, the trees gradually thin out and shorten. As their numbers dwindle, the remaining arboreal frontiersmen huddle in clusters surrounded by fingers of encroaching tundra. Finally, the trees surrender and disappear. But why is the Arctic treeless?

Intuitively, you might guess that it is the extreme cold which keeps the tree line at bay. But the black and white spruces that are the guardians of the tree line are actually quite resistant to cold, able to withstand temperatures down to minus 90 degrees F (−68°C). You might also guess that wind and permafrost are two other possible factors limiting the growth of trees, and this time, you would be right. The winter wind, burdened with crystals of ice, can prune and kill trees, and the permafrost, which creeps closer and closer to the surface the farther north you move, forces trees to anchor themselves with roots so shallow that eventually, they are just too weak to prevent the tree from top-

pling over. But wind and permafrost are just minor players in the determination of the tree line; the leading role belongs to summer warmth. Without a summer growing period of a minimum length, a tree simply cannot survive.

Much of the tree line roughly parallels the 50-degree-F (10°C) isotherm—a hypothetical line joining all the points in the North where the average temperature of the warmest month of the year (usually July) is 50 degrees (10°C). This, then, is the minimum temperature required by the hardiest of trees to complete their annual growth cycle. If it is any colder, the trees will die.

The tree line is not only a blurry boundary but a fluctuating one as well. Naturally, as global climates have changed, so has the position of the tree line. At the peak of the last glaciation, for

Although there is plenty of sunshine in the Arctic for trees to grow, there is simply not enough warmth for most of the year.

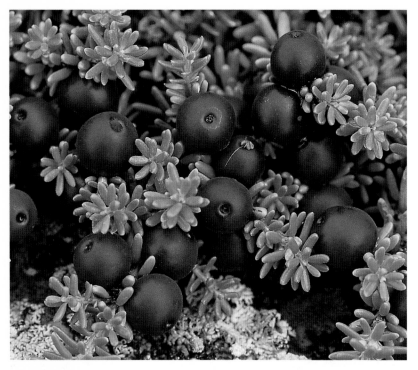

The crowberry (Empetrum nigrum) is a tough evergreen shrub that grows as a thick ground-hugging mat, thriving particularly well in sandy soil. It is a plant of the mainland Arctic and is quite rare in the Arctic Islands.

example, when tons of ice covered much of Canada, the arctic tree line ran across the northern United States. As the ice retreated northward, the tree line followed. During the so-called Hypsithermal Period, 8,500 to 5,500 years ago, the Arctic was the warmest it has been at any time during the present interglacial period (see "Ice Age Forecast"). Then, the North American tree line was as much as 200 miles (320 km) farther north than it is today. With the specter of global warming looming on the horizon, the tree line may once again pick up its roots and head north.

Tundra Talk

Tundra is the name given to the ecosystem beyond the limit of the trees. On the upper slopes of mountains, it is called alpine tundra, and in the circumpolar North, it is known as arctic tundra. The two types of tundra are very much alike, having been shaped by similar climatic extremes, but we will limit our discussion here to the arctic tundra.

If you examine any stretch of arctic tundra, you will immediately realize that it is composed of a patchwork of different plant communities, each of which is quite characteristic in appearance and therefore fairly easy to recognize. Even though ecologists classify arctic tundra into at least seven different types, knowing just half of these will give you a greater appreciation of the subtle complexion and design of the Arctic.

If there is one typical type of tundra, it is the sedge meadow, which covers great areas of the landscape and is found all across the lower and mid-latitudes of the Arctic. To the unschooled eye, a sedge meadow looks like an ordinary grassy field, but it is made up of mostly sedges, which are solid-stemmed marsh plants, rather than grasses. To add to the confusion, many of the different sedges that grow in this type of tundra have the common name cotton grass, even though technically, they are not grasses. I'm not an experienced botanist, so when I first started to tromp around in sedge meadows, the rule I followed went something like this: If it looks like a grass and has the word grass in its name, then it's probably a sedge.

Some cotton grasses may grow in the form of tough fibrous clumps about the size of a volleyball, with bare ground between them. This is called tussock tundra, and it's murder to walk across. The clumps of sedges are attached to the ground by a flexible stalk, so when you step on top of them, they tilt over, throwing you off balance. Nor is there enough space to walk between the clumps, so you are left hopping from tussock to tussock. To make matters worse, the gaps between the hummocks are often soggy or filled with standing water, so in summer, there are usually plenty of mosquitoes anxious to join you on your stroll. My wife Aubrey once watched me lurch and pitch across a particularly nasty stretch of tussock tundra, all the while flailing my arms ineffectually at the clouds of mosquitoes. She said I looked as if I were possessed.

The "rock gardens" of the Arctic are my favorite type of tundra because of the profusion of wildflowers that can grow here. The technical name for such areas is mesic (pronounced MEE-zick) tundra, which means not too dry and not too wet. Typically, there is a fair amount of bare rocky ground that separates blooms of many different colors—crimson lousewort, purple and yellow oxytropes and creamy saxifrages. In some especially good areas of the Low Arctic, there can be more than 100 species of wildflowers blooming simultaneously in an acre (0.5 ha) of mesic tundra.

Shrub tundra, as the name suggests, is characterized by the presence of bushes, usually willows, dwarf birches, heathers, cranberries and blueberries. In the early autumn, when the leaves of the shrubs are flushed with ambers,

reds and oranges, this is the most picturesque type of tundra to photograph. The intensity of the colors rivals anything I've ever seen in the deciduous forests of eastern North America, with one difference: you have to get down on your hands and knees to really enjoy it. While you're there, though, you can gather handfuls of ripe, juicy blueberries.

In the high latitudes of the Arctic, the vegetation thins out dramatically. There, a type of tundra occurs called the polar desert. The harsh climate and short growing season eliminate all but the hardiest plants, the lichens (see "Lichens"), which huddle between the wind-polished stones and splatter the rocks with dashes of color.

For all its diversity, the arctic tundra is still poor in the numbers of plants that it can grow and in the lushness of their growth. A sparse mesic tundra, for example, may yield just half an ounce of vegetation per square yard (17 g/m²), and even a lush, soggy sedge meadow may produce only three to seven ounces (85-200 g) in an area the same size. Compare that with the prairie grasslands or the temperate forests of North Amer-

ica, which produce four to six times more vegetation than the best plot of arctic tundra.

For me, however, the fascination and value of any ecosystem is not in its richness or productivity but in the myriad ways it has evolved to cope with local conditions. The arctic tundra, with its simple beauty and tenacious vegetation, is still one of the world's great ecosystems.

Umiak

I saw my first umiak in the mid-1970s on the fog-shrouded island of Little Diomede, in the Bering Sea. The umiak (pronounced oo-me-ak) is an impressive open boat dating back to the beginnings of the Thule Culture, around 1000 A.D. (see "Thule Culture"). The boat I saw was about 23 feet (7 m) long, although some umiaks may reach lengths of up to 33 feet (10 m). The frame was made of driftwood, which was covered tightly with pieces of walrus hide that had been carefully split and sewn together. When driftwood was not available, the Thule peoples used whalebone, sometimes covering it with the skins of bearded seals instead of those of walruses. I

At the height of summer, the tundra can be surprisingly green, as seen here at 73 degrees north latitude along the banks of the Thomsen River the first week in July.

117

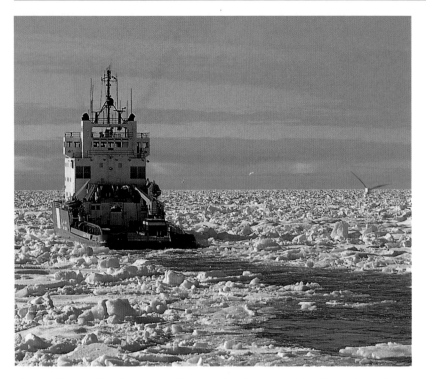

A Canadian icebreaker cuts a channel through the solid pack ice of Peel Sound. Following in its wake, a mixed flock of glaucous and Thayer's gulls feeds on the small fish and invertebrates exposed by the passage of the ship.

Sea Ice Trivia

The life on the underside of the sea ice is called the epontic community.

still remember how the light shone through the hide, giving it a rich golden color.

Powered by broad-bladed paddles, the umiak was used by coastal peoples throughout the Arctic, from eastern Siberia to Greenland. Whereas the single-person kayak was used to stalk seals, the umiak could comfortably hold a dozen or more people and was launched when hunters were planning to tackle larger, more dangerous prey, such as walruses and bowhead whales. Since an umiak could hold up to 20 people, it was also a convenient way for an entire camp of Inuit to relocate from one site to another.

Umiaks are no longer used in the Canadian Arctic, but on my last visit to the Bering Sea in 1994, hunters on Little Diomede Island were still employing these tough skin boats to hunt walruses each spring. Then, as they have for generations, the hunters might live in their boats for days at a time, groping through the emptiness of the cold, dark fog and fighting the crush of the grinding pack ice, hunter and boat maintaining a proud tradition that has survived for thousands of years.

Under the Ice

It was a huge surprise to me to learn that plants and animals live on the salty undersurface of the sea ice. Their presence in the marine ecosystem of the Arctic ensures the support of a great wealth of wildlife, from seabirds to seals.

The story begins in late winter, usually February, when the sun returns to the Arctic. At first, the life-giving sun hangs low on the horizon, sending long fingers of golden light skimming across the ice. But even these weak rays of sunlight are enough to start the growth of algae, the microscopic green or brown plants that are embedded in cracks and crevices on the undersurface of the sea ice, which can be up to six feet (2 m) thick.

As the sun climbs higher in the spring sky, the algae form a thick green-brown layer in the lower few inches of the ice. The plants sometimes detach from the ice, hanging in green, mucuslike strands. By the third week of May, the algae reach their peak, after which they slowly decline as the ice begins to melt and gradually disintegrate.

The microscopic algae do not grow in quiet isolation but, instead, support an entire ecosystem of cryofauna, or ice animals. These ice-adapted animals include single-celled protozoans that graze on the algae, and they, in turn, are hunted by turbellarians (flatworms), nematodes (roundworms), shrimplike amphipods and flat-bodied copepods. The worms and crustaceans are eaten by 6-to-12-inch-long (15-30 cm) arctic cod, which are then pursued by seabirds and fast-swimming seals.

I have lectured on several icebreaker cruises through Canada's Northwest Passage and, during those trips, have spent many enjoyable hours on the fantail as great blocks of sea ice splash to the surface in the ship's wake. It is a wonderful place to watch the workings of the Arctic. Often, flocks of seabirds follow the ship in search of the feast that is unintentionally provided. As the broken chunks of ice roll in the water behind the ship, the dirty brown layer of algae growing on the undersurface spins into view and a kittiwake or a fulmar swoops down and grabs a tiny cod or an amphipod that has been momentarily upended.

The ice algae begin to bloom many months before summer conditions return to the Arctic. Some researchers have estimated that the sea-ice algae contribute as much as one-quarter of the total plant production of the Arctic Ocean. This early algal growth expands the season during which the arctic waters are productive, enabling a greater profusion of life to abound in the North. In fact, because the productivity of the under-

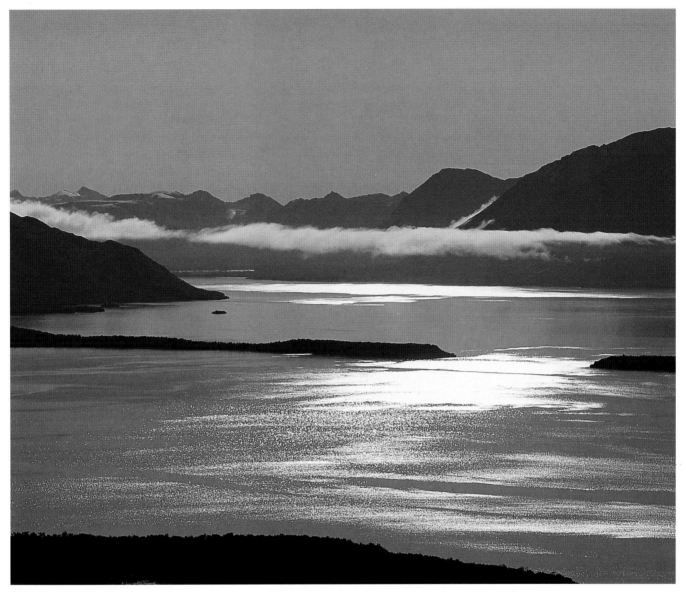

surface of the arctic sea ice is so high, it has been compared to that of a tropical reef.

Volcanoes in the Arctic

"We are waiting for death at any moment," wrote Alaskan fisherman Ivan Orloff to his wife in June 1912. "A mountain has burst near here. We are covered with ashes, in some places 10 feet and 6 feet deep. All this began June 6. Night and day, we light lanterns. We cannot see daylight. We have no water, the rivers are just ashes mixed with water. Here are darkness and hell, thunder and noise. I do not know whether it is day or night. The earth is trembling, it lightens every minute. It is terrible. We are praying."

Fortunately, Ivan and a few others who were nearby survived the famous eruption of the Novarupta Volcano, thought to be 10 times more

powerful than the 1980 eruption of Mount Saint Helens. In the aftermath of Novarupta's fury, more than 40 square miles (100 km²) of peninsular Alaska lay buried beneath volcanic ash up to 700 feet (215 m) thick—the height of a 60-story building. In Vancouver, 1,500 miles (2,400 km) away, acid rain caused clothes to disintegrate on clotheslines.

Plate tectonics is the term used to describe the dual phenomena of continental drift and seafloor spreading. Since the 1960s, an understanding of these two geological processes has revolutionized the study of volcanoes and earthquakes. Central to the theory of plate tectonics is the notion that rather than being a continuous layer of rock, the Earth's crust is fragmented by heat from its interior into at least six major plates and as many minor plates. The boundaries

Alaska's Katmai National Park is home to immense clear-water lakes, such as Naknek Lake, seen here, as well as salmon-fishing brown bears, mountains, glaciers and the famous Novarupta Volcano in the Valley of Ten Thousand Smokes.

of these plates do not necessarily coincide with the boundaries of continents, and most of the major plates include continental and ocean-floor crustal sections.

Tectonic plates are in continual motion, shifting and jostling for position. Since the plates are relatively rigid, all the action occurs along their edges, at the boundaries between adjacent plates. At these boundaries, the plates behave in one of three ways: they move apart, they collide, or they slide past each other. Let's look first at an area where the plates are drifting apart.

Running down the center of the Atlantic Ocean is an undersea chain of mountains, part of a 35,400-mile (57,000 km) ridge system that meanders through the Atlantic, Pacific and Indian oceans like the seam on a baseball. This oceanic ridge system is an area of seafloor spreading, where adjacent tectonic plates are moving apart. Along the ridge, molten rock from the Earth's underlying mantle wells up, cools, hardens and becomes welded to the edges of the ocean plate on either side of the rift. The newly formed ocean crust then moves away in both directions in a conveyor-belt fashion.

It is no coincidence that the Mid-Atlantic Ridge is equidistant from the eastern coast of North America and the western coast of Africa. These lands were once joined, but 200 million years of seafloor spreading has rafted them apart. Today, North America is still drifting west, and in your lifetime, your home will travel west a distance roughly equivalent to your height.

Iceland lies directly atop the Mid-Atlantic Ridge, and the entire country is volcanic in origin. Over millions of years, repeated eruptions and outpourings of molten lava in this area of seafloor spreading gradually piled up until, about 20 million years ago, the rock rose above the surface of the sea, creating an island. Today, there are still nearly 200 active volcanoes in Iceland, and it is the only arctic land that is increasing in area.

Unlike the situation in Iceland, most volcanoes occur in areas other than those where there is seafloor spreading. If new crust is continually being formed along the undersea ridge system, then there must be an area where crust is being consumed, or Earth would gradually increase in diameter. The areas of crustal consumption are called subduction zones, and they occur where tectonic plates collide and form a system of deep ocean trenches. The entire northern and western edges of the gigantic Pacific Plate, including the Aleutian Islands, the Kamchatka Peninsula of Russia, Japan, the Philippines and New Zealand, are one long subduction zone where the Pacific Plate is colliding with the North American Plate and the Eurasian Plate.

Continental crust is lighter than oceanic crust, so when the denser crust of the Pacific Plate collides with the lighter North American and Eurasian plates, the heavy oceanic crust slips beneath. As the crust dips deeper, it folds, fractures and eventually melts. The molten crust then percolates to the surface and erupts as a volcano or rumbles and shakes as an earthquake. Volcanoes and earthquakes are therefore simply the surface belches of this crustal digestive process.

At present, the Pacific Plate is moving north into the outside edge of Alaska's Aleutian Islands at a rate of about 3 inches (7 cm) per year, producing a lengthy area of active volcanism called the Aleutian Volcanic Arc. This arc stretches for more than 1,500 miles (2,500 km), from Anchorage to the western Aleutian Islands, and contains at least 40 historically active volcanoes. The famous Novarupta Volcano is one of these.

Volcanoes occur only on the edges of the Arctic—and for a reason you can now probably predict. Virtually all of the Arctic overlies stable continental plates, whose boundaries, for the time being at least, are relatively quiet.

Voles That Murder

Lemmings are not the only small rodents that live in the Arctic. There are half a dozen or so other species of rodents that are slightly smaller than lemmings but look just like them. These are the voles (*Microtus* spp), or meadow mice.

Voles live life in the fast lane. Mature when less than a month old, they breed like crazy, raise three or four families of six to eight young in quick succession, then burn out and die, having lived no more than a year or so. These fast-living little mammals seem worlds apart from the large, powerful polar bear, which matures slowly, raises a small number of cubs during its lifetime and can live for 25 to 30 years. Yet both mammals share a common trait found in every creature on Earth: all their behaviors have evolved to achieve a single end—to produce the greatest possible number of surviving offspring.

Volcano Trivia

At an elevation of 15,583 feet (4,750 m), Mount Klyuchev, on the Kamchatka Peninsula, is one of the world's highest active volcanoes.

Vole Trivia

The singing vole (*Microtus miurus*), the loudmouth of its kind, may cache two to three quarts (2-3 L) of roots, willow leaves and other greenery in preparation for winter only to have the stash robbed and eaten by a grizzly. Alaskan Eskimos also raid such caches and eat them as vegetables.

One of the startling ways in which both voles and bears achieve this goal is through infanticide, the murder of young animals by adults of the same species.

Infanticide has now been observed in a wide range of animals, from chimpanzees, gorillas and baboons to wolves, hyenas, lions, tigers and a great number of rodents, including voles. The murderous beast lurks within humans as well. Over 100 years ago, Charles Darwin noted that infanticide was, up to that time, one of the most common and widespread forms of birth control.

Voles are found only in the northern hemisphere, and of the 67 species worldwide, just seven or eight of these small furry rodent species are found in the Arctic. None of the different voles has been studied in enough detail for us to know the exact degree to which infanticide rules their fast and furious lives. Nevertheless, we can make some general observations about this behavior and its role in the reproductive biology of other like rodents. I think it is safe to say that in time, we will discover that its role is the same in most, if not all, voles.

Both male and female rodents kill young of their own kind, but each sex may do so for different reasons. Typically, a male rodent has one thing on his mind—to breed with as many females as possible. If he encounters a strange female with a litter of pups in his territory, he might have to wait several weeks for her to finish nursing before she comes into heat again. With the clock ticking away, the quicker solution for him is simply to kill the young so that he can breed with the female immediately.

The female is not totally without her own set of tactics to counteract the killer males. In some rodents, when a pregnant female is approached by a strange male, she fakes coming into heat and mates with him. Then, when the young are born, the duped male thinks they are his offspring. Thus they escape being killed, despite the fact that they were fathered by another male.

Sometimes, a female is able to defend her litter from a roaming male, but often, she cannot. When young animals are killed, the mother loses as well, because she has invested valuable time and energy without gaining any reproductive advantage. This explains "the Bruce effect," another fascinating behavior seen in some pregnant rodents. When confronted by a foreign male or even just the smell of his urine, a

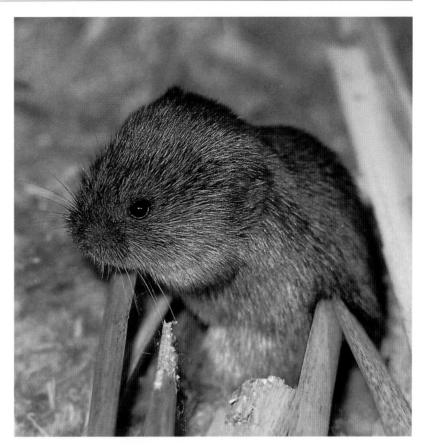

pregnant female may abort her pregnancy. The apparent rationale is that if the resident male which bred with the female in the first place has died or been displaced by a new male, there is no point in the female's carrying the pregnancy to completion just to see her young killed upon birth. The female may as well immediately terminate the pregnancy herself and minimize her losses.

Female rodents can also be killers. When there is overcrowding, as sometimes occurs in vole and other rodent populations, there may be limited space for the female to tunnel and build a nest. One solution is for the female to enter the nest of an established female, kill her offspring and take over her nest. Even when conditions are not quite so crowded, killing another female's offspring whenever possible may be a worthwhile strategy. It serves to lessen the competition for food and space for the killer female's own young and therefore helps to further her reproductive success.

Infanticide is one of the darker sides of animal behavior. Understanding how and why such behavior exists in rodents such as voles may help us develop a better understanding of our own often brutal behavior.

As with most small mammals that live underground or beneath the snow, vision in the meadow vole (Microtus pennsylvanicus) is relatively weak, and the animal relies instead on its hearing and acute sense of smell to guide it.

121

W

When a walrus hauls out on the beach in the warm sunshine, its skin flushes from white to pink. To dissipate body heat and prevent hyperthermia, the blubbery walrus shunts blood to its skin. If the air temperature gets too high, the animal must crawl over its irritated companions and return to the sea to chill out.

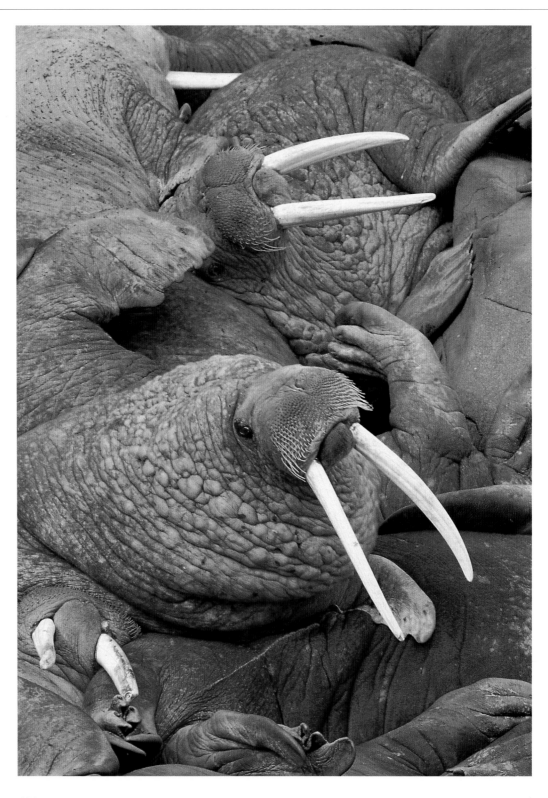

Walrus Ways

The ivory tusks of the walrus (*Odobenus rosmarus*) are its most recognizable feature, and they serve as an important clue to the life history of this cumbersome-looking marine mammal. The walrus uses these oversized teeth in a number of different ways, wielding them like a double sledgehammer to chop holes in the sea ice in winter or, on rare occasions, using them as a weapon against predators such as polar bears, killer whales and human hunters. The walrus also uses its tusks to haul its blubbery body up onto ice floes to rest. This behavior explains the scientific name *Odobenus*, which comes from two Greek words meaning "tooth walker."

All male and female walruses have tusks, although, as you might guess, they are larger in adult bulls, sometimes reaching a length of 30 inches (75 cm). A few years ago, I was riding in a rubber Zodiac boat off Ellesmere Island in the Canadian High Arctic and experienced firsthand the damage a pair of well-aimed tusks can do: an adult female walrus protecting her young calf attacked our boat, viciously smashing the motor with her tusks. I think that was the first day I started to grow white hair.

During the winter breeding season in January and February, adult bull walruses jab each other with their tusks to settle disputes; sometimes, the battles between bulls can become quite bloody. The skin on a bull walrus's neck and shoulders is up to two inches (5 cm) thick, with dense knobs for extra reinforcement, which helps prevent serious injury.

For a long time, the walrus was thought to rake the seafloor with its tusks in its search for food. The normal diet of a walrus includes sea cucumbers, soft-shell crabs, marine worms and plenty of clams and mussels, which the tooth walker finds on the bottom of the ocean. It can eat up to 190 pounds (85 kg) of seafood a day. The tusks, however, are never used as digging tools.

Every walrus has as many as 700 thick, bristly whiskers on its snout. Each whisker can move independently of its neighbors, and each has a rich supply of nerves to decode the details of what it touches. As a result, when a walrus feeds on the ocean floor, its eyes are closed, and it feels its way along the bottom using its whiskers. As soon as it detects something edible, it slurps it up.

Despite the fact that a walrus eats buckets of clams and mussels every day, scientists have never found any shells when they examined the stomach contents of walruses. As it turns out, the walrus sucks out the meaty part of its meal and leaves the shells behind. A thick tongue, strong cheek muscles and a high palate all combine to produce a one-ton high-pressure suction pump that easily separates a clam from its shell. Who says facts aren't better than fiction?

Winter Whites

In "Cold Solutions," I talked about Bergmann's rule and Allen's rule and about how the latitude where an animal lives can sometimes affect its body size as well as the length of its ears, nose and limbs. Let me introduce you to biologist Constantin Gloger, who noticed that the pigmentation in animals tends to lessen gradually the closer they live to the poles, with northern races of animals generally being lighter in coloration than their southern counterparts.

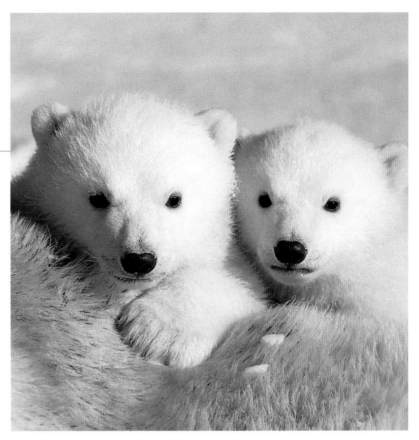

The fur of these 3-month-old polar bear cubs is pure white, in contrast to their mother's fur, which is a dirty yellow color. After exposure to sunlight, the fur of an adult bear yellows due to oxidation.

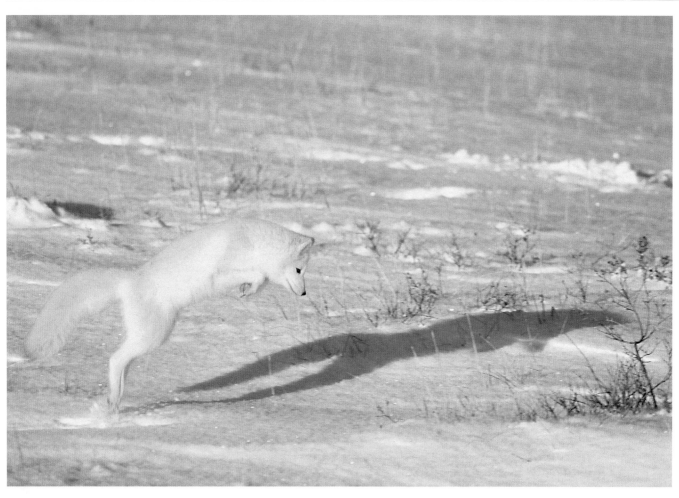

An arctic fox uses its sensitive hearing to locate lemmings and voles hidden beneath the snow. Before pouncing, the fox cocks its head back and forth to pinpoint the exact position of its prey.

Let's use the wolf as an example of Gloger's rule. Those living in the forests near my home in Alberta, Canada, are gray-, tan- and black-colored, whereas the wolves on Ellesmere Island in the High Arctic are almost always completely white. Although Gloger made the observation that many arctic animals are white in color, he didn't answer the obvious question: *Why* are these animals white?

One reason for a predator to be white might be camouflage. If we look at the situation closely, however, whiteness may not be as helpful as we think. A polar bear stalking a seal basking on the sea ice could benefit from being white, but bears hunt seals in this way less than 25 percent of the time. Usually, a bear crouches by a breathing hole and waits for a seal to surface, or it breaks through the ceiling of a snow lair and takes the seal by surprise before it can escape. In both cases, protective coloration would appear to offer no advantage to the bear.

Next, consider the white wolves of the Arctic. These predators approach prey openly, test its vulnerability by chasing it, then close in for

the kill. Generally, the wolves don't try to hide from their prey, and camouflage doesn't appear to offer any substantial benefit. The same can be said of the arctic fox and the snowy owl. Both predators hunt mainly lemmings that are hidden from sight in tunnels under the snow. Once again, camouflage doesn't appear to confer any advantage on the hunter.

The gyrfalcon, which is white in the most northern part of its range, is a ptarmigan hunter. Typically, the falcon relies on stealth and sudden surprise to capture its sharp-eyed prey. In this case, camouflage could benefit the predator. There is just one problem: 50 percent of the gyrfalcons in the mainland Northwest Territories, where there is certainly lots of snow in winter, are dark gray in color, and their hunting success with ptarmigan is just as good as that of the white-colored birds. After all is said and done, it seems that none of the five predators we have just discussed gains any substantial hunting advantage by being white.

If being white doesn't benefit the hunter, perhaps it benefits the hunted. Certainly a stronger

case can be made for this possibility. Arctic hares, collared lemmings, ermine and ptarmigan are white in winter, and their coloration may afford them some protection by making them less noticeable to predators.

Unfortunately, this argument weakens when you consider that collared lemmings are usually concealed beneath the snow, where cryptic coloration is not necessary. Many arctic hares remain white in the summertime as well. At that time of year, they are quite conspicuous, with their white coloration drawing attention *to* them rather than concealing them.

Dall's sheep (*Ovis dalli*) and Peary caribou (*Rangifer tarandus pearyi*) are two other examples of white arctic animals, and once again, neither seems to rely on its light coloration to hide it from predators. Since we can't make a good case for white camouflage benefiting either the hunters or the hunted in any major way, perhaps there is another reason for being white.

When researchers subjected two groups of birds (one white and the other dyed black) to sunshine and measured their metabolic rates, they discovered that the black birds absorbed more heat from the sun, had a lower metabolic rate and thus used less of their energy reserves. Consequently, the black-colored birds seemed to have an energy advantage over the white ones. If this is the case, why aren't most arctic animals black, like the raven?

If strong sunshine were present during the coldest time of the year, when an animal's energy demands are the highest, there might be a benefit to being black in the Arctic. However, winters throughout much of the Arctic are dark, and what little sunshine there is is weak in intensity. It's probable, then, that black coloration would not confer any energy advantage. In fact, being black may be a distinct disadvantage.

My theory? Most hair and feathers are hollow. In dark animals, the hollow spaces are filled with pigment; in white animals, the hollows are filled with air. Since air insulates better than pigment, less body heat is lost. Thus the best possible reason to be white is to conserve energy. I have to admit that this is speculation. No studies have been done to confirm my theory. Even so, it's the explanation that makes the most sense, and in my mind, until further research resolves the question, arctic animals are white simply because it keeps them warmer than any other color.

Willows

Most of the Arctic is treeless. Taking the place of trees are what I think must be the world's toughest shrub: the willow (*Salix* spp). There are at least two dozen different kinds of willows in the Arctic, but the variety quickly decreases the farther north you travel. For instance, on Canada's Victoria Island at 70 degrees north latitude, there are just six willow species, while on northern Ellesmere Island at 80 degrees north latitude, only one type of willow is tough enough to withstand the harsh climate.

A common way for willows in the Arctic to grow is flat out, and I don't mean as fast as they possibly can—I mean as *flat* as they possibly can, hugging every dip and crack in the ground. One willow plant I examined on the Barren

In the willow family, male and female flowers occur on separate plants. Here, a female willow plant hugs a lichen-encrusted rock on Devon Island, Northwest Territories.

Wolf Trivia

The average weight of a wolf ranges between 50 and 100 pounds (23-45 g) The heaviest recorded was a 174-pound (79 kg) male.

The pelt color of the wolf varies the most of any arctic mammal; ranging from black to white, through intermediate shades of gray, brown, rust and sandy yellow.

Lands north of Baker Lake in the Northwest Territories was about 14½ feet (4.5 m) long, yet the main stem of the plant was never more than two inches (5 cm) above the dry, rocky soil. Willows cling to the ground in order to escape damaging ice crystals driven by the winter winds.

As if the sharp ice crystals and the cold weren't enough for the wind-battered willows to handle, they seem to be on everyone's menu as well. Lemmings, voles and arctic hares gnaw off the bark, muskoxen and caribou eat the twigs and leaves, and ptarmigan nip off the buds.

Even humans have developed a taste for willows. In spring, according to writer Page Burt, the children of Bathurst Inlet eat the "fat of the willow." The kids strip away the outer bark of the smaller twigs and then scrape off the sweet white sapwood with their teeth.

Wind Chill

Everyone who has spent any time in cold weather is familiar with the expression wind chill factor. It is a system that was developed in Antarctica by American scientist Paul Siple to calculate the cooling effect of the wind on the bare skin of a human exposed to different cold temperatures. The greater the wind, the greater the cooling effect and the colder it feels.

Because of the wind chill, a strong wind can make you feel bitterly cold, even though the temperature may be relatively warm. For example, at the freezing point (32 degrees F/0°C), a 30-mile-per-hour (50 km/h) wind makes the air feel like a frigid minus 2 degrees (–19°C). Take that same wind and drop the temperature to minus 5 degrees (–20°C), and the wind chill becomes minus 55 degrees (–48°C). At such a wind chill value, exposed areas of the face will freeze in less than one minute, and conditions for travel become dangerous.

While hiking outside in the winter, I have often wondered what effect the wind chill factor has on arctic wildlife. While these animals have little choice but to be active in cold, windy weather, I have been unable to find any research papers that discuss this obvious aspect of arctic-animal physiology. Even so, I am certain that arctic animals can, and do, suffer frostbite and freezing injuries just as humans do. The essential difference is that their resistance to injury is likely much higher than ours. There are two simple hypothetical situations which illustrate the dra-

matic impact that wind chill could have on the lives of arctic animals.

In the first example, a peregrine falcon is hunting migrating ducks in early spring. Let's suppose that the temperature is near the freezing mark. The high-flying hunter suddenly spots an old-squaw beneath it, winging its way across the tundra. The falcon immediately dives toward the duck at 50 miles per hour (80 km/h). Considering that a peregrine may sometimes dive at speeds in excess of 175 miles per hour (280 km/h), this is an extremely modest velocity. Nevertheless, at 50 miles per hour (80 km/h), the face of the plunging peregrine is exposed to a wind chill that is the equivalent of an astonishing minus 55 degrees F (–48°C).

Snowy owls commonly overwinter in the Arctic, so they frequently endure long stretches of cold weather during which temperatures of minus 22 degrees F (–30°C) are not exceptional. Picture such an owl gliding across the snow on large ghostly wings, soaring at a mere 12 miles per hour (20 km/h), its gaze fixed on a lemming poking its nose out of a snowdrift. At such a speed and temperature, the wind chill factor is minus 52 degrees (–47°C), very similar to that experienced by the peregrine under a different set of circumstances. Regardless, in the case of both the owl and the falcon, the wind chill is so extreme that areas of exposed skin should normally freeze in less than 30 seconds.

In each of these examples, the situation is typical, the sort that arctic animals face every day of the winter. Yet wind chill injuries are relatively rare in wildlife, and no one can completely explain why this is so. Clearly, there is still much to learn about the adaptations of animals to the rigors of the Arctic.

The Arctic Wolf

On a canoe trip along the Thomsen River in Canada's High Arctic Islands several years ago, we spotted wolves on five different occasions, and they were a daily topic of conversation. I recorded one of the sightings in my journal:

"This afternoon, five white wolves suddenly appeared on a ridge next to camp. Their pelts were scruffy with the summer molt, but the animals moved with the fluid grace of highly tuned hunters. They stared at us for a few moments, each of them alert and tense, then moved on to more productive business. As the pack departed,

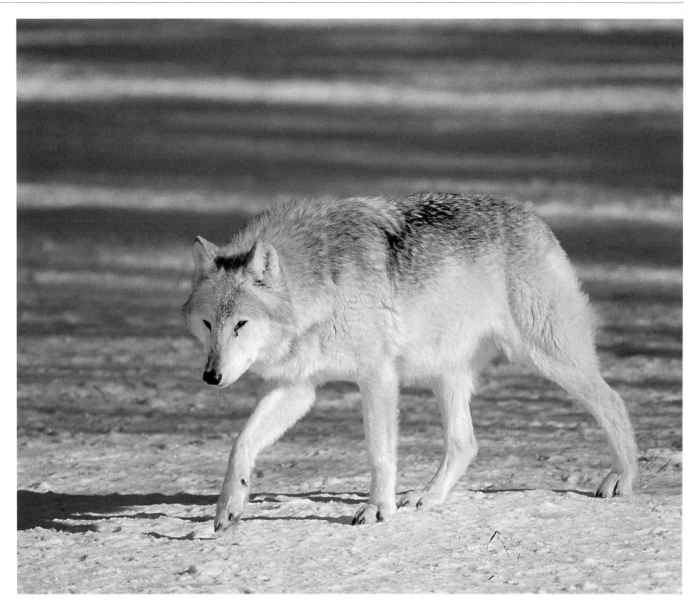

one of the wolves lagged behind the rest and howled in our direction a dozen times or more.

"The howl of the wolf is one of those natural events that instantly transforms the moment into something magical. It is a haunting sound that penetrates deep into the soul of the listener, stirring the embers of life and fanning them into glorious flame. The five wolves that visited our camp this afternoon were gone in a matter of minutes, but the sight and sound of those legendary beasts flushed me with excitement for hours afterwards."

Ten different carnivores live in the Arctic, and all are solitary hunters, with the exception of the wolf. The average wolf pack contains two to seven animals, although there is a record of a pack in Alaska with three dozen wolves.

Worldwide, many carnivores live in groups, and they apparently do so for a couple of reasons: multiple members can act as a surveillance system to detect predators, increasing the pack's ability to defend a hunting territory and enabling it to tackle large, sometimes dangerous prey. However, wolves in the Arctic have little to fear from other predators. Since wolves don't compete on a major scale with any other arctic carnivores, it is often claimed that the main reason they are social is to enable them to hunt powerful hoofed mammals, which may weigh 5 to 10 times as much as they do. Indeed, throughout their circumglobal range, wolves commonly hunt deer, elk, moose, caribou and muskoxen. But like most of the Arctic's predatory creatures, the wolf is first and foremost a flexible opportunist that will take food where it can find it. As a result, wolves sometimes hunt some rather unexpected prey.

Generally, wolves specialize in hunting whichever hoofed mammals share their range. In the Arctic, where large prey animals are often widespread and patchy in distribution, the wolf is less specialized and hunts whatever it can catch, regardless of size.

127

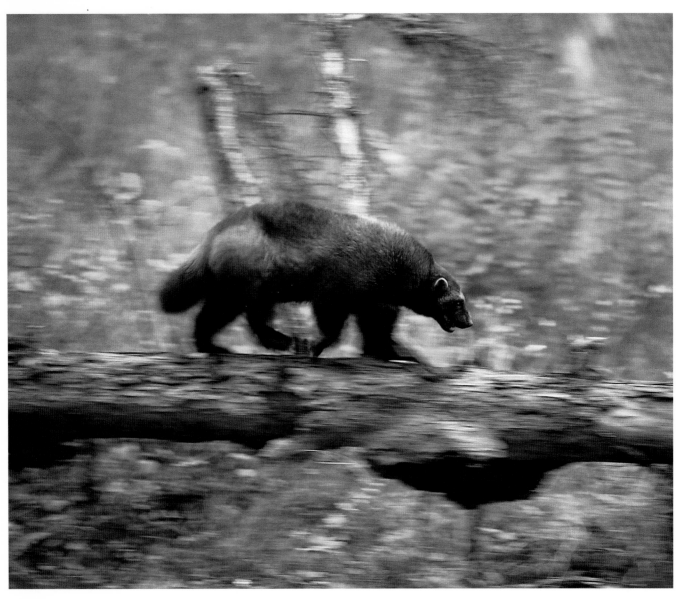

In Canada's High Arctic, solitary wolves frequently target herds of white arctic hares. This is such a common occurrence that the hares have evolved a special running gait, called "ricocheting," which is characterized by the hares' hopping away on their hind legs when a wolf is sighted (see "Herding Hares").

Arctic wolves will even venture onto the sea ice to see what they can find. The most abundant marine mammal in the Arctic is by far the ringed seal, and there are several reports from coastal Labrador and other regions of the Canadian Arctic of wolves scavenging ringed seals that had been killed by polar bears. The bears often eat only the fat-rich blubber and skin of a seal kill, leaving large amounts of edible muscle and viscera behind. But wolves are not always content to eat just the scraps. From northern Ellesmere

Island, there is a report of a wolf stalking and killing a ringed seal as the animal rested on the sea ice beside its breathing hole.

While searching through scientific papers about wolves, I found that the most unusual prey for a wolf to pursue is fish. In one instance, a researcher studying muskrats was paddling down the Taltson River in the Northwest Territories when he spotted a black-colored female wolf fishing for whitefish in a shallow rapids of the river. When a fish swam within six feet (2 m) of the riverbank where the wolf was lying, the animal lunged at it, trying to grab the fish in her jaws. The wolf's capture rate averaged about 50 percent, and in one particularly good hour, she caught 16 whitefish. Three other wolves nearby—an adult male and two juveniles—were apparently watching the fishing female, but they

did not get their feet wet. Researcher Ernie Kuyt, who studied wolves on the Barren Lands, believes that fish are an important element in the wolf's diet, especially during the summer denning period, when most of the resident caribou have migrated north to their calving grounds.

It seems to be human nature for us to try to cram people into neat little behavioral boxes. We tend to categorize the lives of wildlife even more than we do our own lives, and as research has shown, we are often just as unsuccessful at predicting the behavior of wild animals as we are at predicting human behavior. Wolves and other arctic animals have evolved a rich diversity of behaviors, the details of which we have just begun to understand. For the time being, I think we should assume that wild carnivores are likely to be every bit as interesting as we find ourselves—and probably much more surprising.

Wolverines: Hyenas of the North

During the first quarter of the Ice Age, there was a carnivore in North America called the bone-eating dog (*Borophagus diversidens*), a highly specialized predator and scavenger that looked as though it was part dog and part hyena. From the appearance of its skeleton, the bone-eating dog was not a particularly good runner, but it had powerful teeth and jaws, ideal for crushing the bone-and-sinew remains of carcasses abandoned by other predators. This unique animal became extinct about 1½ million years ago, and it took half a million years more for another carnivore to move in and fill the vacancy it left. That carnivore was the wolverine (*Gulo gulo*), the present-day hyena of the North.

The wolverine lives in relatively low numbers throughout a vast circumpolar range that includes the arctic tundra and adjacent boreal-forest wildlands in both North America and Eurasia. It has many common names, none of them complimentary: devil bear, glutton and skunk bear are just some of them. An adult male wolverine can weigh up to 60 pounds (27 kg) and resembles a small bear with a bushy tail, although it is actually the largest terrestrial member of the weasel family (Mustelidae). The world's largest mustelid is the giant river otter of tropical South America, which can weigh as much as 75 pounds (34 kg).

Officially, the wolverine is classified as an omnivore—it will eat just about anything: berries, birds' eggs, baby birds, voles, mice, lemmings, ground squirrels, hares and beavers. It has even been known to tackle and kill mammals as large as reindeer, caribou and moose, although these are exceptional cases and the victims have usually been mired in deep snow, giving the wolverine a killing advantage.

Examining the skull and teeth of any mammal will reveal a lot about the owner's life style and diet. The skull of the wolverine is massive and broad for the size of the animal and has well-developed anchor points for powerful jaw and neck muscles, used in lifting and dragging. Its molar teeth are big and solid, designed to cut through tough cartilage and ligaments and to crush all but the largest of bones. Clearly, the wolverine's impressive dentition and skull anatomy did not evolve to pluck berries and capture small mammals but are the tools of a major scavenger.

In summer, scavenging provides the wolverine with at least one-third of its diet, and in winter, it accounts for a much greater proportion than that. In northern Alaska, researcher Audrey Magoun found that some winters, the wolverines she was studying lived entirely on scavenged caribou bones and hide as well as ground squirrels that they had cached the previous summer. Some of the animals' winter droppings consisted entirely of bone fragments, and sometimes, the only excrement that Magoun found was small amounts of chalky liquid. Since bone contains 40 percent protein, most of it collagen, there is considerable nutrition to be gained if it can be chewed up and swallowed, something that wolverines seem well equipped to do.

In the Alaska study, Magoun followed 50 miles (80 km) of winter trails in an attempt to discover the dietary details of the mysterious wolverine. She found 186 "digs" along the trails. Among these, 16 digs had ground-squirrel remains; 6 had flecks of blood, probably that of live voles or lemmings; 16 had splinters of caribou bone; 5 had ptarmigan feathers; 1 had a whole shrew; 1 had the dried-up mud-caked carcass of a duck; and 3 had eggshells. There was no evidence of any food remains in the rest of the digs. Magoun concluded that "the wolverine's ability to survive the most severe time of year on such a meager diet attests to its efficiency as a scavenger."

Wolverine Trivia

My favorite description of the wolverine—a colorful but inaccurate one—was penned in 1518: "It eats until the stomach is tight as a drumstick, then squeezes itself through a narrow passage between two trees. This empties the stomach of its contents, and the wolverine can continue eating until a carcass is completely consumed."

XYZ

The eye-catching orange xanthoria lichen grows on rocky surfaces and old bones throughout the Arctic.

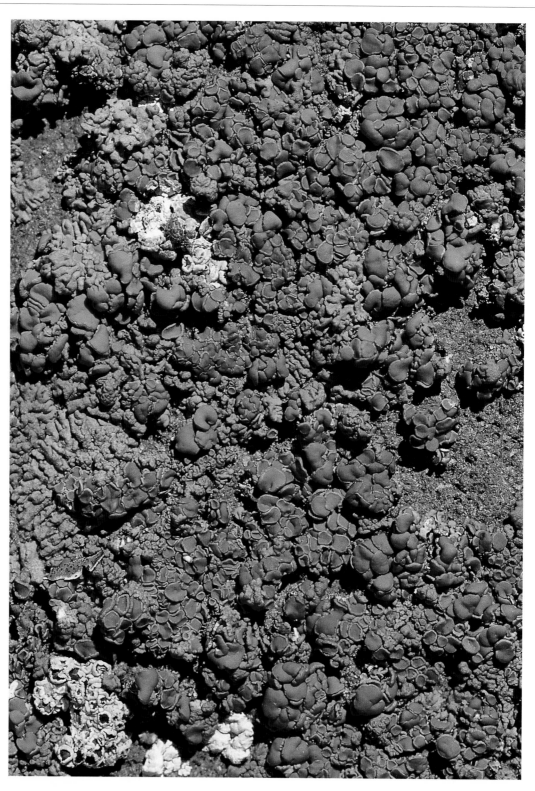

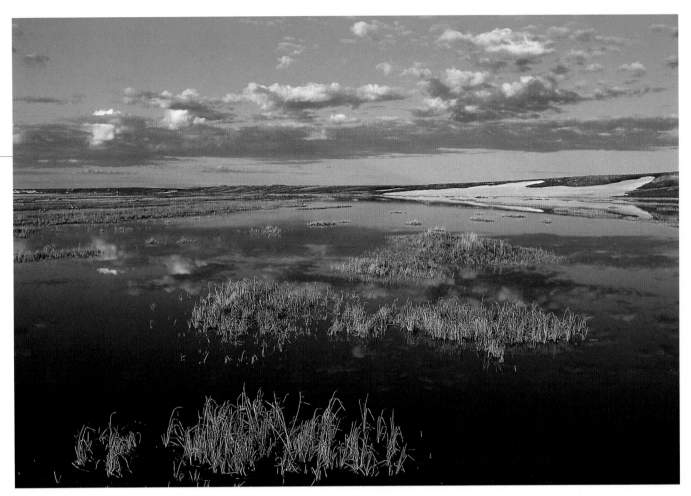

Xanthoria

Xanthoria (pronounced zan-THOR-ee-ah) is the scientific name for the jewel lichen, a beautiful, bright orange crusty lichen that grows on many arctic rocks. Even the gravestones of lead-poisoned sailors from the ill-fated Franklin Expedition are decorated by patches of xanthoria. Writer Fred Bruemmer reports that Polar Inuit of northern Greenland call the colorful lichen *sunain anak*, meaning the sun's excrement.

Small mammals, such as pikas, arctic ground squirrels and hoary marmots, regularly use rocks as lookout posts, and over time, these spots become soiled with urine that is high in nitrogen. The jewel lichen grows especially well on such nitrogen-enriched rocks. For the same reason, it likewise grows on any outcrops of rocks that birds have repeatedly whitewashed with their droppings. The characteristic habitat of the xanthoria lichen has even proved helpful to biologists trying to locate raptors in the Arctic. As naturalist Page Burt observed: "It is possible to fly along cliffs and locate traditional hawk and falcon nesting sites from an aircraft just by looking for spots where this colorful lichen is abundant."

Yukon Territory

The Yukon Territory takes its name from the mighty Yukon River, which Inuit call *Yukun-ah*, the great river. And the river is indeed great, for it drains most of the Yukon Territory and, at a length of 1,980 miles (3,185 km), is the fifth longest river in North America. Although many Southerners think of Yukon as an arctic region, most of the Yukon Territory is actually located in the subarctic. Only the northern coastal plain lies beyond the tree line and is therefore part of the Arctic.

Yukon is shouldered between the rest of Canada and Alaska, with which it shares a 1,320-mile (2,125 km) border. It also shares with Alaska one of the great arctic wildlife spectacles on the continent—the Porcupine caribou herd. Technically, the 180,000 caribou that belong to this great herd are Grant's caribou (*Rangifer tarandus granti*), a different subspecies from those of the Barren Lands, although many people mistakenly clump them together with the five or so Barren Lands herds.

After wintering in the mountains of central Yukon, the Porcupine herd migrates to the

In Ivvavik National Park, Yukon, there is ample daylight at 2 o'clock in the morning in late June for diurnal sparrows and longspurs to remain continuously active. Even so, the birds usually rest for four to six hours each night.

131

The St. Elias Mountains, in Kluane National Park, Yukon, are the youngest mountains in North America. This active mountain range is the most earthquake-prone area in Canada, recording an average 1,000 tremors a year.

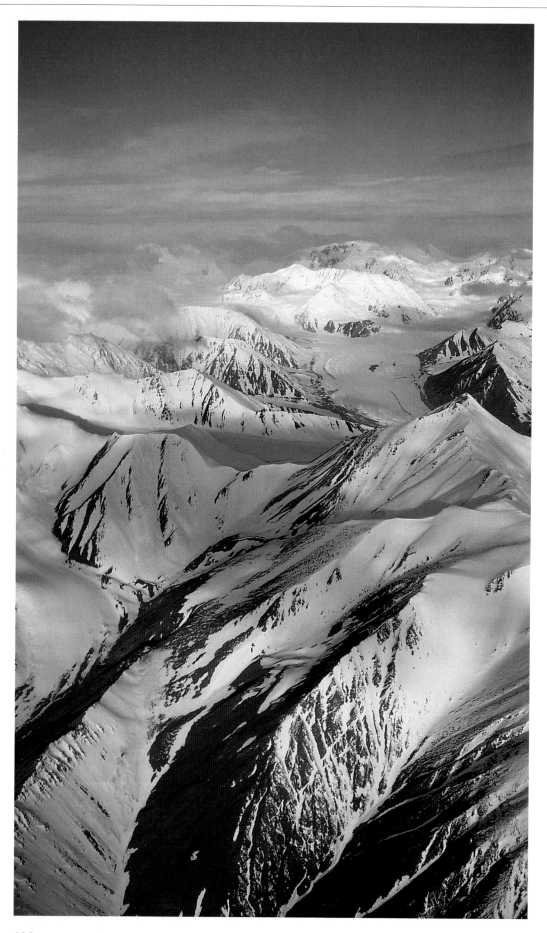

Yukon Trivia

The lowest temperature ever recorded in North America is minus 81 degrees F (–63°C), in Snag, Yukon.

The highest point in Canada is the 19,520-foot (5,950 m) summit of Mount Logan, in the southwest corner of the Yukon Territory.

coastal plain in May and early June to calve, although the exact location varies from year to year. When spring weather arrives late or the snow is deep, the cows usually calve on Yukon's coastal plain. In milder years, when snow conditions are lighter, the animals migrate farther, reaching the coastal plain of Alaska. In those years, they calve in the famous Arctic National Wildlife Refuge.

Zoophiliac: A Critter Junkie

For as long as I can remember, I've been interested in wildlife. When I was a boy of 10 or 11, I was given a book of Audubon bird paintings. At the time, I thought that the hundred or so species pictured must surely include every different kind of bird on Earth, and I eagerly searched the woods near my home in southern Ontario trying to find them. My success rate was rather low; I didn't know at the time that many of the birds illustrated in the book were found only in the forests and wetlands of Florida.

Eventually, I put the book aside and realized that I could still enjoy watching birds without trying to identify them. As a young teenager, I spent many days sitting alone in the woods hoping a new animal or bird would stray close enough so that I could get a good look at it. Most of my friends thought I was a little odd, and my parents weren't sure just what I was up to.

Today, as I near my fiftieth birthday, I still love to sit and watch the workings of the natural world, even more than I did as a child. The difference is that now I've discovered the endlessly fascinating science of animal behavior, a science whose limits seem to be boundless. The more I learn, the more I discover there is to learn.

Scientists estimate that there are tens of millions of creatures other than *Homo sapiens* living on Earth today, and each of these has a life characterized by incredible complexity. We all have a primordial attachment to the natural world, and although that link may be weak in many of us, it is never completely severed and can always be strengthened and revitalized. It takes only a modest initial interest to unlock a world that can challenge and stimulate you for a lifetime. This was never more clear to me than it was after an experience I had in the Arctic one September several years ago.

I was a guest lecturer for the Smithsonian Institution on an icebreaker traversing the historic

Northwest Passage in Canada's High Arctic. The ship had anchored offshore from Beechey Island, in Lancaster Sound, where the first three members of the doomed Franklin Expedition had died in the mid-1800s. It was a gray, overcast day, and a brisk, icy wind whipped sheets of spray off the wavetops, making a boat ride to shore very unappealing. After strolling along the gravel beach and gazing for a few moments at the lifeless wooden grave markers, a few of us returned to the water's edge, where we spotted some movement along the shoreline. I gently scooped up a mysterious tiny animal in a plastic bowl.

Although it was mostly colorless and transparent, the edges of its body were streaked with rich purple and pink. Its rounded wings rippled rhythmically, propelling it slowly like a bird in flight. It was a pteropod (*Clione limacina*), a type of snail that has no shell. None of us had ever seen a pteropod (pronounced TER-o-pod) before, and its delicate elegance was an unexpected sight in the remote reaches of the Arctic.

Back on board the ship, we talked about how marvelous it had been to see a creature that seemed to have come from outer space. For a few brief moments, all of us were focused on something wild and wonderful beyond our own existence. In that instant, we were hooked, as I have been all my life, on the incomparable beauty and marvel of nature's creatures.

Author and photographer Wayne Lynch crawls out of a limestone cave, the overwintering site of thousands of red-sided garter snakes, the most northerly ranging snake in North America.

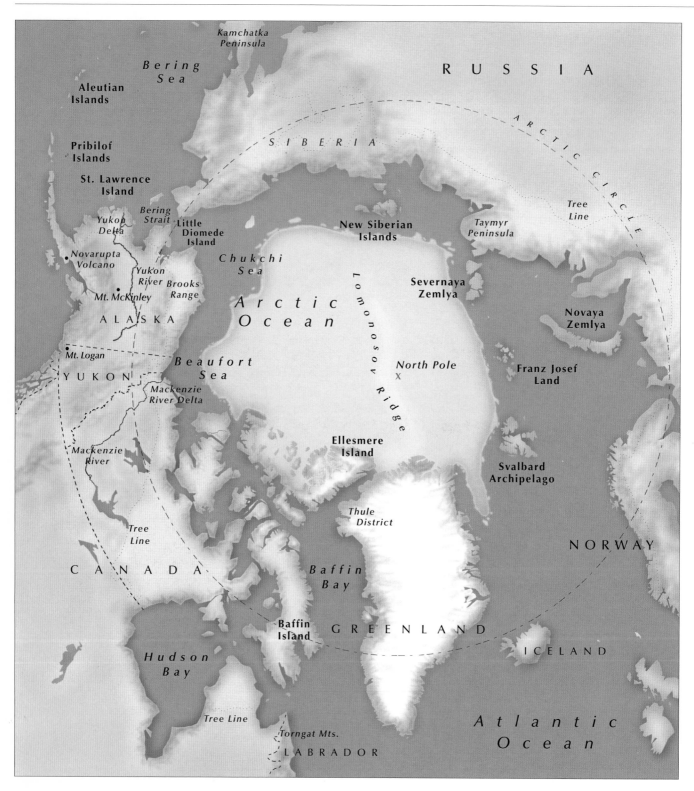

Kamchatka
Peninsula

B e r i n g
S e a

R U S S I A

**Aleutian
Islands**

S I B E R I A

A R C T I C C I R C L E

**Pribilof
Islands**

**St. Lawrence
Island**

*Tree
Line*

*Yukon
Delta*

*Bering
Strait*

**Little
Diomede
Island**

**New Siberian
Islands**

*Taymyr
Peninsula*

*Novarupta
Volcano*

*Yukon
River*

*Chukchi
Sea*

**Severnaya
Zemlya**

**Novaya
Zemlya**

*Brooks
Range*

*A r c t i c
O c e a n*

Mt. McKinley

L o m o n o s o v R i d g e

**Franz Josef
Land**

A L A S K A

Mt. Logan

North Pole
X

*B e a u f o r t
S e a*

Y U K O N

*Mackenzie
River Delta*

**Ellesmere
Island**

**Svalbard
Archipelago**

*Mackenzie
River*

**Thule
District**

N O R W A Y

*Tree
Line*

C A N A D A

*B a f f i n
B a y*

**Baffin
Island**

G R E E N L A N D

I C E L A N D

*H u d s o n
B a y*

Tree Line

Torngat Mts.

*A t l a n t i c
O c e a n*

L A B R A D O R

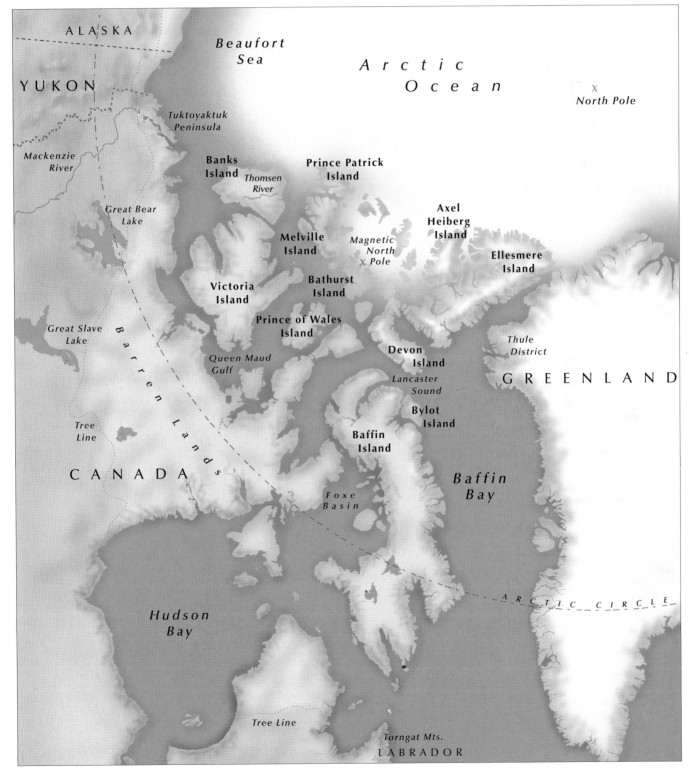

ALASKA

YUKON

Beaufort Sea

Arctic Ocean

X
North Pole

Tuktoyaktuk Peninsula

Mackenzie River

Banks Island

Thomsen River

Prince Patrick Island

Great Bear Lake

Axel Heiberg Island

Melville Island

Magnetic North X Pole

Ellesmere Island

Victoria Island

Bathurst Island

Prince of Wales Island

Thule District

Devon Island

GREENLAND

Great Slave Lake

Queen Maud Gulf

Lancaster Sound

Bylot Island

Tree Line

Baffin Island

B a r r e n L a n d s

CANADA

Foxe Basin

Baffin Bay

A R C T I C C I R C L E

Hudson Bay

Tree Line

Torngat Mts.

LABRADOR

FURTHER READING

Thousands of scientific papers have been written about the Arctic and its wildlife. Most of these can be found only in university libraries, and although many of them are rich with information, the average reader might find them quite technical and dry. Because of this, I have limited the reading list to my favorite books and, in particular, to those which are still in print or available in virtually every community library through interlibrary loan.

General

Burt, Page. *Barrenland Beauties: Showy Plants of the Arctic Coast.* Yellowknife: Outcrop Ltd., 1991.

Ehrlich, Paul R., David S. Dobkin and Darryl Wheye. *The Birder's Handbook: A Field Guide to the Natural History of North American Birds.* New York: Simon and Schuster, 1988.

French, Hugh M., and Olav Slaymaker (editors). *Canada's Cold Environments.* Montreal: McGill-Queen's University Press, 1993.

Harington, C.R. *Canada's Missing Dimension: Science and History in the Canadian Arctic Islands, Volumes I & II.* Ottawa: Canadian Museum of Nature, 1990.

Philips, David. *The Climates of Canada.* Ottawa: Ministry of Supply and Services Canada, 1990.

Sage, Bryan. *The Arctic and Its Wildlife.* New York: Facts on File Publications, 1986.

Stonehouse, Bernard. *North Pole, South Pole.* Toronto: McGraw-Hill Ryerson, 1990.

Young, Steven B. *To the Arctic: An Introduction to the Far Northern World.* New York: John Wiley & Sons Inc., 1989.

Specific

Alcock, John. *Animal Behavior: An Evolutionary Approach,* 5th edition. Sunderland: Sinauer Associates Inc., 1995.

Alerstam, Thomas. *Bird Migration.* Cambridge: Cambridge University Press, 1993.

Bergerud, Arthur T., and Michael W. Gratson (editors). *Adaptive Strategies and Population Ecology of Northern Grouse.* Minneapolis: University of Minnesota Press, 1988.

Bruemmer, Fred. *The Narwhal: Unicorn of the Sea.* Toronto: Key Porter Books, 1993.

Calef, George. *Caribou and the Barren-lands.* Toronto: Firefly Books Ltd., 1981; revised edition 1995.

Chernov, Yu I. *The Living Tundra.* Cambridge: Cambridge University Press, 1985.

Conder, Peter. *The Wheatear.* London: Christopher Helm, 1989.

Davis, Neil. *The Aurora Watcher's Handbook.* Fairbanks: University of Alaska Press, 1992.

Duxbury, Alyn C., and Alison B. Duxbury. *An Introduction to the World's Oceans,* 4th edition. Dubuque: Wm. C. Brown Publishers, 1994.

Foelix, Rainer F. *Biology of Spiders.* Cambridge: Harvard University Press, 1982.

Furness, Robert W. *The Skuas.* Calton: T. & A.D. Poyser, 1987.

Gittleman, John L. (editor). *Carnivore Behavior, Ecology and Evolution.* Ithaca: Cornell University Press, 1989.

Gray, David R. *The Muskoxen of Polar Bear Pass.* Markham: Fitzhenry & Whiteside, 1987.

Grooms, Steve. *The Cry of the Sandhill Crane.* Minocqua: Northword Press Inc., 1992.

Halfpenny, James C., and Roy Douglas Ozanne. *Winter: An Ecological Handbook.* Boulder: Johnson Books, 1989.

Hall, Ed (editor). *People and Caribou in the Northwest Territories.* Yellowknife: NWT Department of Renewable Resources, 1989.

Heinrich, Bernd. *The Hot-Blooded Insects: Strategies and Mechanisms of Thermoregulation.* Cambridge: Harvard University Press, 1993.

Johnsgard, Paul A. *The Plovers, Sandpipers, and Snipes of the World.* Lincoln: University of Nebraska Press, 1981.

Johnsgard, Paul A. *Diving Birds of North America.* Lincoln: University of Nebraska Press, 1987.

Johnsgard, Paul A. *North American Owls: Biology and Natural History.* Washington: Smithsonian Institution Press, 1988.

Johnsgard, Paul A. *Hawks, Eagles, and Falcons of North America: Biology and Natural History.* Washington: Smithsonian Institution Press, 1990.

King, Carolyn. *The Natural History of Weasels and Stoats.* Ithaca: Cornell University Press, 1989.

Leatherwood, Stephen, and Randall Reeves. *The Sierra Club Handbook of Whales and Dolphins.* San Francisco: Sierra Club Books, 1983.

Lynch, Wayne. *Bears: Monarchs of the Northern Wilderness.* Vancouver: Douglas & McIntyre, 1993.

Lynch, Wayne. *Bears, Bears, Bears.* Toronto: Firefly Books Ltd., 1995.

Marchand, Peter J. *Life in the Cold: An Introduction to Winter Ecology.* Hanover: University Press of New England, 1987.

McGhee, Robert. *Ancient Canada.* Ottawa: Canadian Museum of Civilization, 1989.

Nethersole-Thompson, Desmond. *The Snow Bunting.* Leeds: Peregrine Books, 1993.

Nettleship, David N., and Tim R. Birkhead (editors). *The Atlantic Alcidae: The Evolution, Distribution and Biology of the Auks Inhabiting the Atlantic Ocean and Adjacent Waters.* New York: Academic Press, 1985.

Nowak, Ronald M. *Walker's Mammals of the World, Volumes I & II,* 5th edition. Baltimore: Johns Hopkins University Press, 1991.

Reeves, Randall R., Brent S. Stewart and Stephen Leatherwood. *The Sierra Club Handbook of Seals and Sirenians.* San Francisco: Sierra Club Books, 1992.

Riedman, Marianne. *The Pinnipeds: Seals, Sea Lions, and Walruses.* Berkeley: University of California Press, 1990.

Stenseth, N.C., and R.A. Ims. *The Biology of Lemmings.* New York: Academic Press, 1993.

Vaughan, Richard. *In Search of Arctic Birds.* London: T. & A.D. Poyser, 1992.

Government Publications

A number of government agencies publish small three-to-six-page fact sheets on different wildlife species found in the Canadian Arctic. These are available by writing to:

Arctic Wildlife Sketches, Conservation Education, Department of Renewable Resources, Government of the Northwest Territories, Box 1320, Yellowknife, Northwest Territories X1A 2L9.

Hinterland Who's Who, Distribution Section, Canadian Wildlife Service, Ottawa, Ontario K1A 0H3.

Underwater World, Communications Directorate, Department of Fisheries and Oceans, Ottawa, Ontario K1A 0E6.

INDEX

ACKNOWLEDGMENTS

After a 17-year love affair with the Arctic, I have many people to thank for helping me to understand this enchanting polar world. I would especially like to mention Fred Bruemmer, Dr. Fenja Brodo, Peter Clarkson, Dr. David Gray, Dr. Kit Kovacs, Dr. Olga Kukal, Dr. Pål Prestrud, Dr. Malcolm Ramsay, Dr. Chris Shank, Dr. Tom Smith, Dr. Ian Stirling and Alasdair Veitch. Many others offered valuable assistance while I was writing this book. Ed Bailey provided information on Alaskan red and arctic foxes; Lorraine Brandson, curator of the Eskimo Museum in Churchill, Manitoba, talked to me about kayaks; Dr. Sue Cosens shared her knowledge about Atlantic bowhead whales; Graham Campbell gave me the scoop on oil in the Arctic; Bonnie Chartier, arctic bird watcher *extraordinaire*, gave me the inside story on Ross' gull; Dr. Barry Hargrave talked to me about pycnogonids; Dr. Jack Mathias faxed me information on arctic sharks; meteorologist Peter Skeates introduced me to the science of blizzards; and Arch Stewart, chief librarian at the Canadian Museum of Nature, helped me track down some elusive Russian papers on foxes. To all of them, my sincere thanks.

My gratitude also to my friend Joe Van Os of Joseph Van Os Photo Safaris, who over the years has hired me as a naturalist on numerous trips to the Arctic, which allowed me to broaden my experience in the North; to David Krygier, general manager of Calberta Manufacturing, who provided me with a custom winter parka and pants that always kept me warm; to the many staff members at Canadian Heritage/Parks Canada, in particular André Guindon, who helped me whenever they could; and to my younger brother Brian, the computer whiz who called me a dinosaur and then cheerfully helped me upgrade my word processor and join the '90s before the decade was over.

Four topics covered in this book—ptarmigan, mosquitoes, salt hunger in Dall's sheep and wood frogs—first appeared in slightly different forms in my monthly wildlife column in *Outdoor Canada* magazine. Thanks to editor Teddi Brown for permission to reprint the material here and to editor Jon Fisher of *International Wildlife* magazine for allowing me to reprint portions of an article I wrote for him on polynyas. Thanks are also due to *Natural History* magazine and author John Reynolds for permission to use a quote from his article "Philandering Phalaropes" (8/1985), copyright the American Museum of Natural History 1985, and to the University of Minnesota for allowing me to quote David Mech's book *The Wolf: The Ecology and Behavior of an Endangered Species.*

Four brave souls—wildlife biologists Dr. Andy Derocher and Gary Hornbeck, behavioral ecologist Dr. Bruce Lyon and naturalist/writer David Middleton—agreed to take time from their busy schedules to read the text for *A is for Arctic* and to offer editorial advice. Each made valuable suggestions, and all were gentle in their criticisms. I thank them heartily for a job well done. Of course, I alone accept all responsibility for any errors that may have crept into the text.

This is my second book project with the committed people at Bookmakers Press. As before, editor Tracy Read, designer Linda Menyes, copy editor Susan Dickinson and proofreader Catherine DeLury were professional and delightful to work with from start to finish.

One last person deserves thanks above all others, my wonderful friend and wife, Aubrey Lang. She edited the text with her usual skill and perceptiveness and was always available to discuss details about the book, no matter how boring it must have sometimes been to her. Her unselfish enthusiasm has never wavered in 21 years of marriage. She is a marvel.

In 1979, at the age of 32, Dr. Wayne Lynch left a career in emergency medicine to work full-time as a science writer and photographer. Today, he is the author of award-winning books and television documentaries, a popular guest lecturer and Canada's best-known and most widely published professional wildlife photographer. His photo credits include hundreds of magazine covers, thousands of calendar shots and tens of thousands of images published in over 30 countries.

Since 1993, Lynch has authored two books on topics relating to the Arctic: *Bears: Monarchs of the Northern Wilderness*, published by Greystone Books in Vancouver, British Columbia; and *Bears, Bears, Bears*, published by Firefly Books in Willowdale, Ontario.

Lynch lives in Calgary, Alberta, with his wife Aubrey Lang.

591.998 Lynch, Wayne.
LYN
 A is for arctic.

$24.95 pb 6/6/97

DATE			

BAKER & TAYLOR